LONDON
EVERY DAY

There must be room in our world for eccentricity,
even if it offends the prudes, and room for the vague
otherworldliness that often goes with genius.

BORIS JOHNSON
Mayor of London

ANDREA HAMILTON

LONDON EVERY DAY

booth-clibborn
editions

HE CH

BORIS JOHNSON

Mayor of London, Patron of the
Mayor's Fund for London

I love pubs. I used to go and just sit on the pavement by pubs, or stand outside and drink in the evenings. That was one of my great pleasures in life. Pubs are so much more than a place to drink. And with over 7,000 in this city, it is clear that this is a view shared by many Londoners – a reason we have put in extra protection powers for them, and helped communities to keep their locals going.

For centuries London's pubs have played a key role at the heart of their communities and this particular pub is one of our more historic, built way back in 1750, and frequented in the 1800s by Winston Churchill's grandparents. And we know the great man himself enjoyed a tipple!

Anyone looking at Andrea Hamilton's picture of The Churchill Arms will envision a quintessential, perfect English long lunch in the greatest city in the world.

MAYOR'S FUND FOR LONDON

HELPING YOUNG LONDONERS GROW

CONTENTS

CHARLOTTE COTTON

Founding Curator-in-Residence
International Center of Photography
250 Bowery, New York

INTRODUCTION

This photographic journey through London embodies the endless ways in which we experience its unique nature. This magnificent city's architecture butts together its governmental, royal, industrial and civic histories, inevitably felt as improbable aggregations of past and present that noisily fill our everyday encounters. If we lift our eyes from its grey pavements on any journey through London and its sprawl, we can indulge in a form of time travel. We observe, speculate upon and imagine this city as we scan its vistas and alleyways, cumulatively constructing our own evolving narrative of its identity. London is a city that is shaped by personal understanding, with each of us carrying our own version of this layered metropolis constituted out of our individual lived experiences.

London is not an explicit city, despite its plenitude of imposing architecture and public spaces that declare its civic structure. Instead, it is a terrain of secrets and a maze of hidden domains. We create notions of what goes on inside a building beyond its façade, and we make its history from the expectations and assumptions that fill our ample imaginations. London is a place where you can take the same path a hundred times before noticing its full nature. It is not only the fixed density of its streets (the city bides its time, revealing itself gradually, when we are ready to see it), but also its fluidity that moulds our comprehension. London is a city that changes constantly; it is a place that we define through its developing contingencies, where corporate architecture rises up as its new landmarks; bridges and roadways shift our vantage points; and gentrification in one quarter is matched by the slow creep of dereliction and temporary solutions elsewhere. It is a city that today prides itself on its diversity of race and religion, rich and poor, and while the shadow of disparity between the "haves" and "have nots" casts ever-wider, these contradictions and tensions play out in our engagements with its historic spaces.

London is a place that promises each of us the pleasures of anonymity. When we race down its main thoroughfares in the rain, take the swiftest of shortcuts through its back streets, breathe out its frosted air as we stomp across its parks or laze on its

summery riverbanks, we become part of the seasonally orchestrated performance that is London on any given day. The city embraces us in this glorious great unfolding, on condition only that we acquiesce to its momentum and enter into its flow. London is remarkably incurious about us: it doesn't welcome us back after our absences nor miss us when we are gone. It can be harsh and unforgiving, but, with the quid pro quo agreement that it will keep our secrets, it promises that we will be merely casually surveyed as part of its landscape, and allows us to roam freely.

Andrea Hamilton's photographs of London encapsulate the permission that both London and photography grant us. For her, the camera is a passport to scrutinize and also chance upon the myriad of situations and unexpected encounters that London continually provides. As the seasons pass, laid out in the sequence of this book, the vast delights, the historic rituals and jarring contradictions are caught as if waiting for Hamilton's camera. Since photography's cultural beginnings in the mid 19th century, it has mapped our actual and symbolic worlds. A camera permits us to look longer than the naked eye, to be within the city but somewhat removed and able to bear witness to its eddies of people and the auspices of its present situations. In many of Hamilton's photographs, London performs to type, still rich in its civic pride, with its royal processions, age-old sports and venerable museums all represented here. This "picture postcard" version of London is mitigated in combination with Hamilton's well-observed vignettes of contemporary life, of the poverty and disuse of the city. Similarly, she gains access to closed worlds – sites of worship and privilege, artists' studios and other secret spaces – that reveal yet more layers in the character of London. Hamilton allows us to move with her through this wonderful city. We get to stand back and see London as a site of continual, ongoing human endeavour, ever re-presenting and re-mapping itself, and as a place of immense yet distinctive wonder. Hamilton's photographs also allow us to enter into its street throngs, gatherings and ramblings, capturing the enduring promise of London.

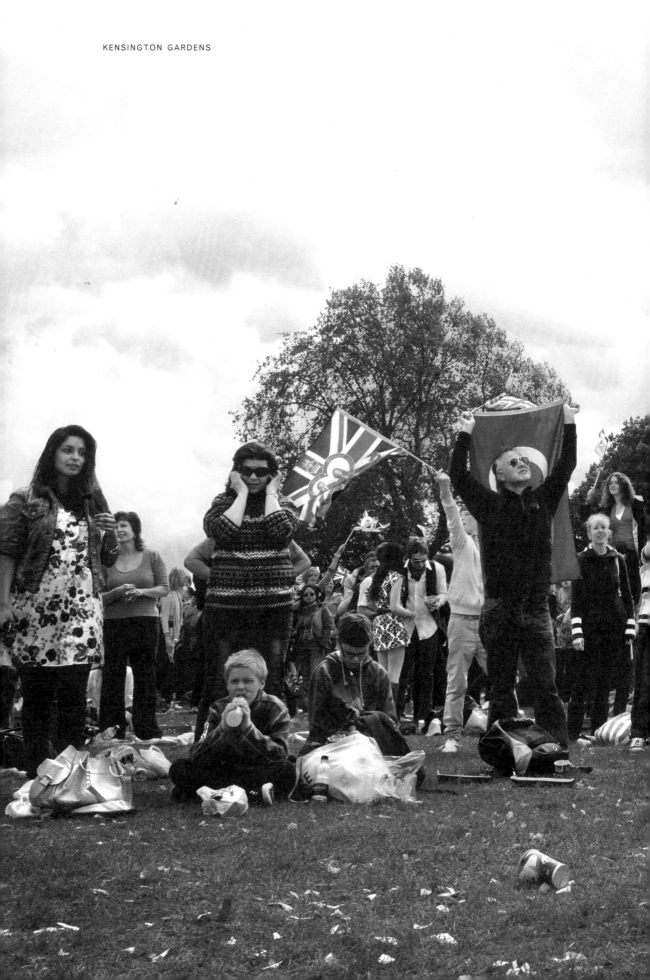

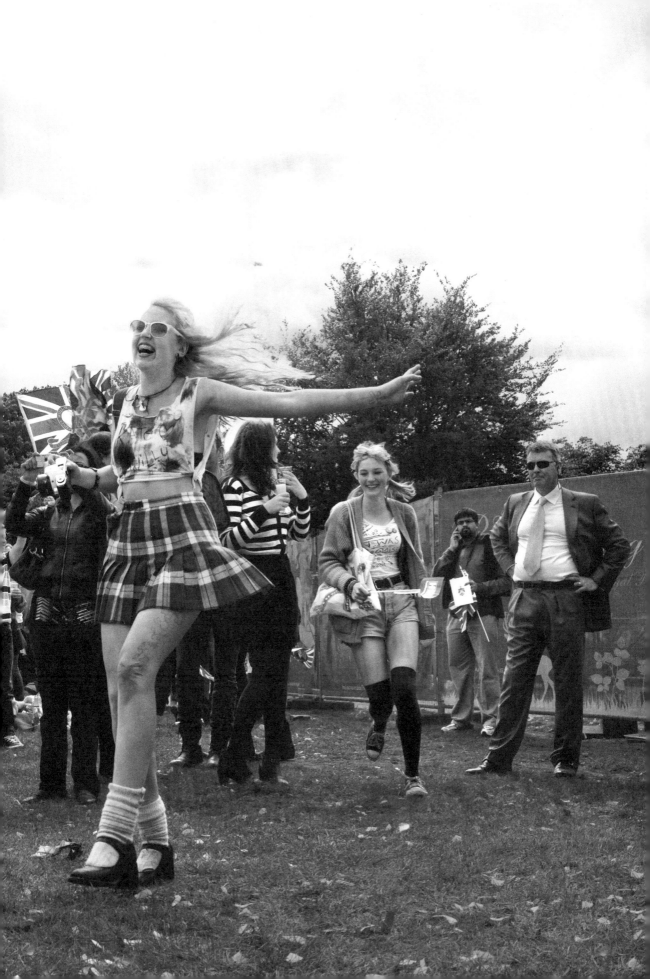

SPRING JAN FEB MAR APR MAY JUN

SPRING

London Every Day is part of a photographic body of work made of individual pictures that have been gathered together under the unifying theme of the ephemeral aspects of daily life. A morning buying flowers in Broadway Market, an afternoon in Shoreditch or Hyde Park, a visit to a museum in South Kensington, a day trip to an event at Ascot Racecourse or along the river to Greenwich – these, among others, are the social contexts of these images. But there is a universal aspect to many of these photographs; they are everywhere and nowhere, capturing moments both important and insignificant, but always real.

Spring in London is a time of sudden rain showers, blossoming trees and flowering plants. This book is a personal walking diary but its aim is to inspire others to explore this wonderful city as a creative hub and see all that it offers. It is a love letter to photography. It is about London moments seen through my eyes but sometimes influenced by others' visions and interpretations, included in this book in the form of citation and visual complicity. And it is filled with references to a wider experience of life – to new encounters and perceptions that have added refinement to my way of seeing the world as a cumulative sharing of knowledge.

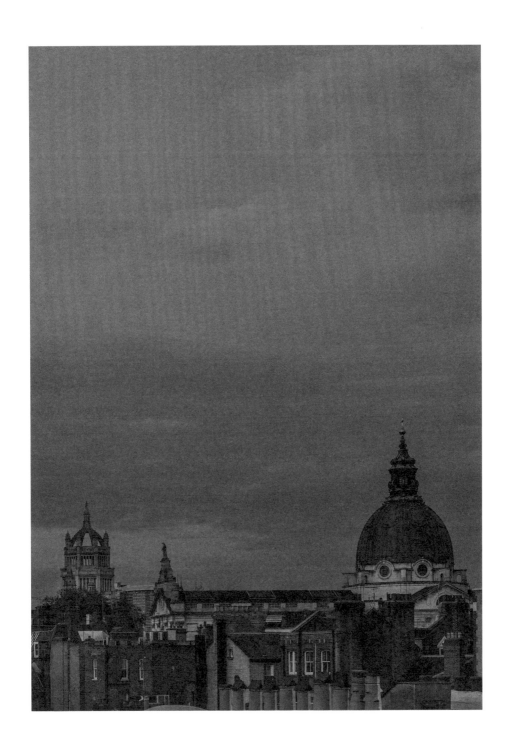

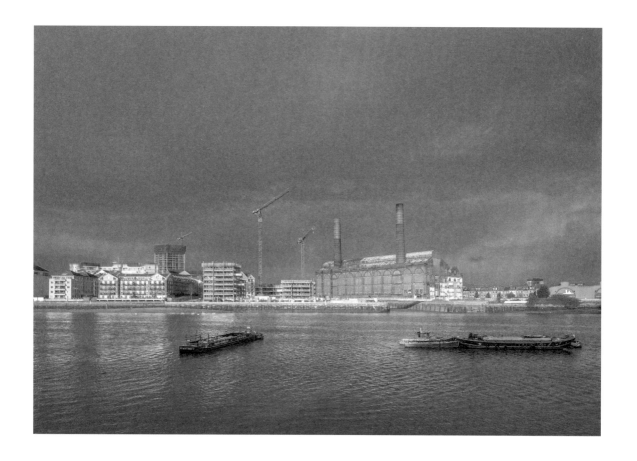

SPRING JAN FEB MAR APR MAY JUN

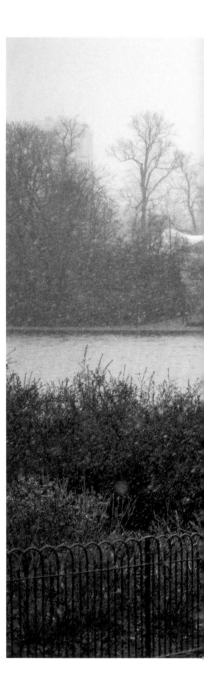

SPRING JAN FEB MAR APR MAY JUN

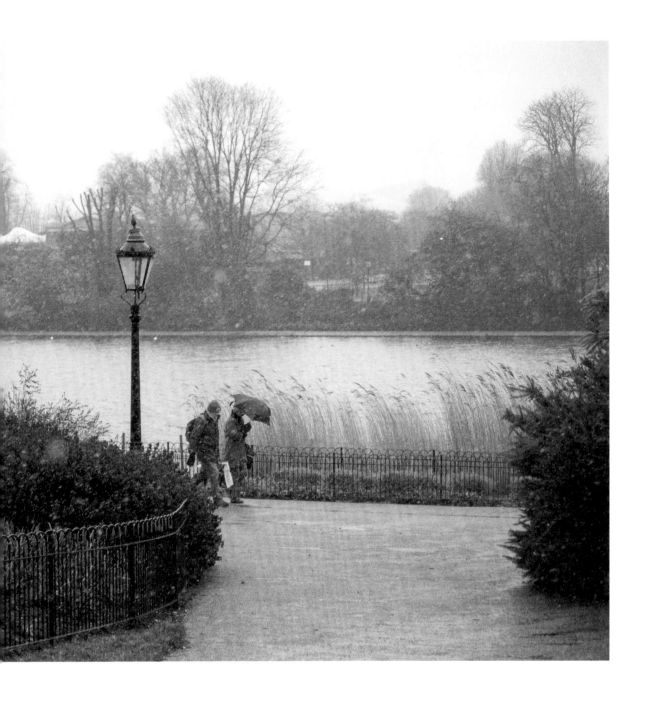

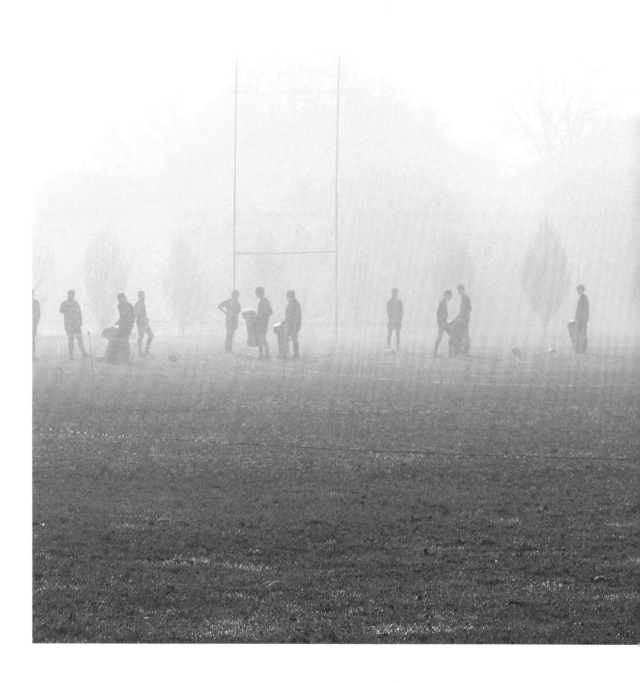

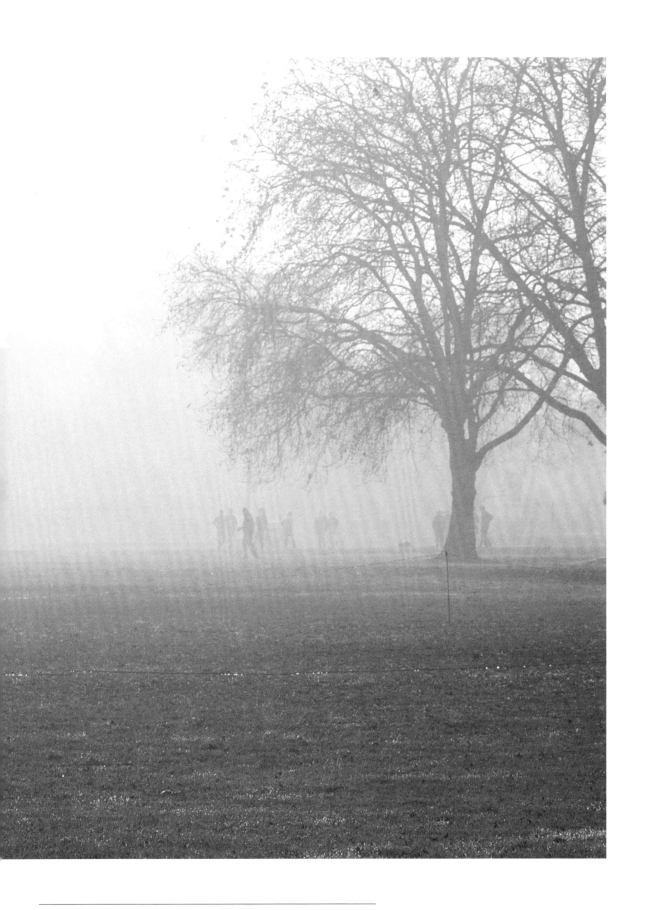

Street photography is for me the most pure form of traditional photography: it all comes down to the human spirit or the confrontation of a particular moment in time. Elliott Erwitt once said: "Photography is an art of observation. It's about finding something interesting in an ordinary place. I've found it has little to do with the things you see and everything to do with the way you see them." There is something about kindness or tenderness between human beings that makes me pause and reflect on this.

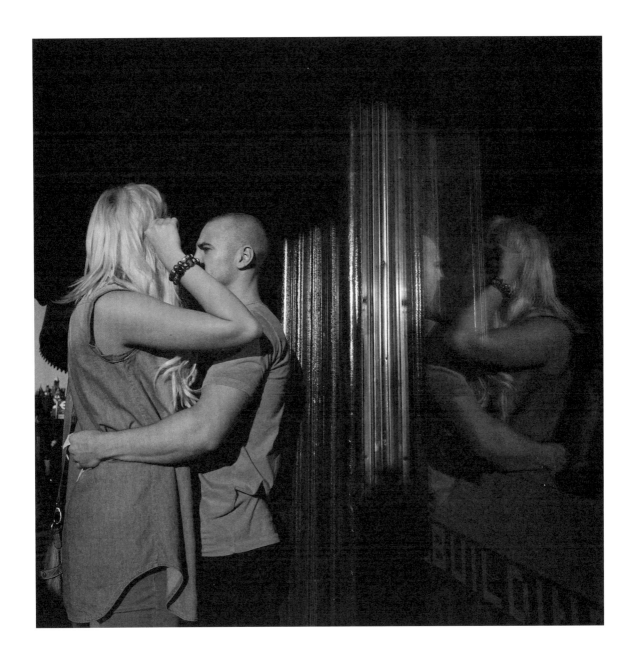

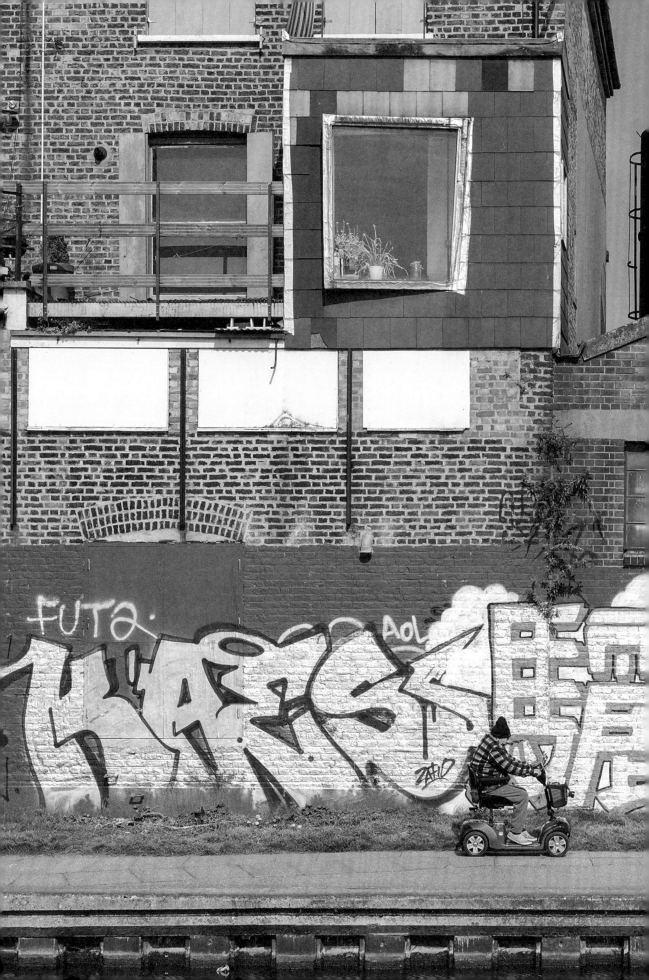

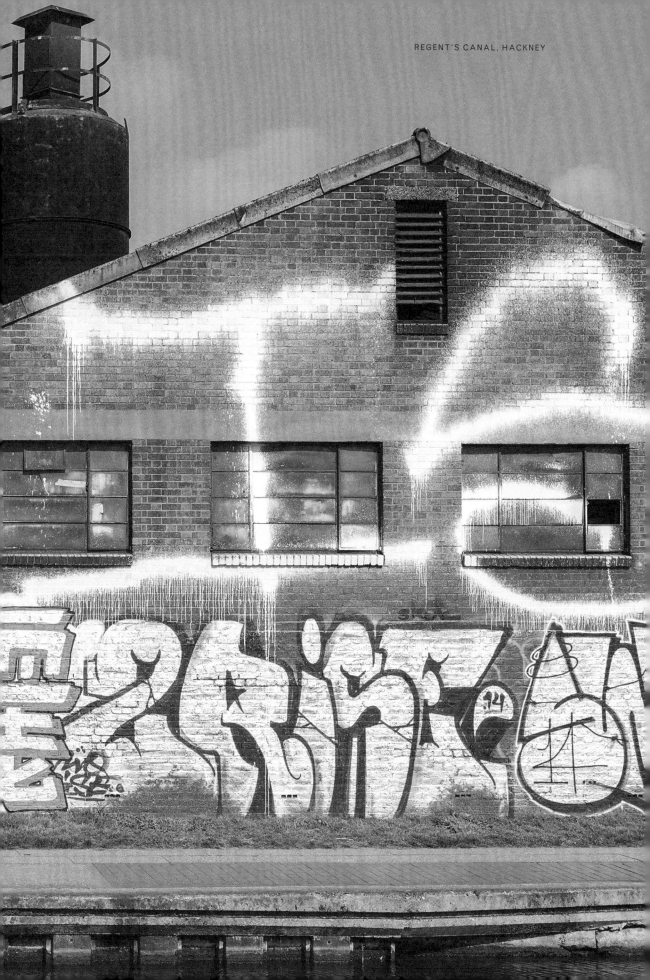

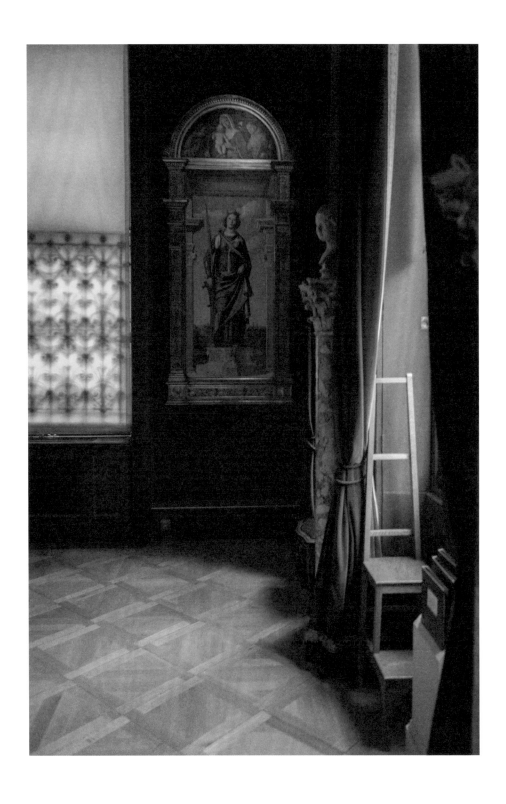

SPRING JAN FEB MAR APR MAY JUN

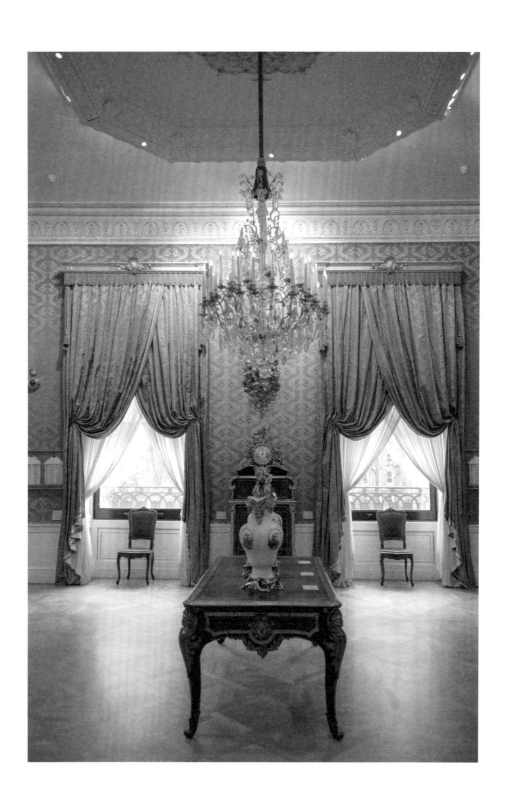

THE SERPENTINE LIDO, HYDE PARK

SPRING JAN FEB MAR APR MAY JUN

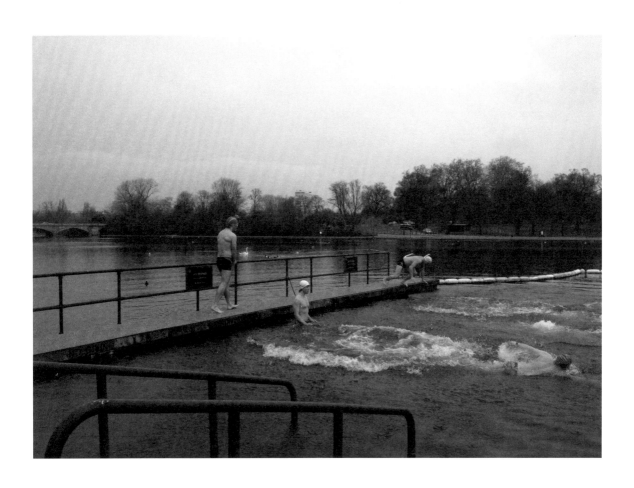

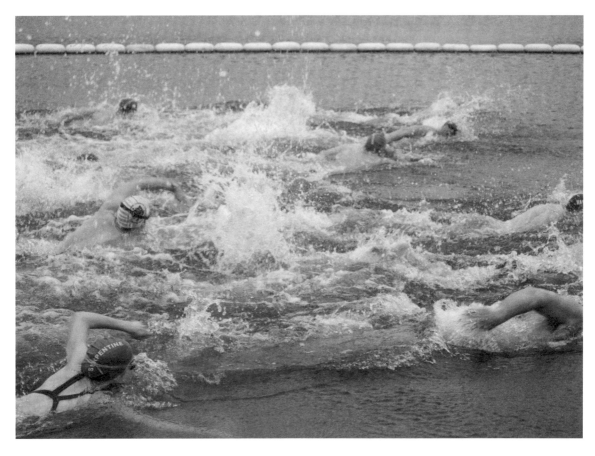

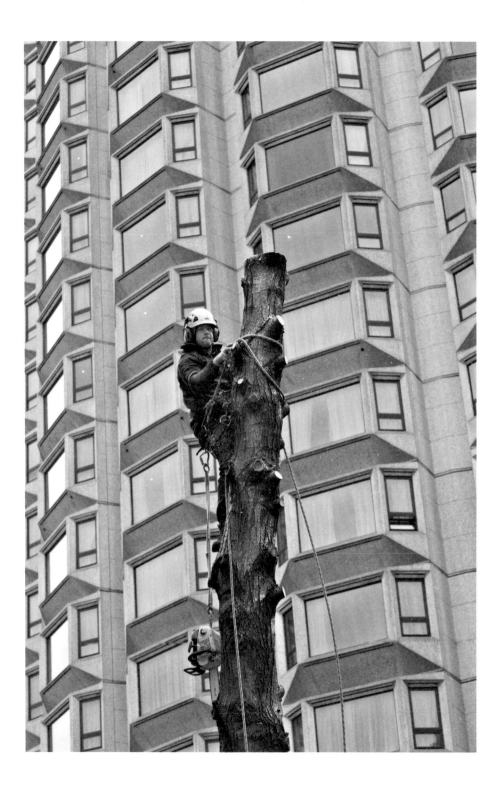

SPRING　　　　　　JAN　　FEB　　MAR　　APR　　MAY　　JUN

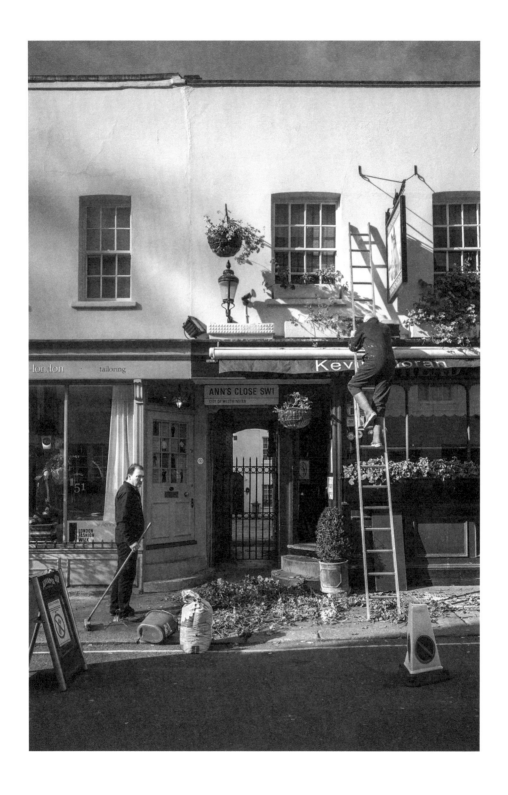

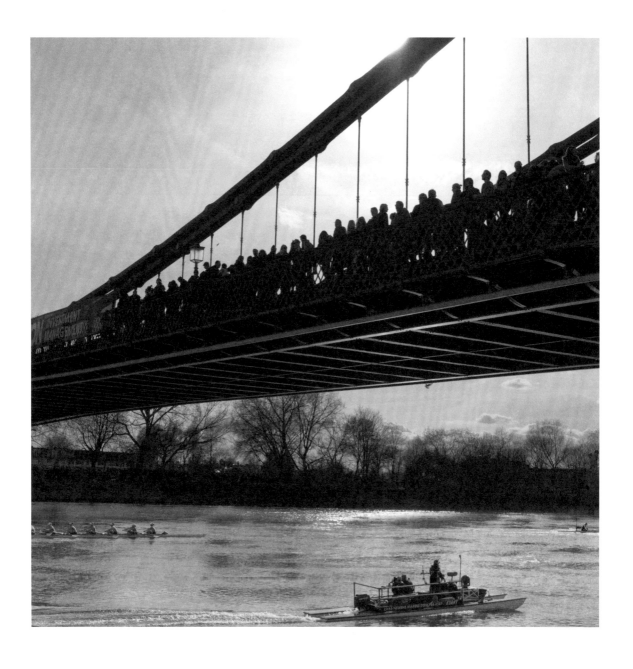

In this particular photograph, as the boats were speeding by,
I thought of the many rowing races to have gone before, down this
river. In its course through London, the river carries the weight
of the past in its currents. As John Burns put it: "The Thames
is liquid history."

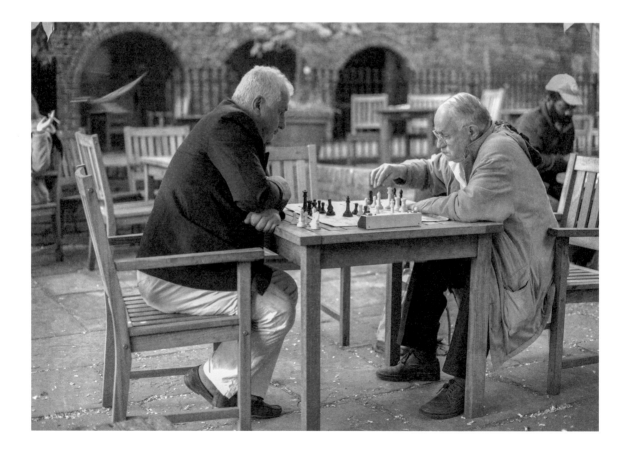

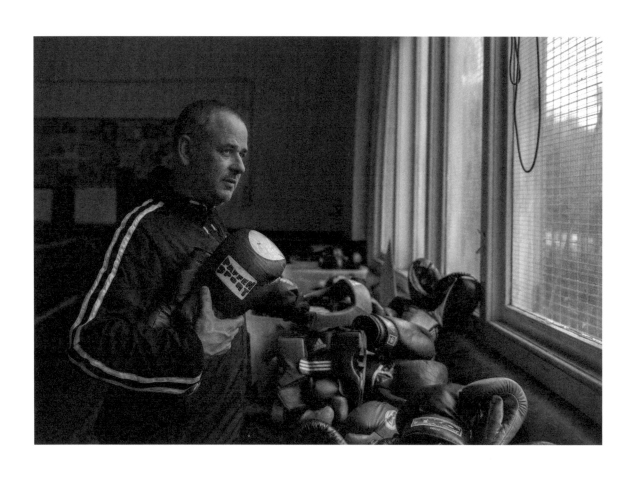

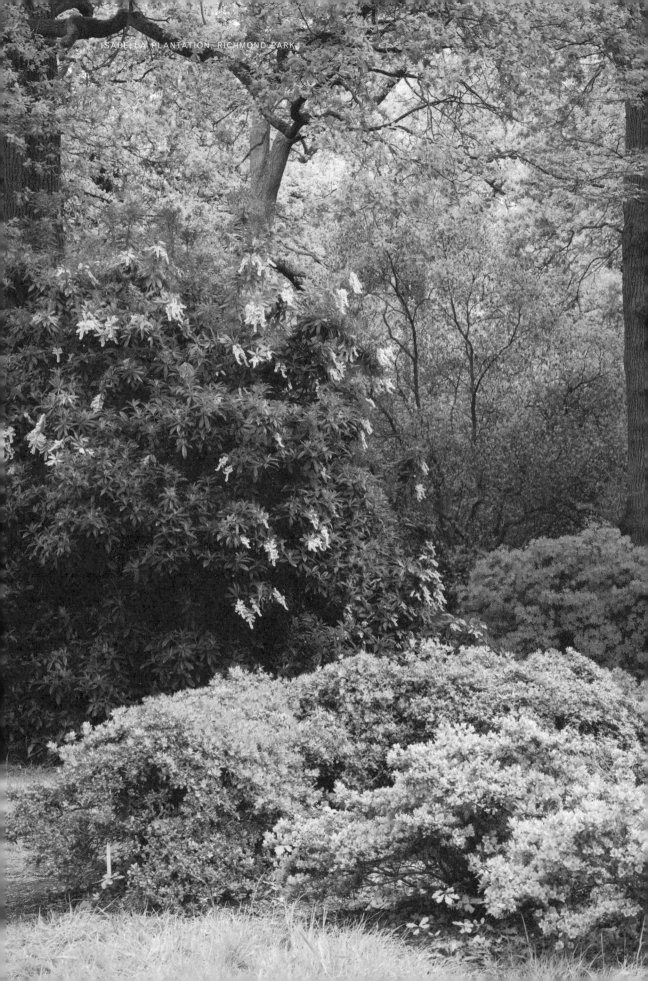
ISABELLA PLANTATION, RICHMOND PARK

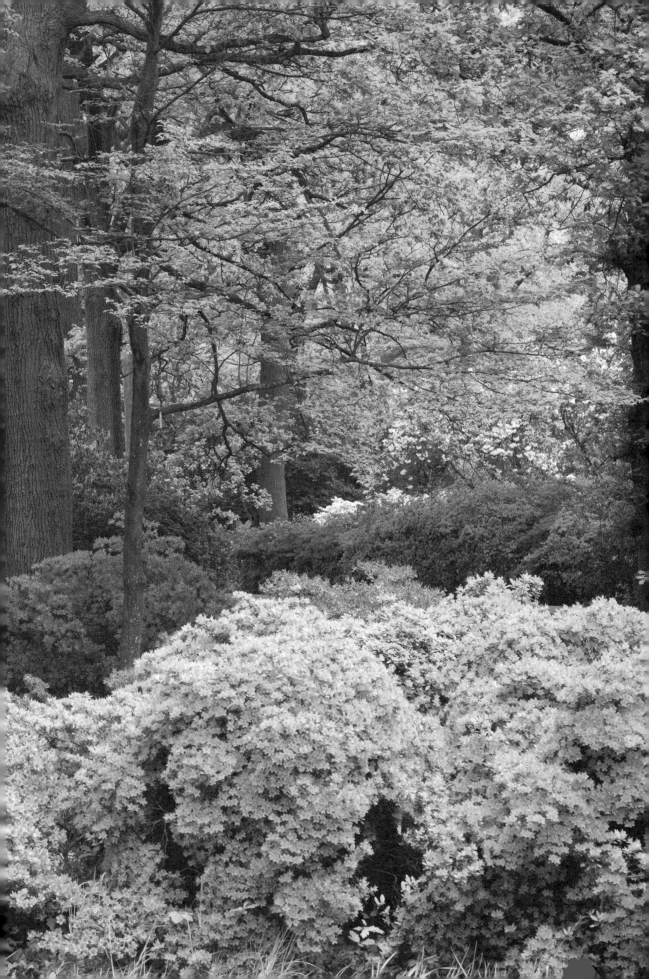

GREEN PARK

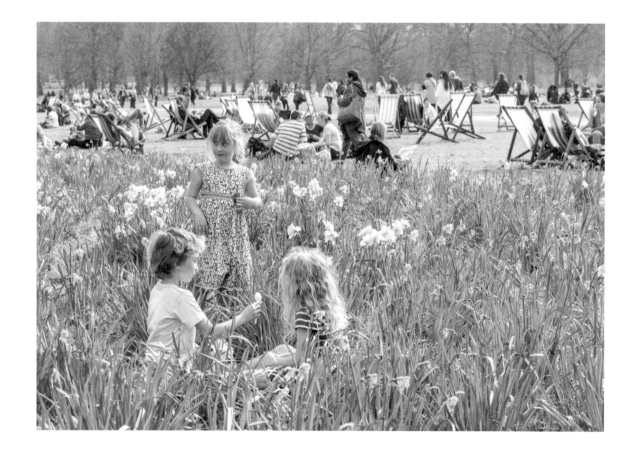

SPRING JAN FEB MAR APR MAY JUN

I lost my mother to cancer six years ago and remember her telling me, poignantly, what really matters: it is not the material things at all, but simply being able to walk and feel the sunlight on your forehead or smell the blossoms, to look and to feel.

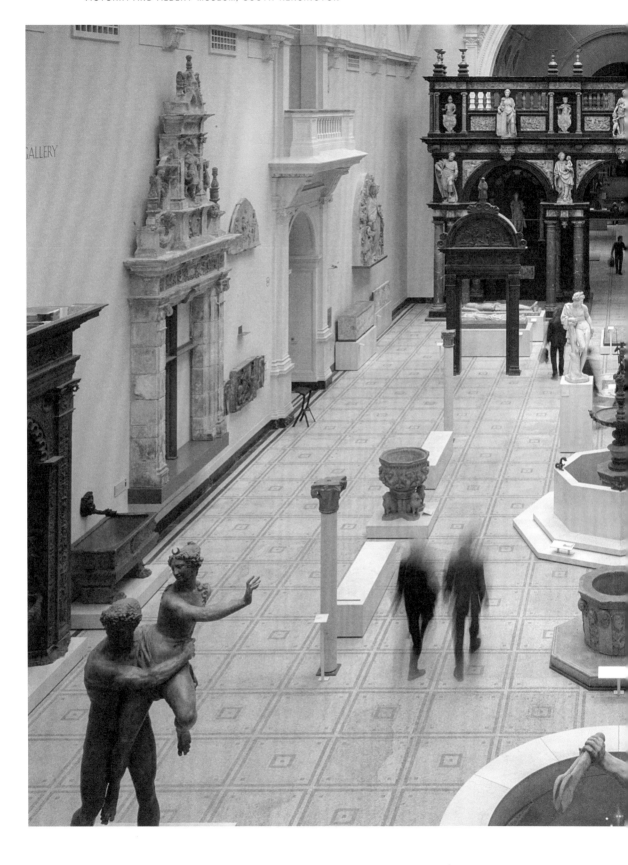

SPRING JAN FEB MAR APR MAY JUN

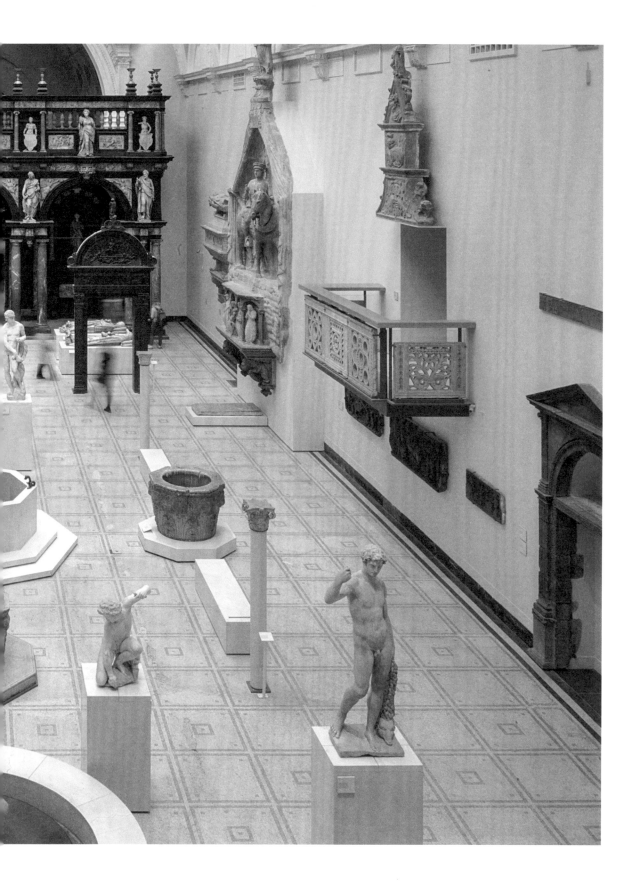

GREEN PARK

SPRING JAN FEB MAR APR MAY JUN

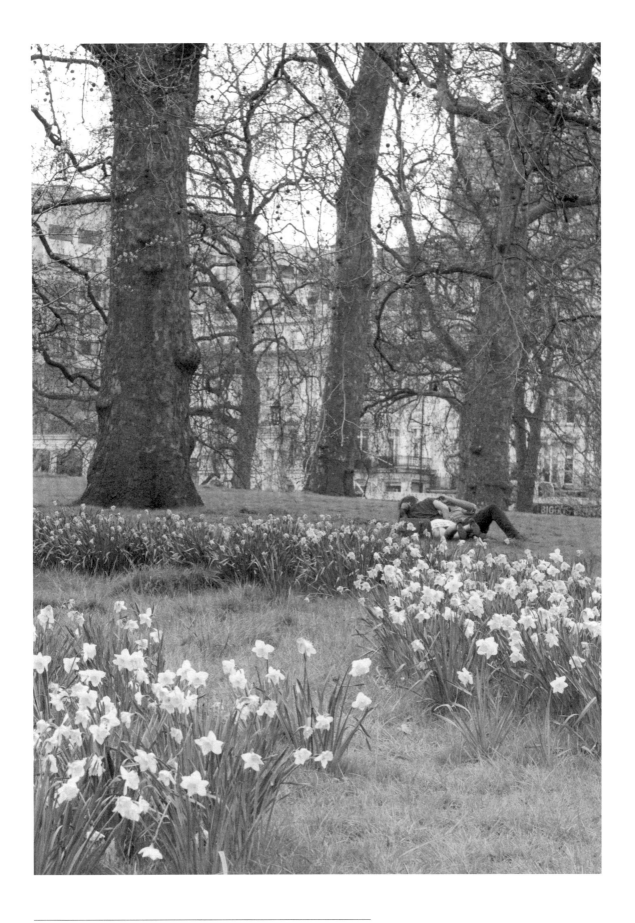

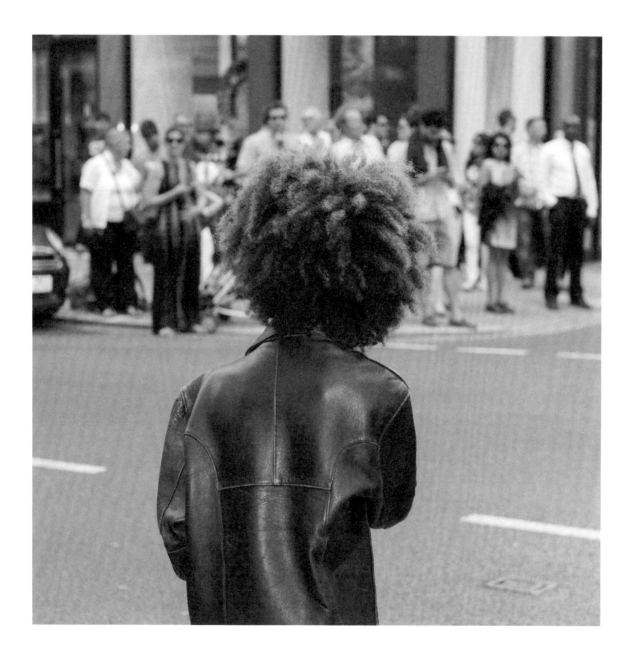

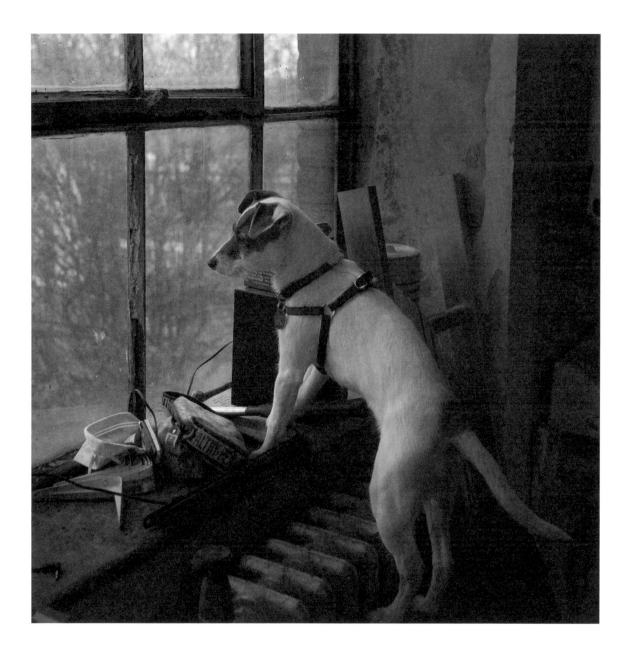

This picture is redolent of one of my favourite photographs taken by André Kertész. He captured the image in 1929 and called it *Broken Plate*. Technically, they are completely different, yet their execution suggests a certain elegiac fragility in our powerful urban cityscapes.

SIR ELTON JOHN
Composer and Singer

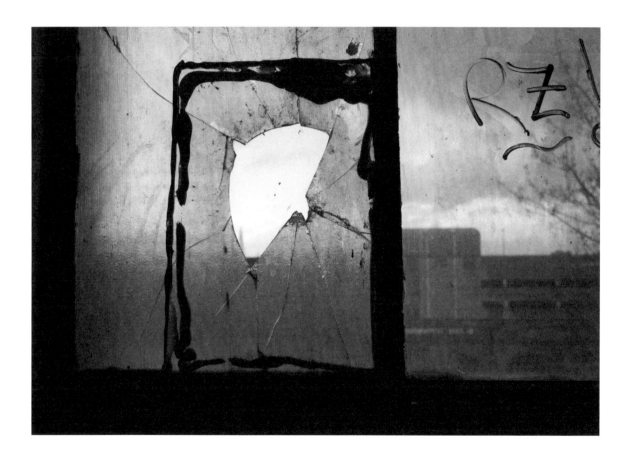

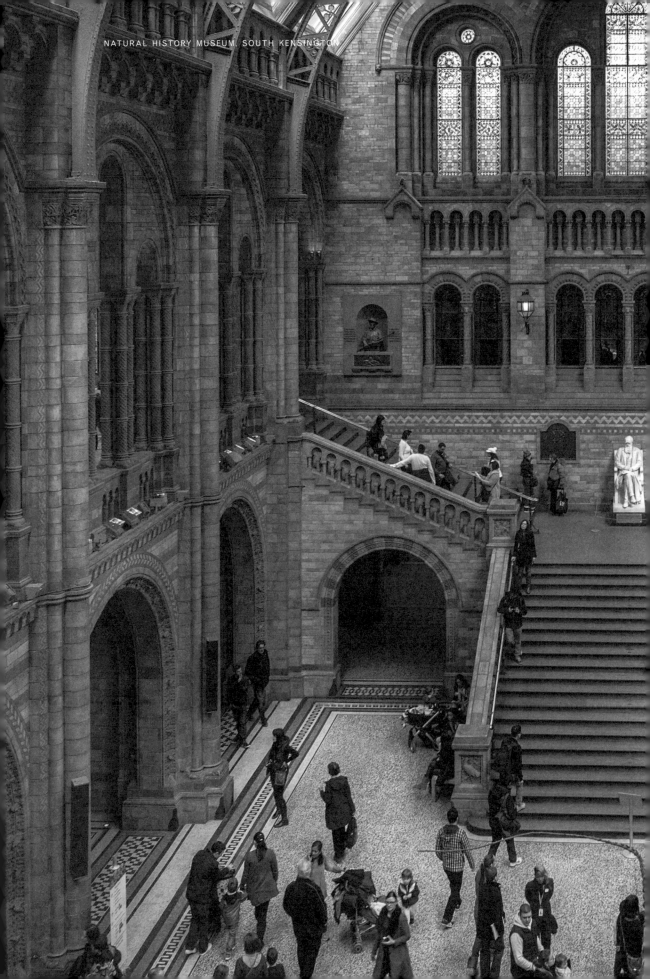

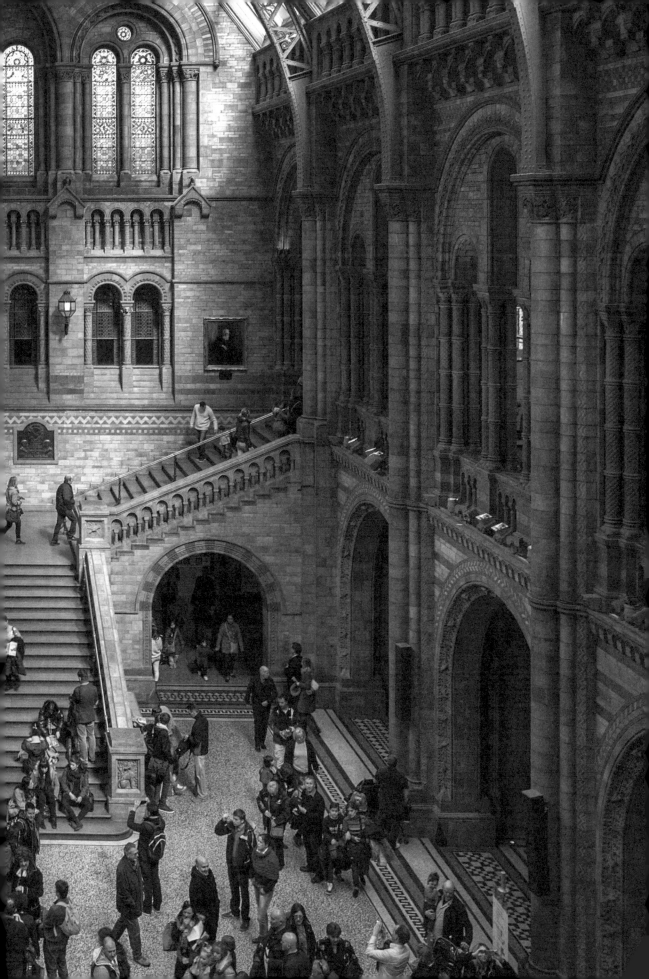

SPRING JAN FEB MAR APR MAY JUN

I watch scenes unfold in front of me, some quite hard to believe.
Other times, I catch just glimpses of things that fascinate me.
Alec Soth said: "There's a kind of beautiful loneliness in voyeurism."
This image reminds me of this idea. As an artist, occurrences
come at you: they happen by accident. The surprise is the point
of crystallization.

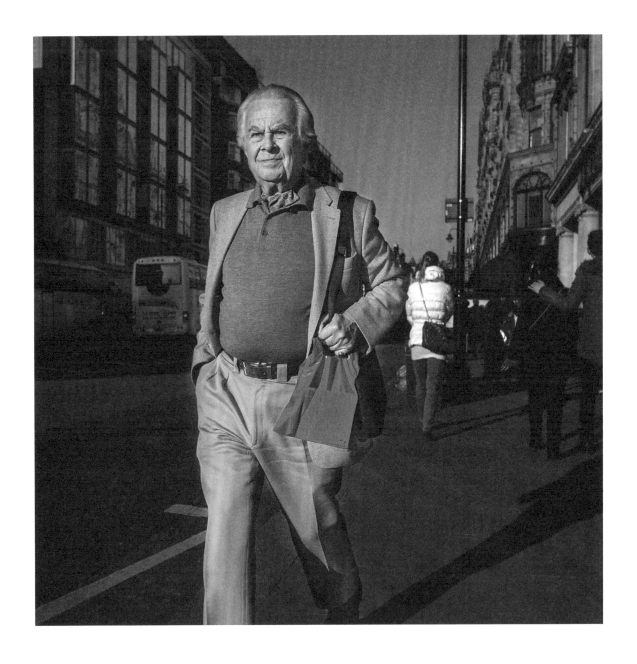

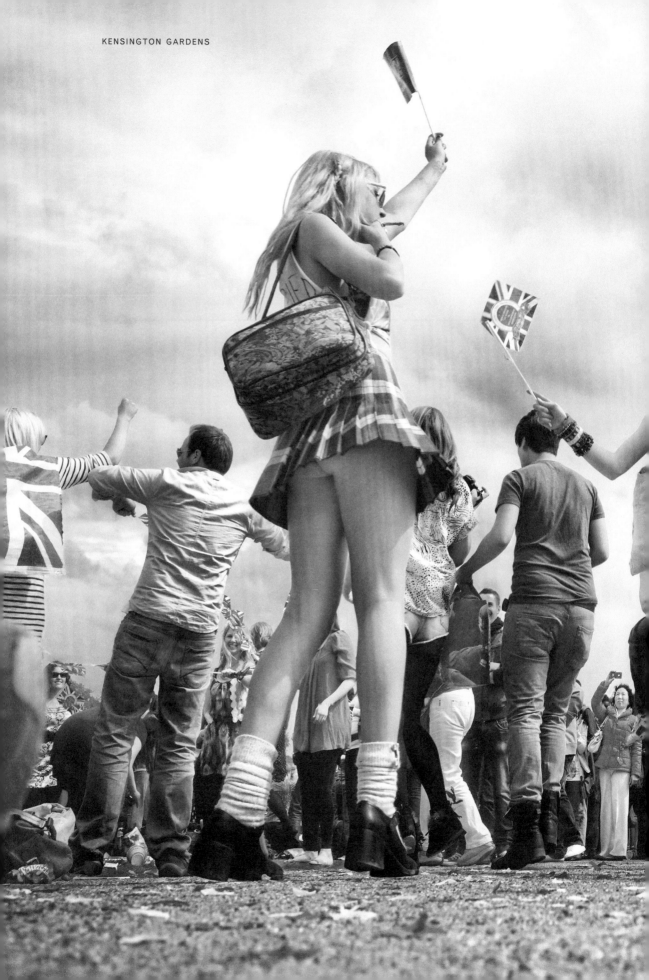

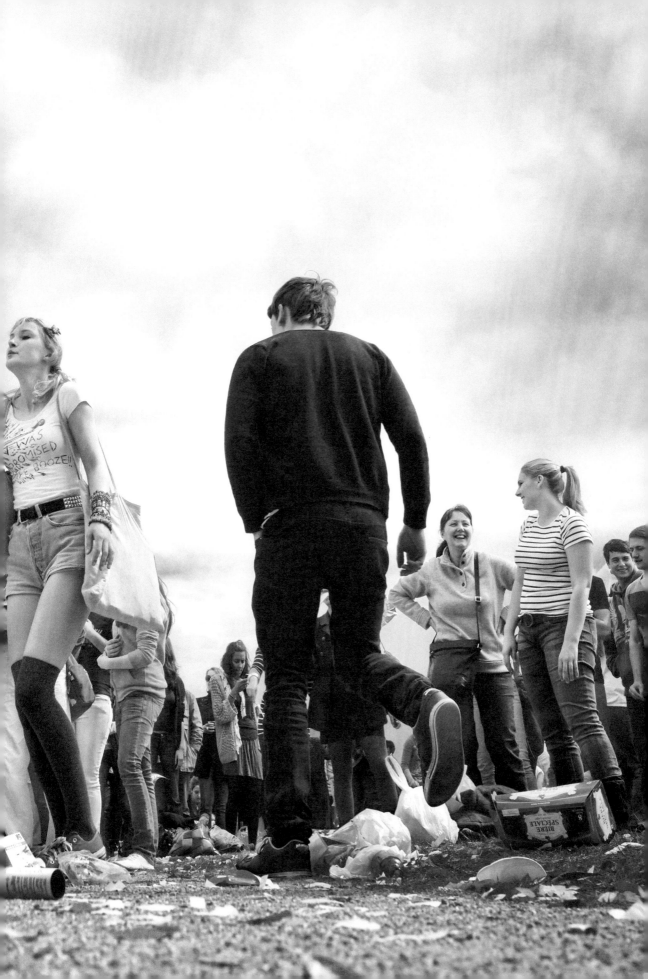

I chose this image initially as it features everything that I love about London; the classical architecture of St Paul's, the iconic red bus, the leafy plane trees and even a characteristically leaden sky – you get the sense that a rain shower is imminent. But, more importantly, the movement of the bus depicts the sense of energy and urgency that, for me, epitomizes the spirit of London – the clouds are gathering and a summer storm may be on its way, but there's a job to be done and we must crack on with it! I guess this resonates with my own approach to life, which I believe has stood me in good stead over the years, particularly when it comes to travel, the industry which I have been involved in all my adult life.

Travel by its very nature is unpredictable – which is partly what makes it so compelling; it appeals to our sense of adventure. The trick is to be prepared for all obstacles and eventualities, and able to respond accordingly to achieve what you originally set out to do, accommodating, even enjoying, the surprises that can get thrown up along the way. I'd love to know what the individual passengers on that bus are thinking. Where is their intended destination, are they anxious to arrive there quickly? Are they sitting back enjoying the journey, absorbed on their own thoughts? Or did they jump on board simply to avoid the rain...?

GEOFFREY KENT
Founder, Abercrombie & Kent

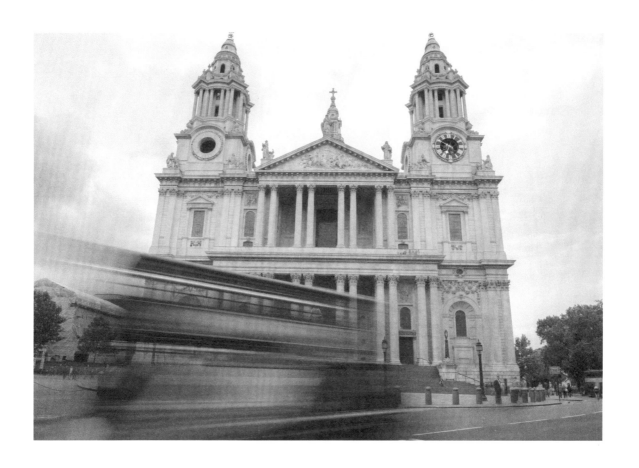

This project came about because I don't usually leave home without a half-decent camera. I feel like an explorer when I have a camera in hand, it makes life more of an adventure. Not only do you discover the world around you, but you discover yourself in this process.

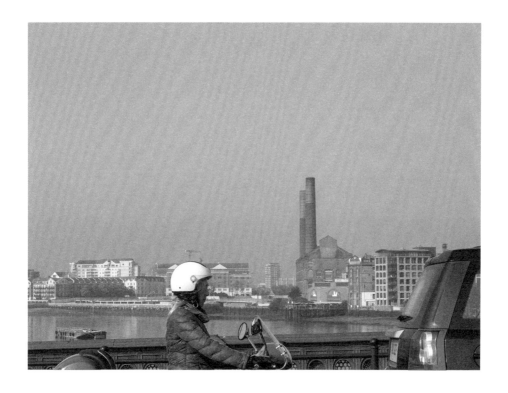

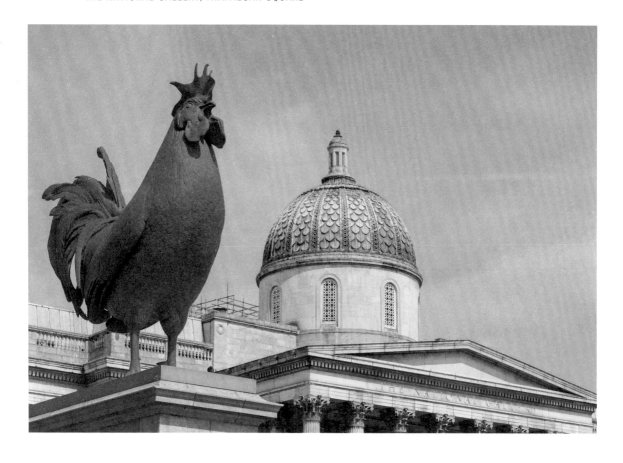

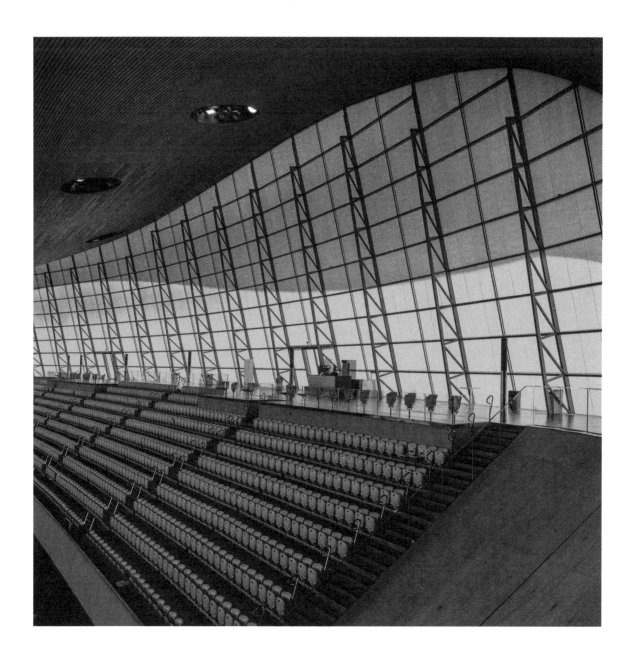

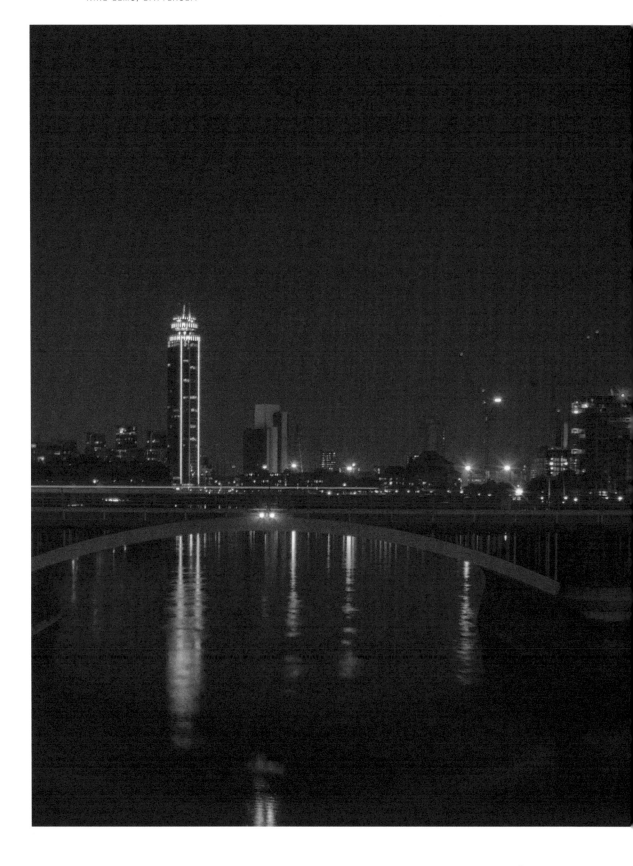

JAN FEB MAR APR MAY JUN

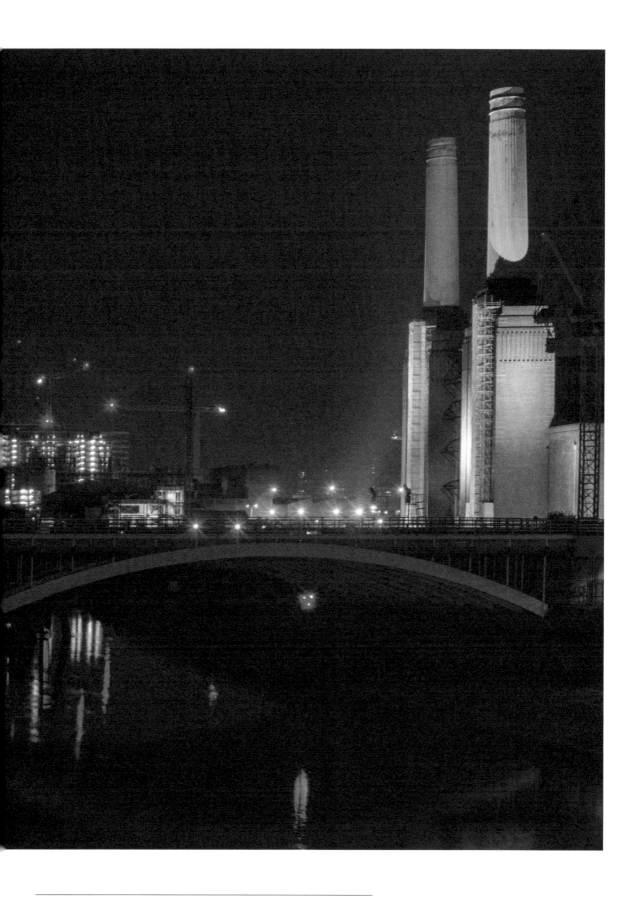

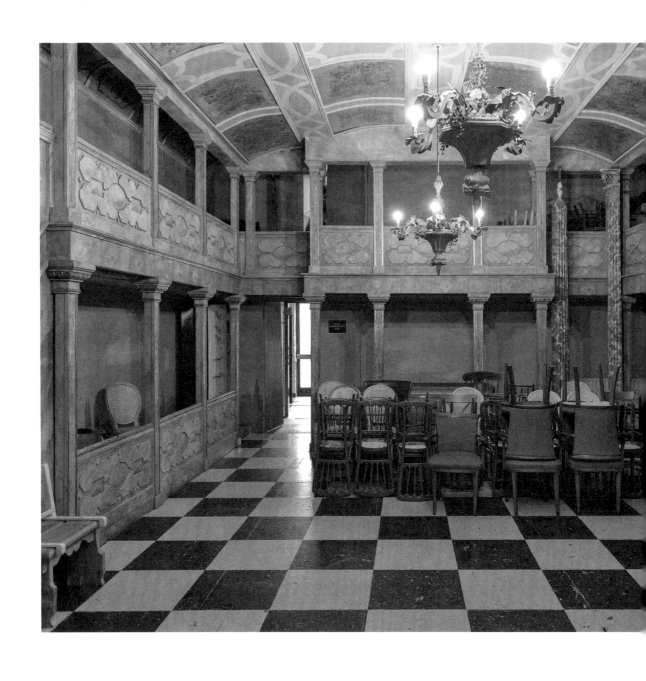

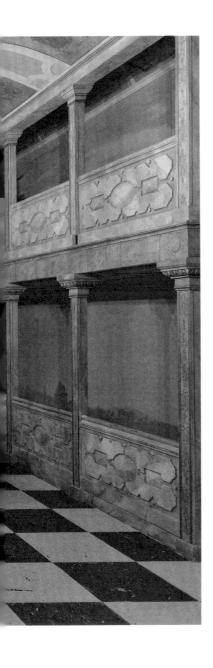

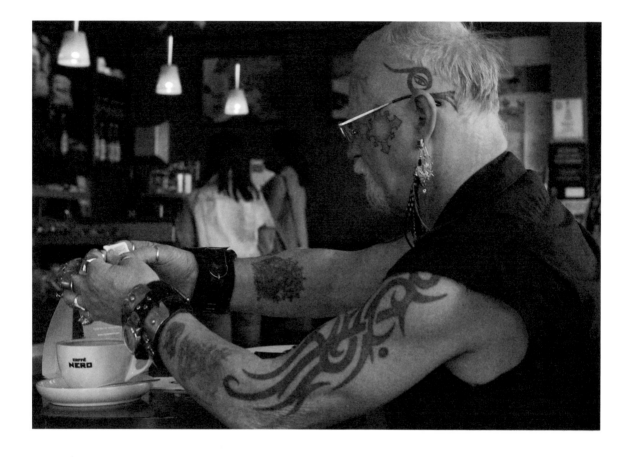

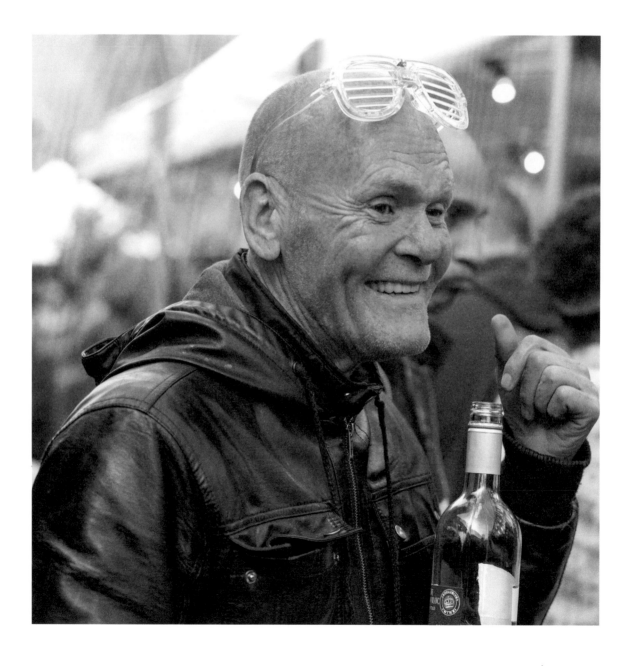

SPRING JAN FEB MAR APR MAY JUN

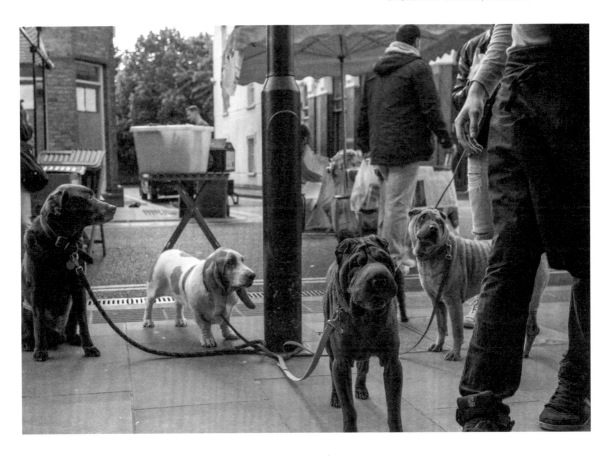

Winston Churchill said, "We shape our buildings; thereafter our buildings shape us." Tate Modern's Turbine Hall with its volume, its magnificent forms assembled in light, is often the site of great installations, like Olafur Eliasson's *The Weather Project* in 2003–4. In between, it offers the enjoyment of having the space to oneself, as this couple found early one morning.

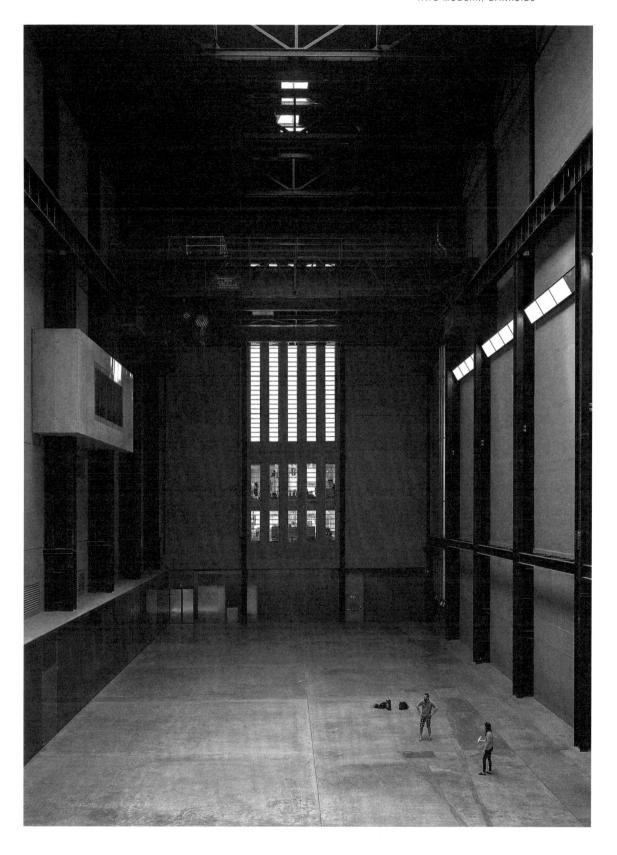

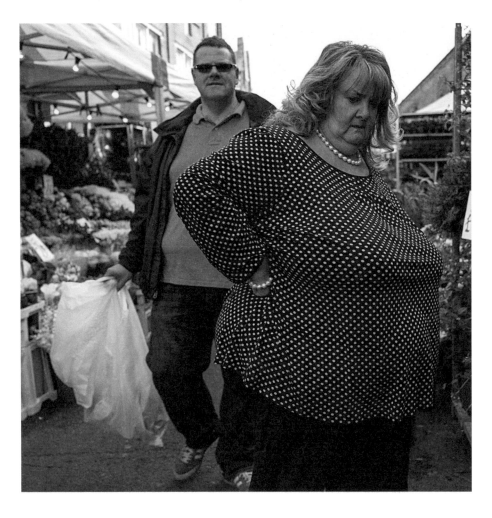

SPRING

JAN FEB MAR APR MAY JUN

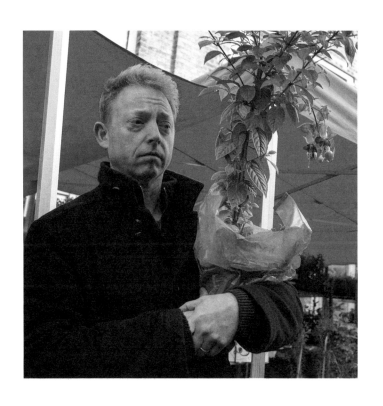

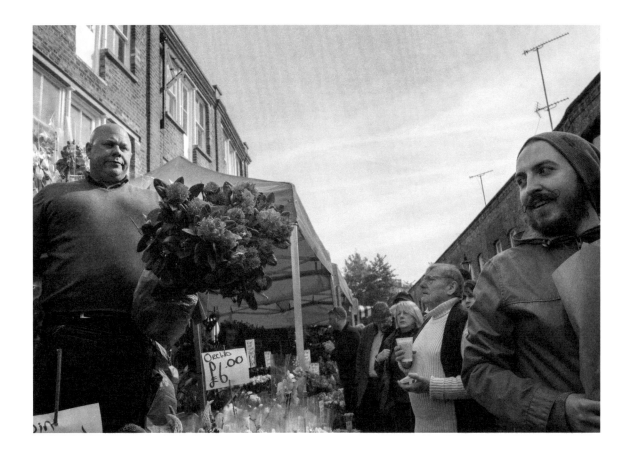

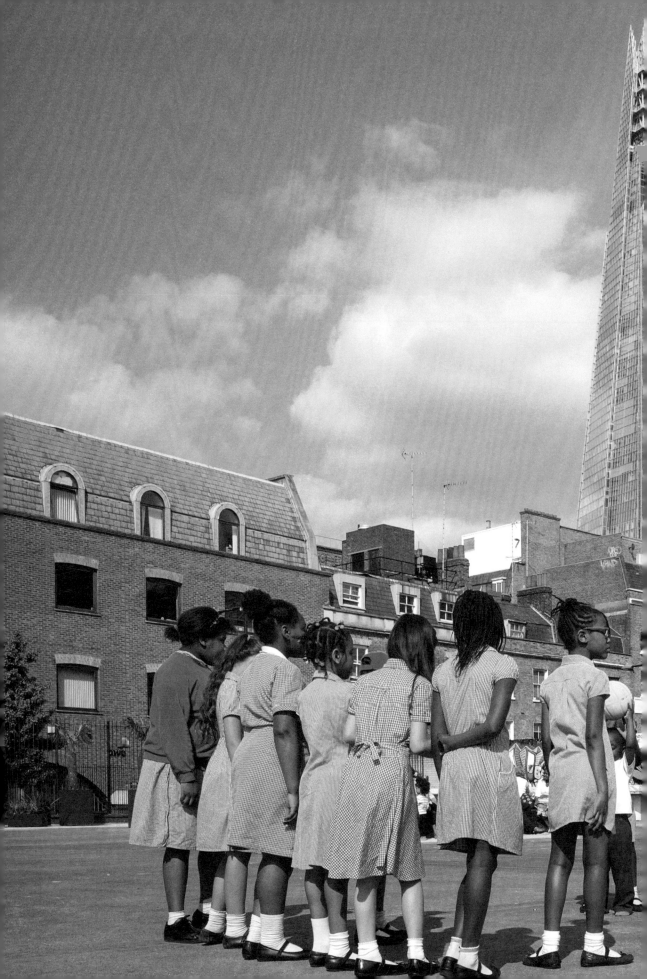

I love how this image celebrates London's extraordinary diversity.
For me, one of the things that makes London so special is this unique
"mix"; a truly international city where diverse cultures, aesthetics and
architectural styles blend together in uncharacteristic harmony. It's
the antithesis of Paris where everything is so perfectly symmetrical.

DAVID FURNISH
Producer

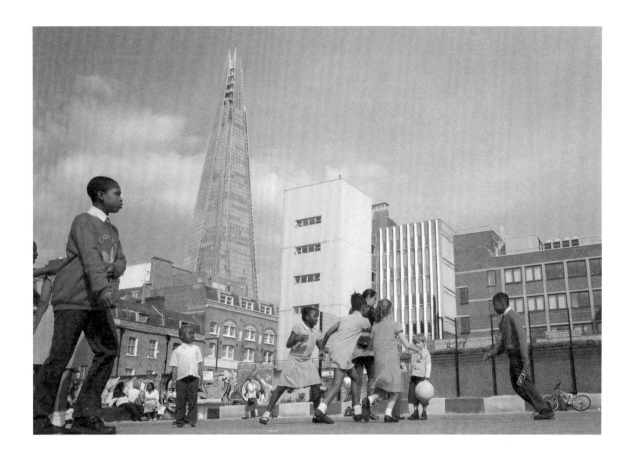

HYDE PARK

SPRING JAN FEB MAR APR MAY JUN

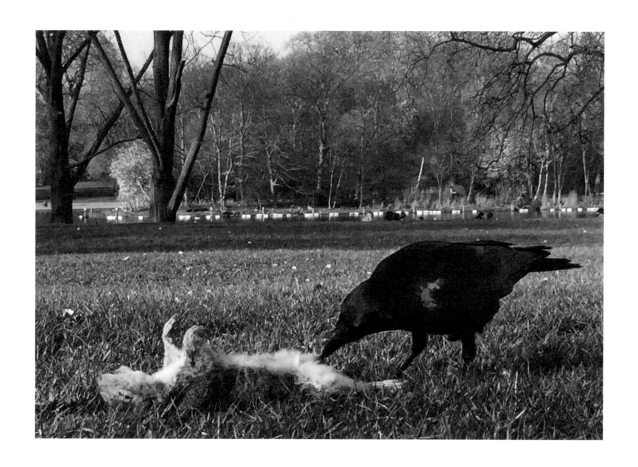

SUMMER

Summer is London's warmest season, with long sunny days, occasional thunderstorms and, in some years, heat-waves. With so many people outdoors in the city, or on day trips to special events, I never cease to find interesting human behaviour, in interactions, body language, clothing and eccentricities. London is renowned as a green city. Hyde Park, Green Park, Regent's Park, Richmond Park, Battersea Park – the great parks are the lungs of London; its veins are secret garden squares, the woods of Hampstead Heath and other little pieces of the natural world.

I have always tried to take pictures every day, as a sort of visual diary. Like Cartier-Bresson said, "the camera is an extension of my eye". My aim is not only to document the imprint of humankind on our environment, but also to capture scenes that suggest the romantic ideals associated with the seasons of the year. My own negotiations with time, space and beauty are what motivate this project, as well as the pursuit of the "decisive moment". *London Every Day* becomes an opportunity to experience the performative possibilities of photography through its merging of methodology with movement, of timing with walking. This daily pilgrimage is a contemplative process, which enacts a specific reality of a single person within a city populated by 8.6 million people.

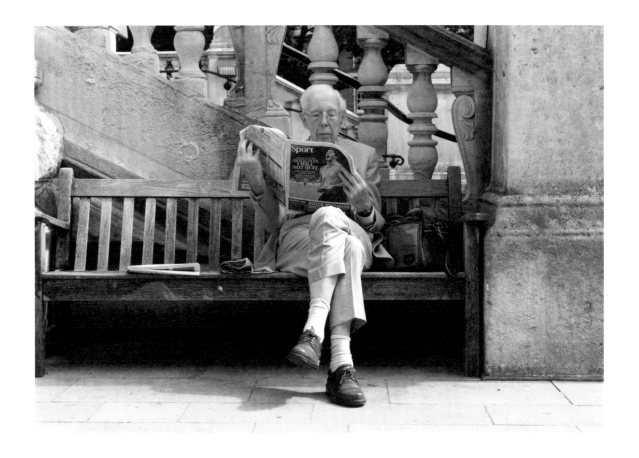

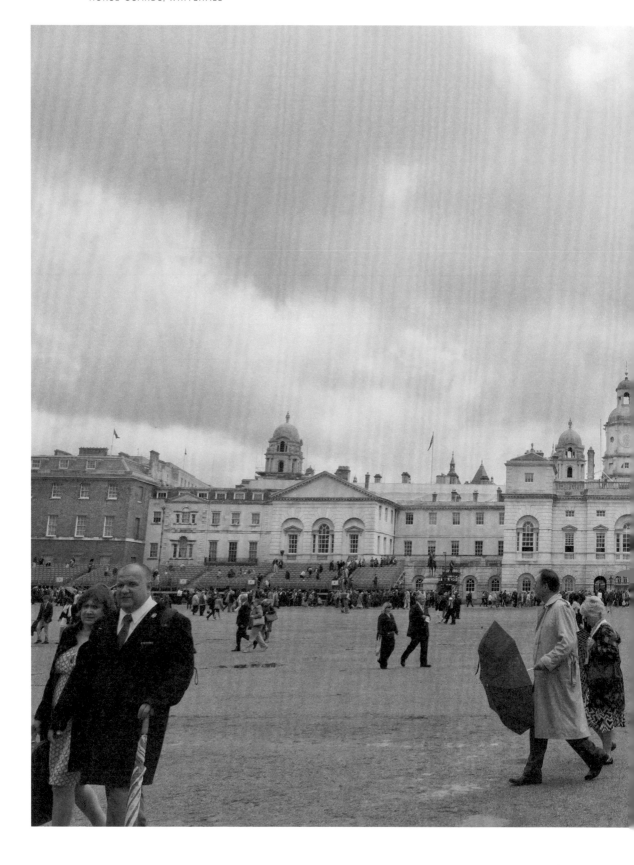

SUMMER JAN FEB MAR APR MAY JUN

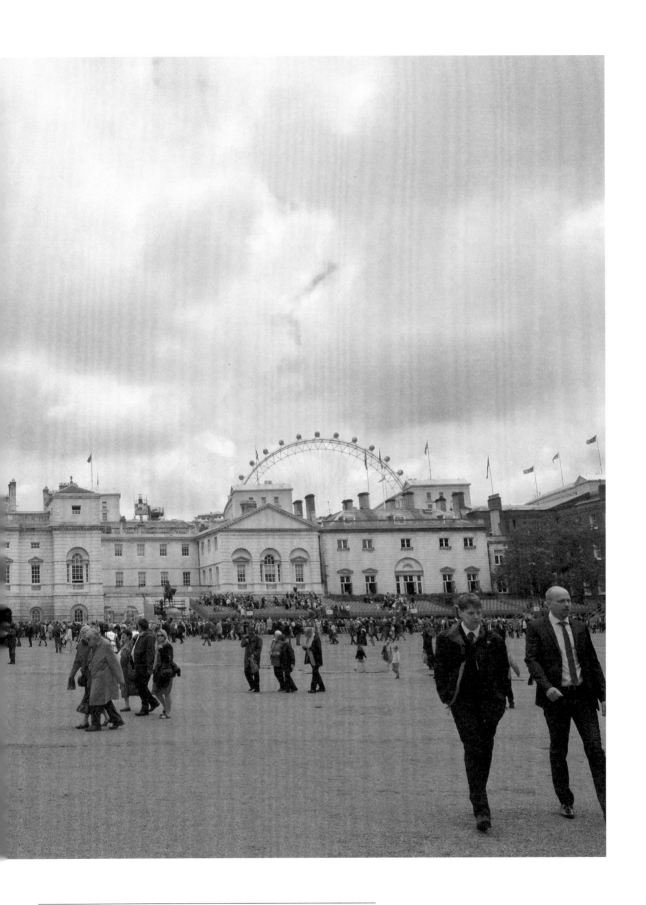

This image captures London at its best. With our reputation for rain, and our "show must go on" attitude in evidence. And, in the distance, a skyline of development cranes illustrating how this great city is evolving, developing and retaining its world-class status; old alongside new. London has the pageantry, the heritage, the culture, the financial City, fantastic green parks, the stunning Thames, and of course, the people. It all comes together to create one of the best cities in the world. As Chairman of Berkeley I can say that Berkeley is proud to be contributing to the rich tapestry of London – helping create new homes – both private and affordable, set around new public and private spaces that contribute so much to the community. Good development creates economic benefits, new jobs as well as the much-needed new homes. There is no place better to live – rain or shine – than London. This picture reminds me of that.

TONY PIDGLEY, CBE
Property Developer

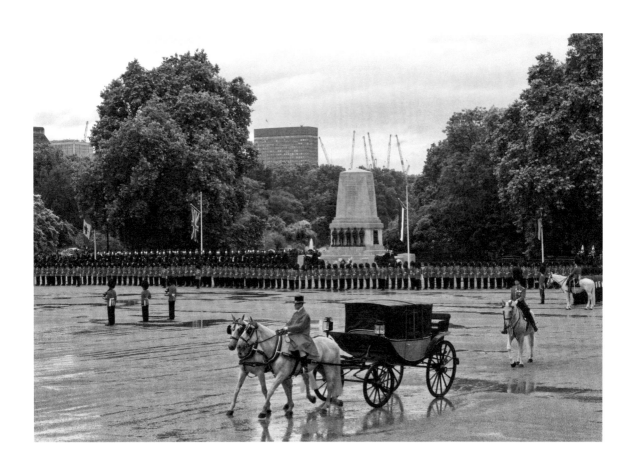

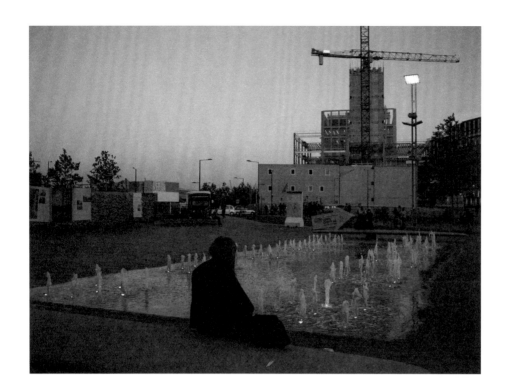

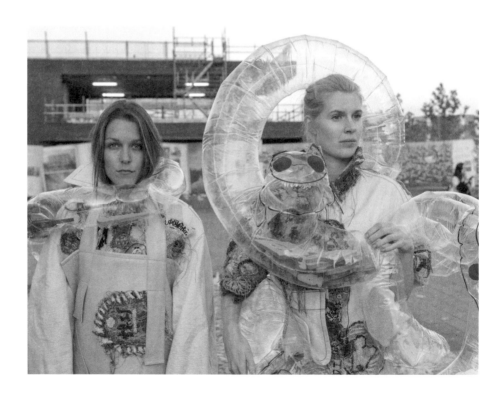

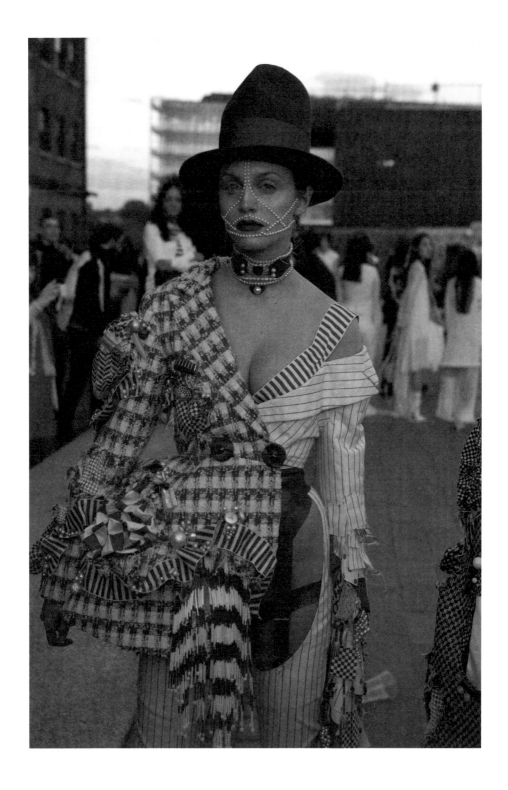

ANISH KAPOOR
Artist

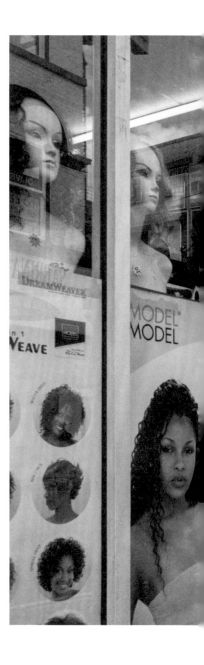

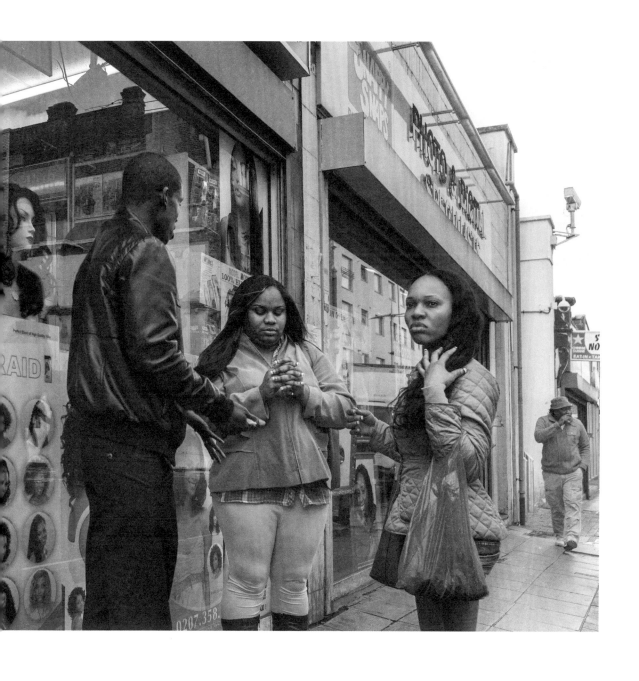

Art deals with feelings and aesthetic experience, including the judgements about an artwork that an artist makes while creating it and her enjoyment in the finished image. If it is good and there is a benefit from it, then the subject is coming through in some emotional or intellectual way. I look at this and think of a line from a Woody Allen film: "Tradition is the illusion of permanence."

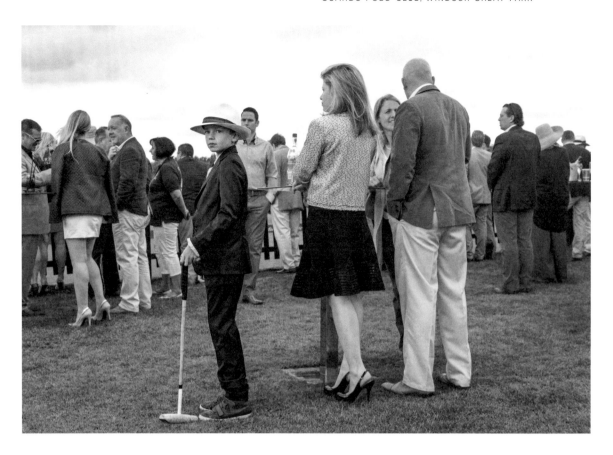

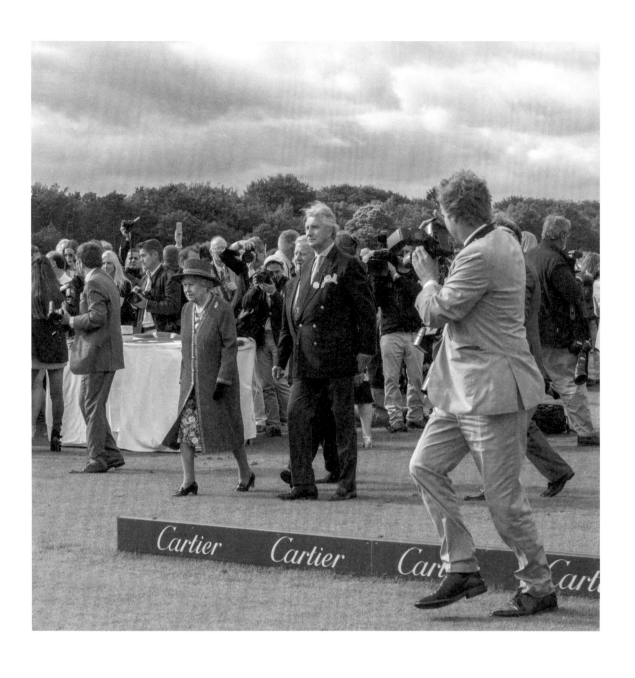

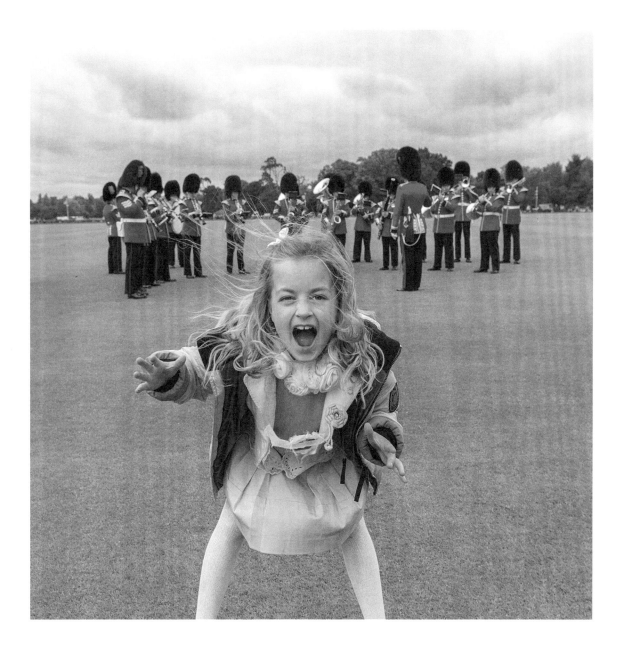

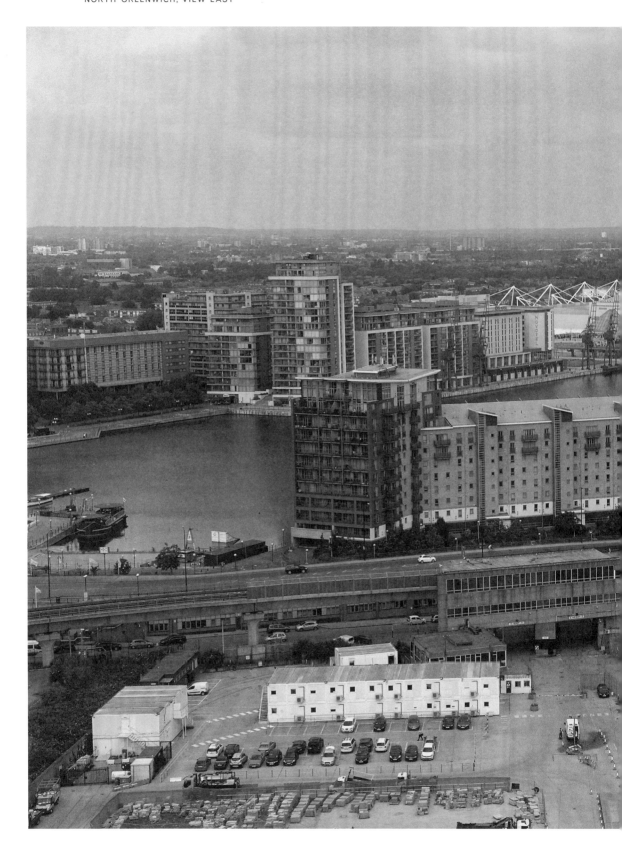

SUMMER JAN FEB MAR APR MAY JUN

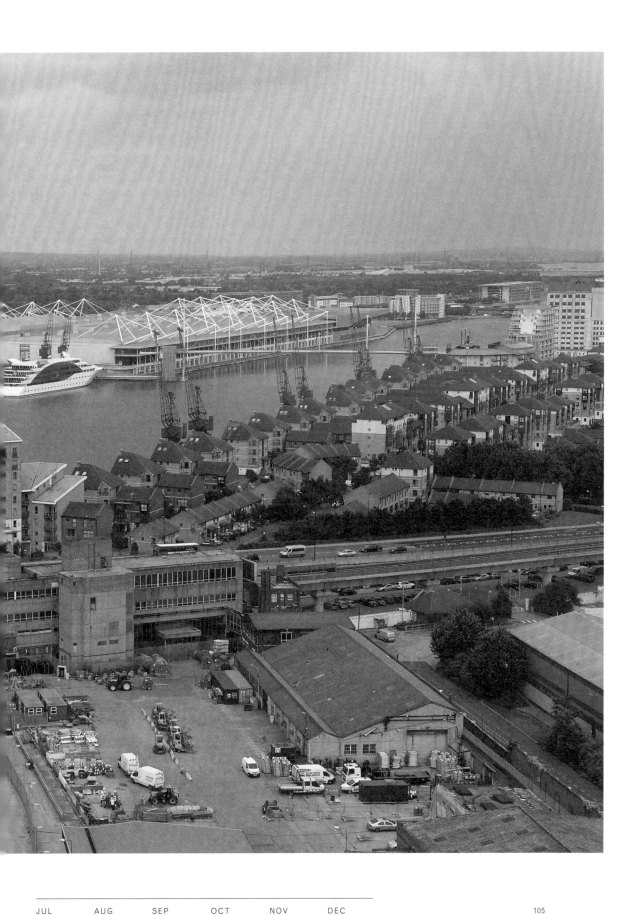

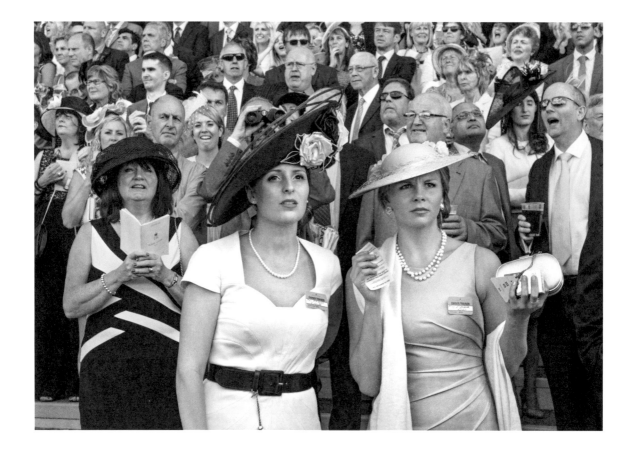

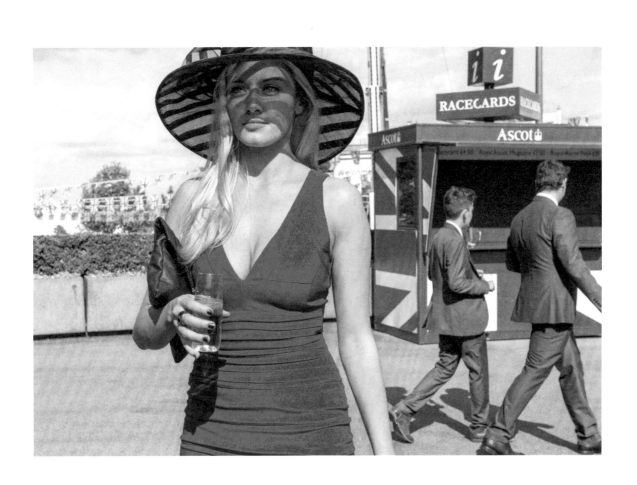

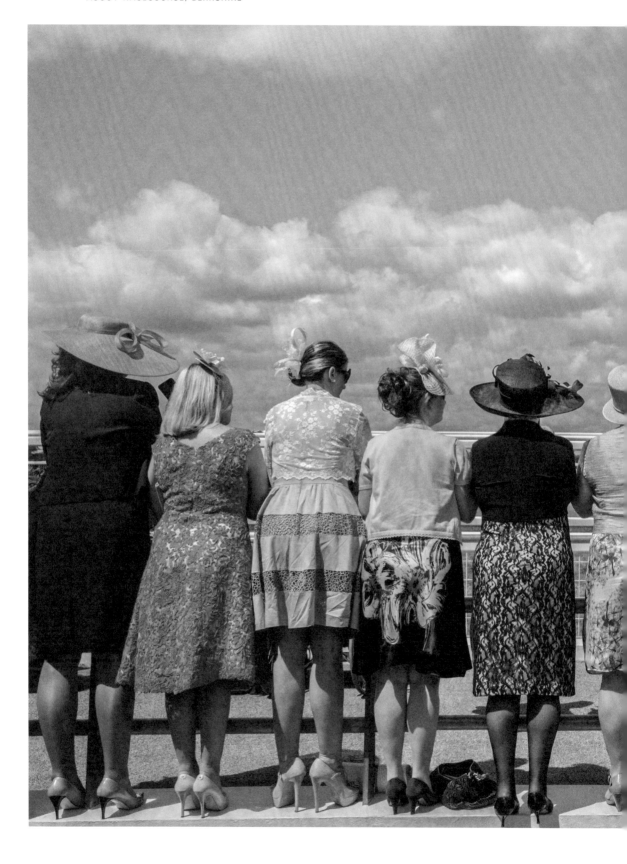

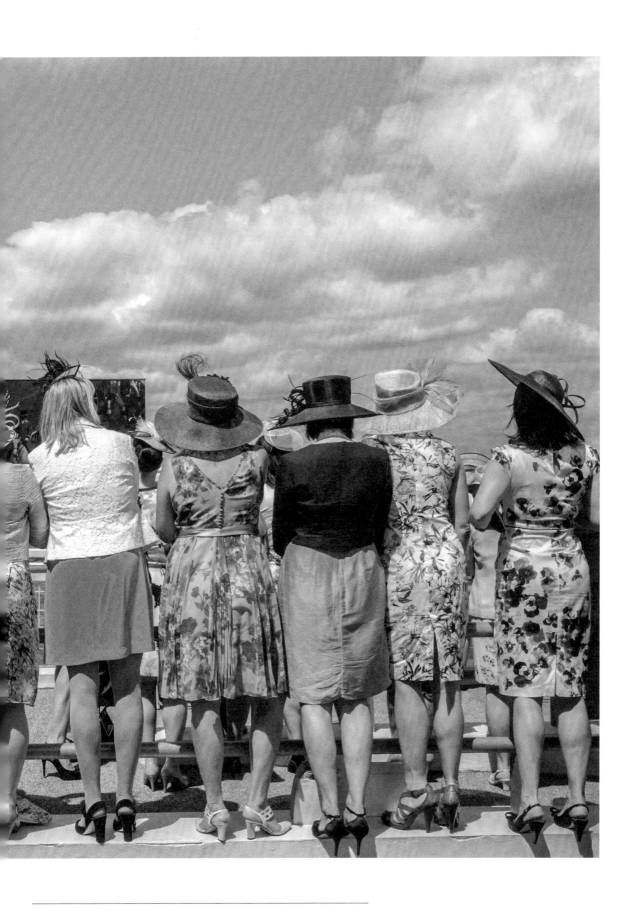

RYE LANE, PECKHAM

JAN FEB MAR APR MAY JUN

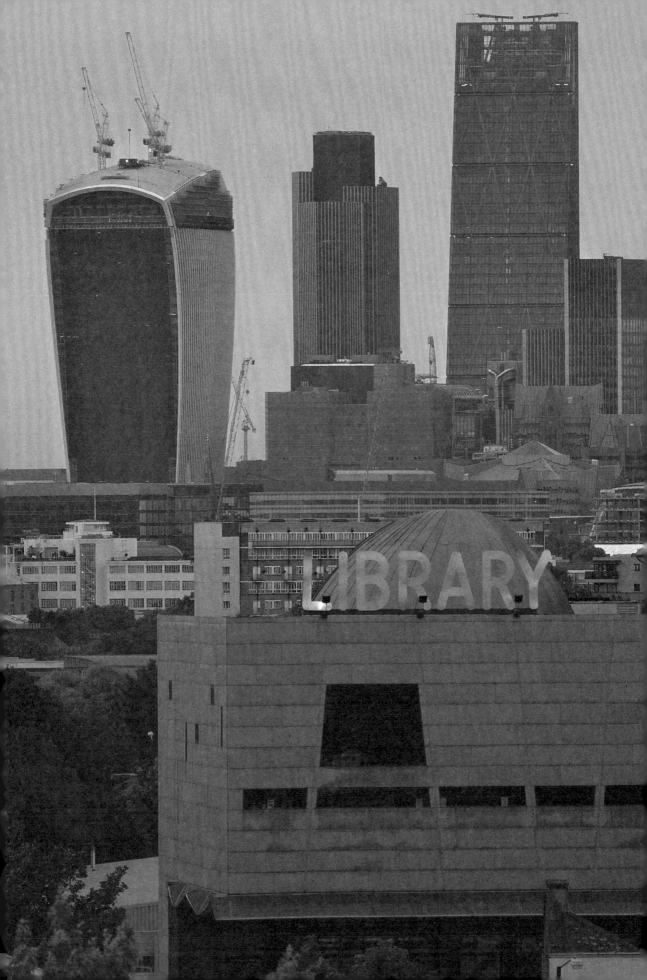

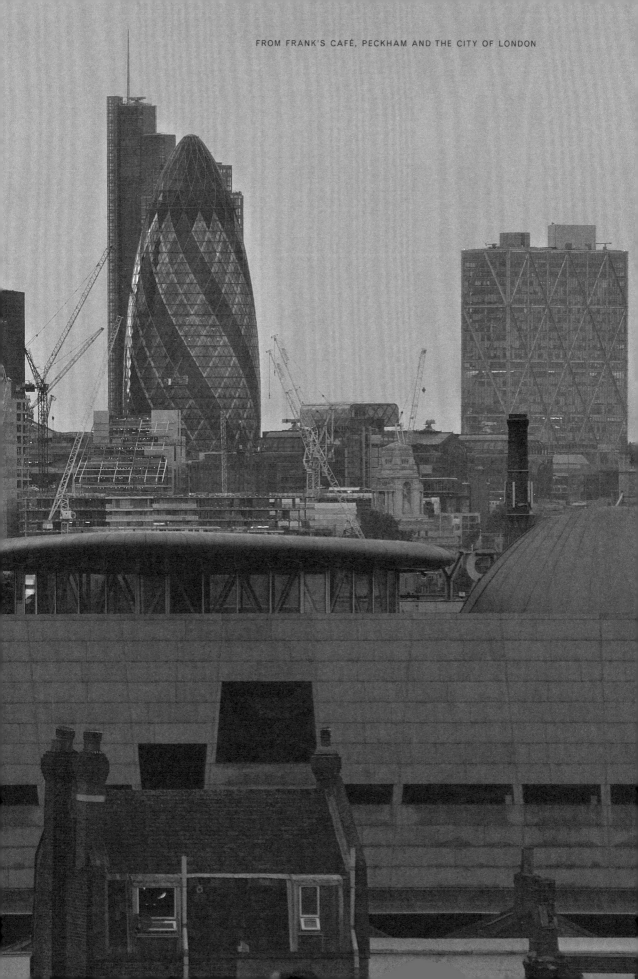

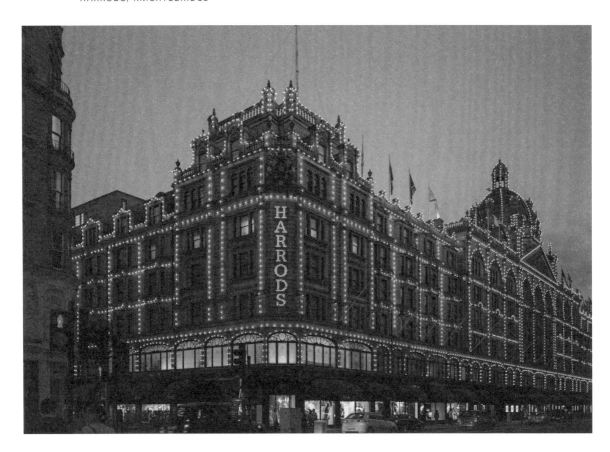

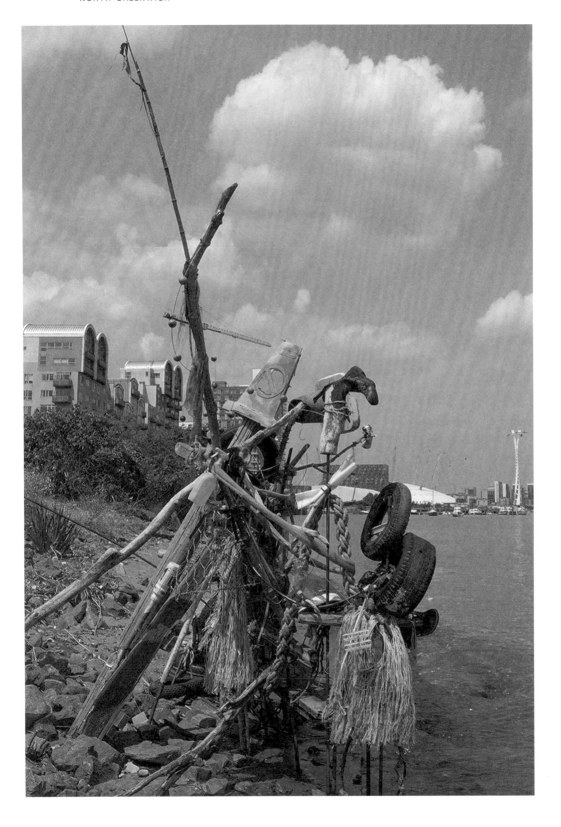

London Burning, a project for which I was commissioned to shoot the everyday lives of top creative talents in the city, diverted my daily walks, my drift – or *dérive*, to borrow a phrase from the Situationist practices of the 1950s – taking me into the furthest reaches of London, and I walked new and exciting streets each week as well as travelling to my usual destinations. This picture transports me to the work of Hiroshi Sugimoto, who makes comparisons between fossils and photography, and by extension, with history itself: "The accumulation of time and history becomes a negative of the image. And this negative comes off, and the fossil is the positive side. This is the same as the action of photography." In the end, we are all part of London's own history. Together we form what this city is, but also what it was and what it will be. That's how I understand history.

| | JAN | FEB | MAR | APR | MAY | JUN |

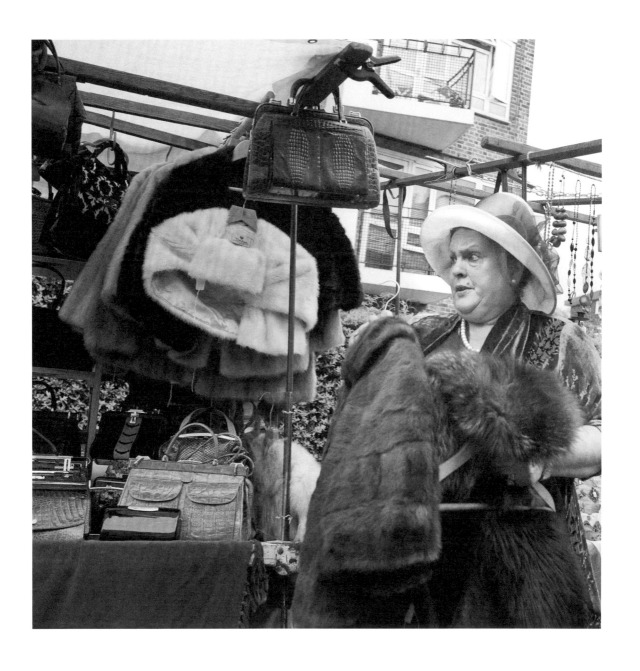

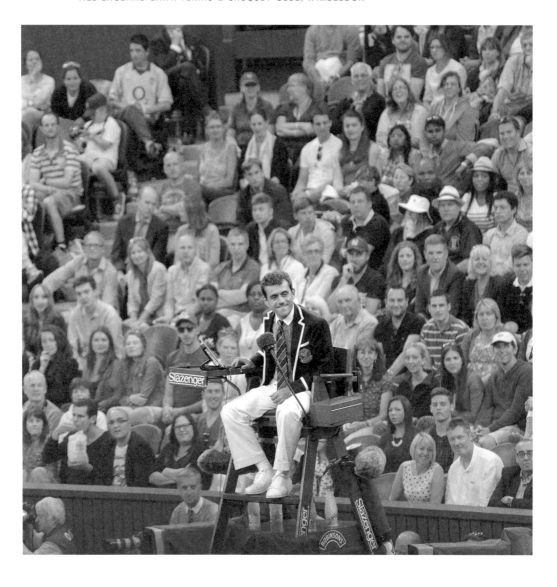

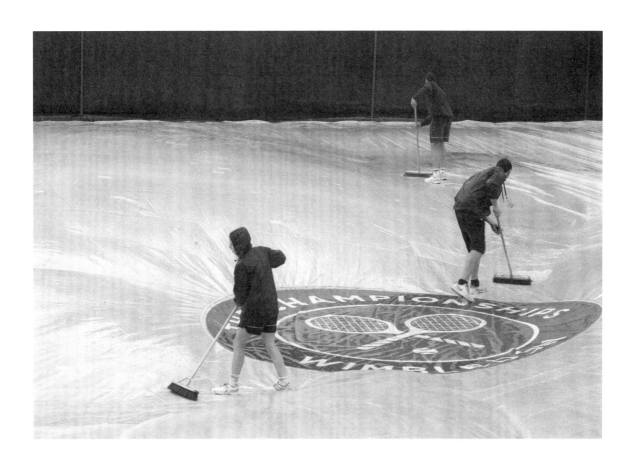

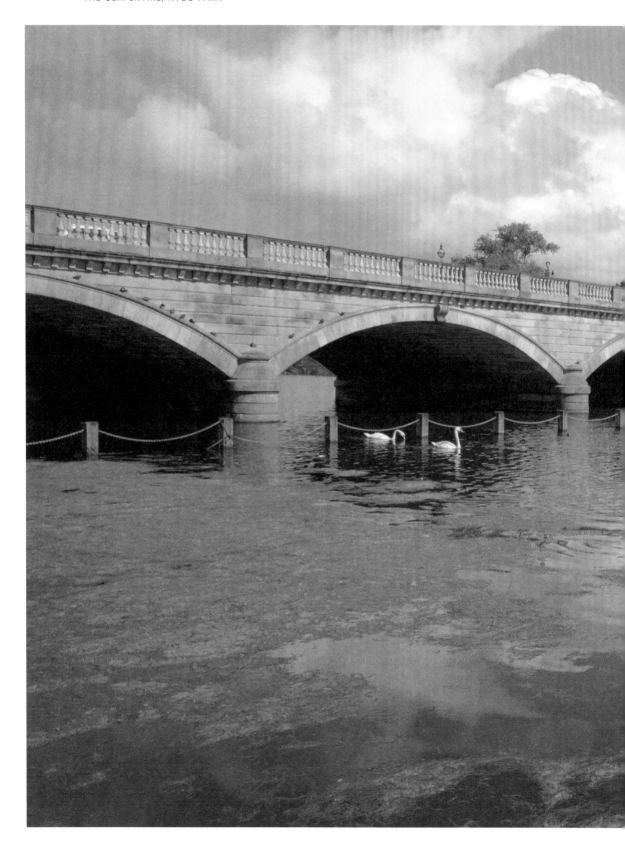

Jeff Wall refers to the "trivial" as just a failed version of the everyday. "The everyday, or the commonplace, is the most basic and the richest artistic category. Although it seems familiar, it is always surprising and new. But at the same time, there is an openness that permits people to recognize what is there in the picture, because they have already seen something like it somewhere. So the everyday is a space in which meanings accumulate, but it's the pictorial realization that carries the meanings into the realm of the pleasurable."

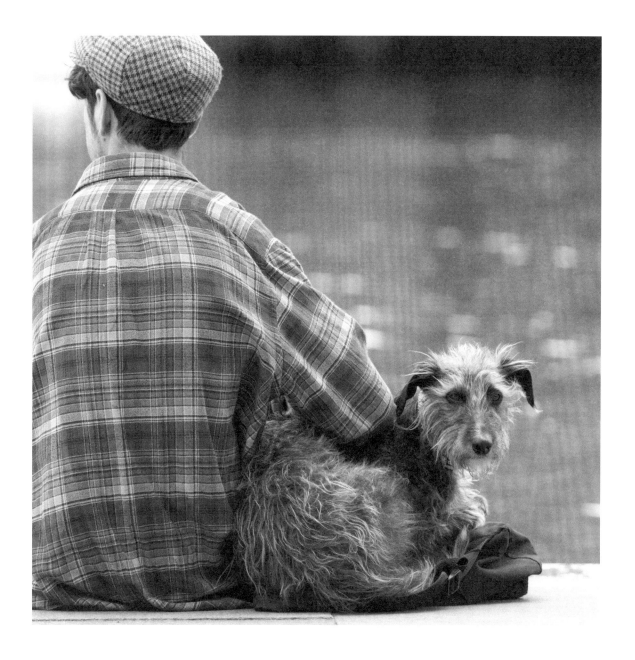

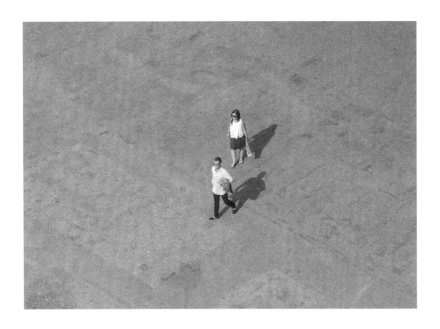

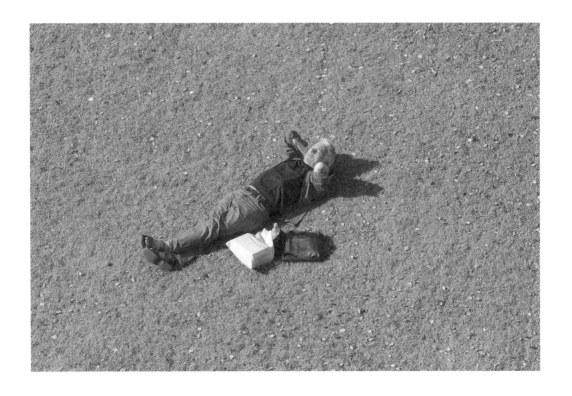

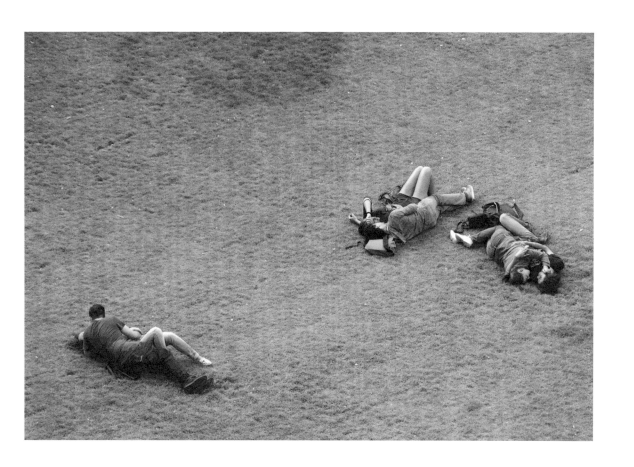

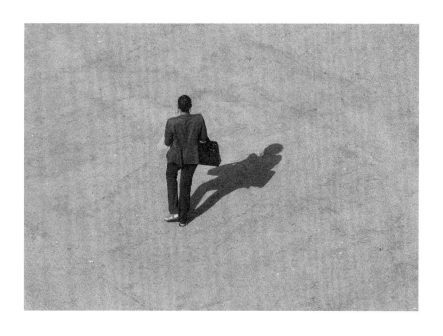

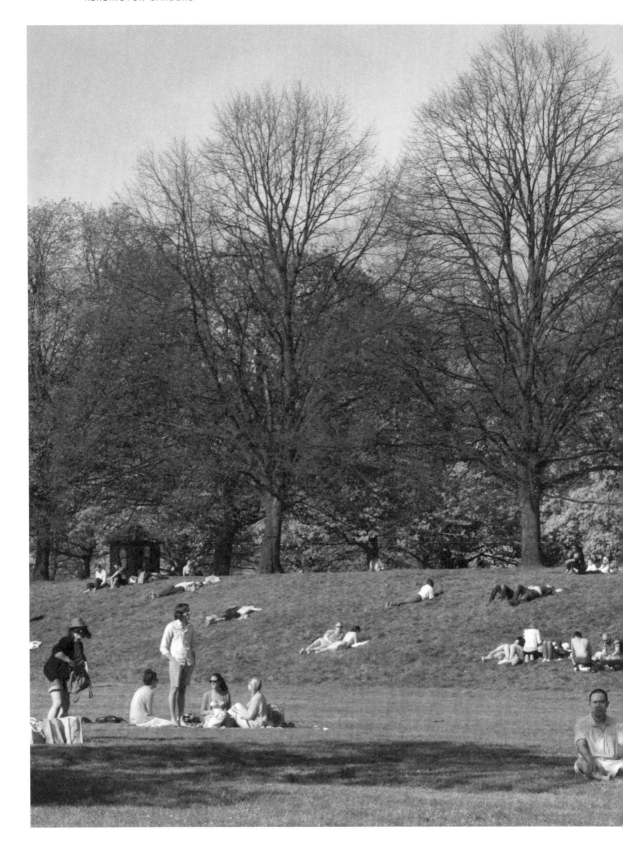

SUMMER JAN FEB MAR APR MAY JUN

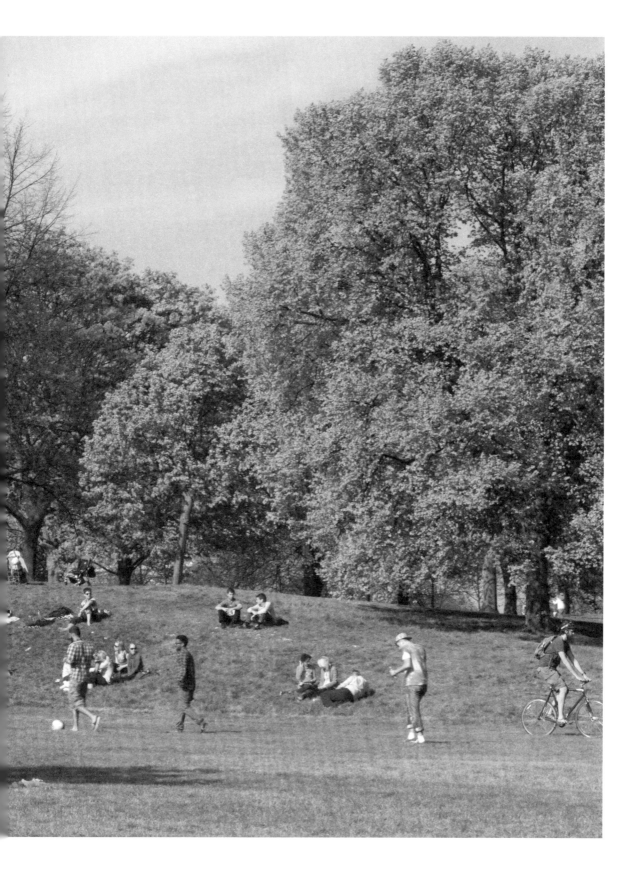

I once designed a ring in the shape of the Trellick Tower. It was one of the buildings that made a big impression on me when I first moved to London from New Zealand. I still see it on the way to and from work and each time it stirs something in me. Why? It's hard to say. Its beauty is certainly challenging. Everyone calls it brutalist, with its decaying concrete and wood façade, its soaring but redundant plant room and its indifference to its surroundings. And it was built when high-rise living was at its last gasp, plagued by crime and unpopularity. It would be among the last of its kind.

But Ernö Goldfinger gave it character: a rebellious spirit that emanates energy. It conjures up a world of contrast and wonder, simultaneously outdated and futuristic. To me it's an unlikely modernist beauty. And its Grade II listed status means it's not just me.

My Trellick Tower ring featured the iconic silhouette, with its distinct lift tower and main block. A piece of jewellery can be a miniature architectural piece, using unusual diamond shapes to reflect the skyline of skyscrapers and landmarks. My BT Tower earrings are another example of how the London cityscape has inspired me.

A building dispute in Hampstead between Ian Fleming and Goldfinger famously led to Fleming naming his bad guy after the architect. The architect threatened legal action when the Goldfinger book came out. Fleming stopped him by saying he'd change the name to Goldprick – a great story, whether or not it actually happened. Maybe that's partly what lifts me when I see the Trellick Tower.

JESSICA MCCORMACK
Jewellery Designer

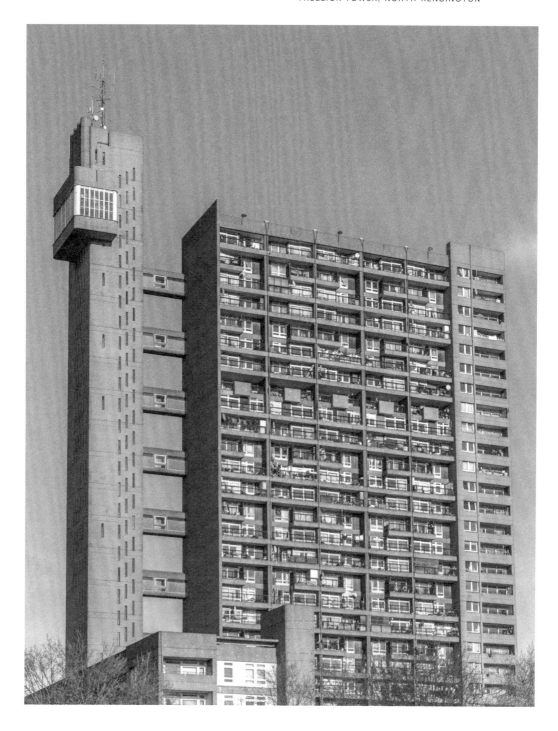

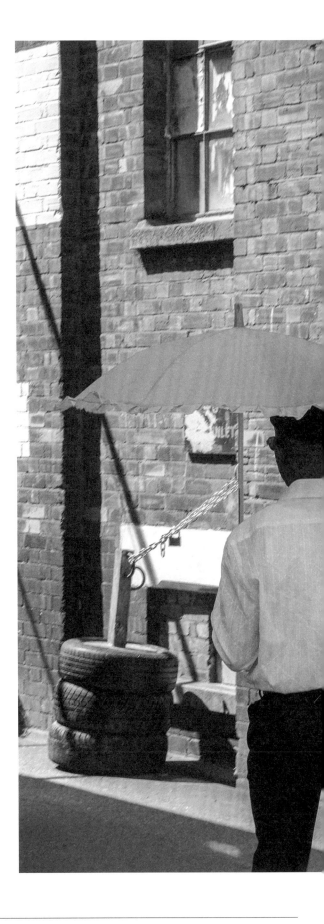

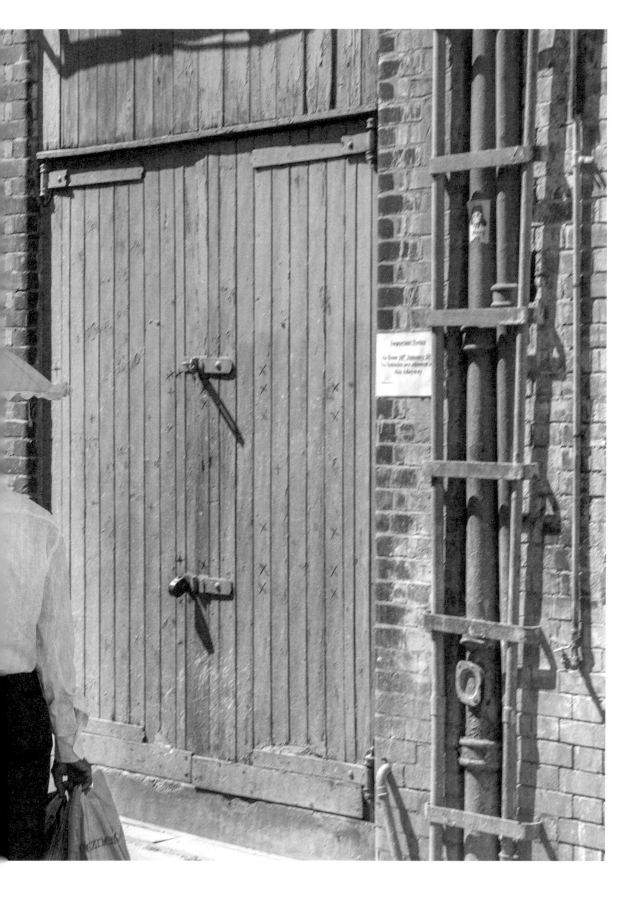

Photographers are observant. I try to deal with the world as it appears. I can also get enjoyment from a sidewalk. Here, there is so much charm and pride in this lovely flower shop.

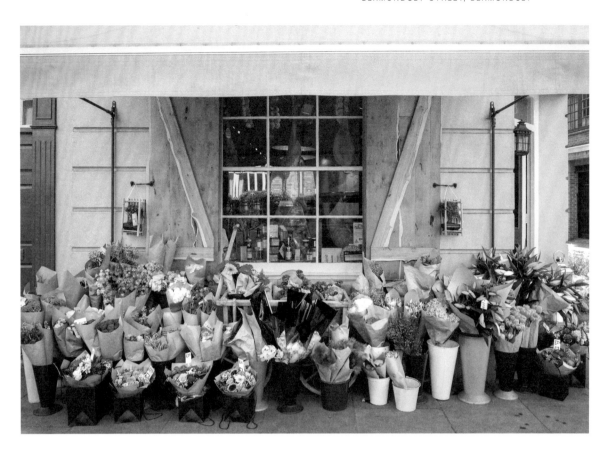

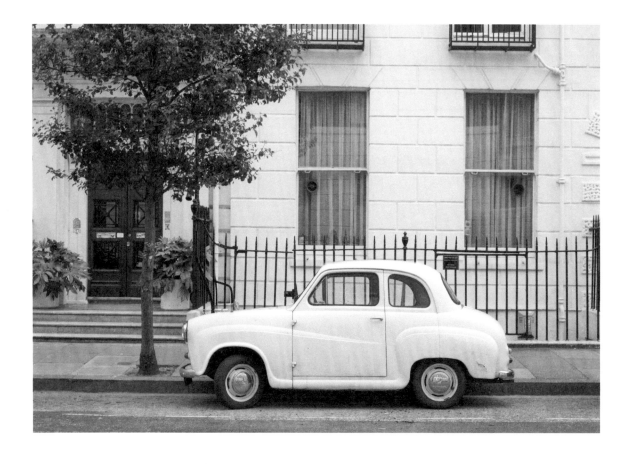

SUMMER JAN FEB MAR APR MAY JUN

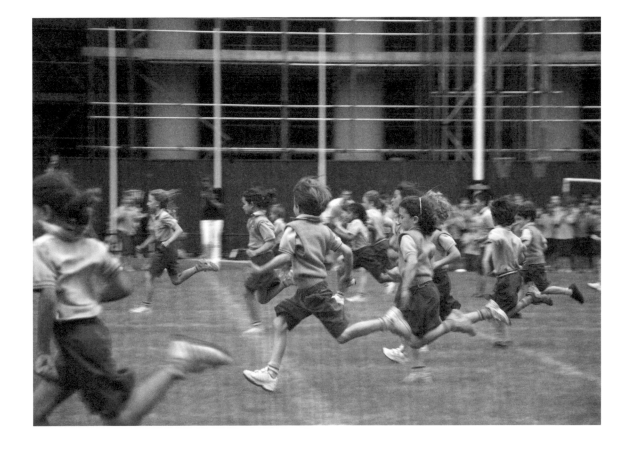

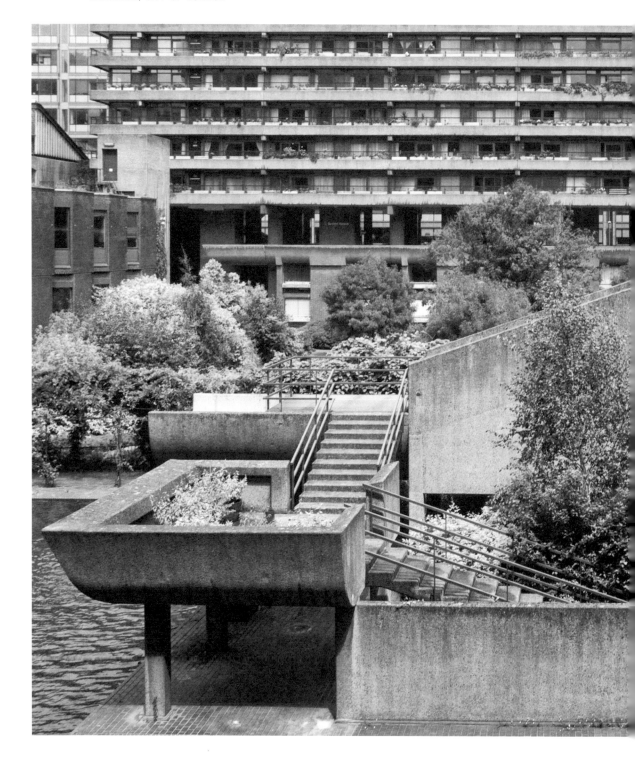

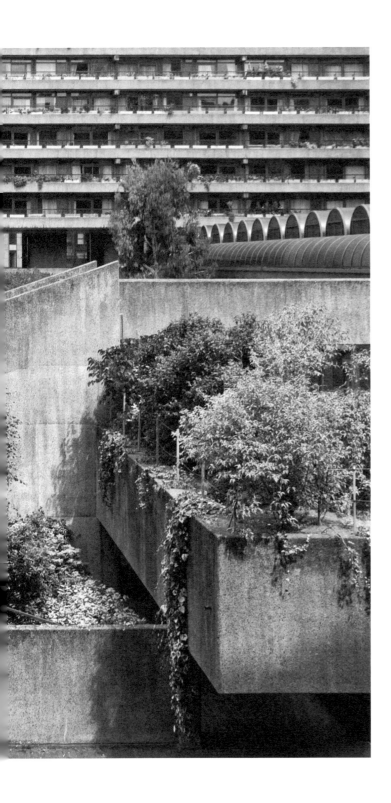

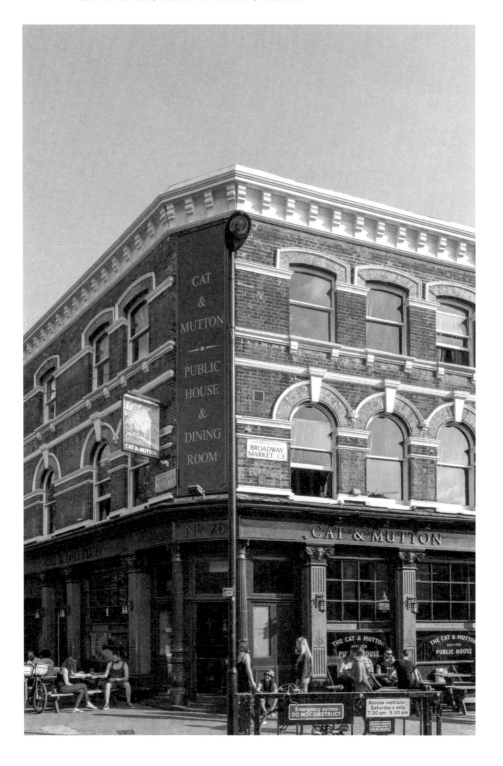

Today we seem to live in a world that is constantly moving, a world that does not ever stop. London is one of the most vigorous and spirited cities in Europe. Perhaps part of the reason has been the pubs on every corner, in every neighbourhood – a gift from the past, though so many are closing now. These communal spaces bring us back to finding the right balance, our own rhythm and time for others.

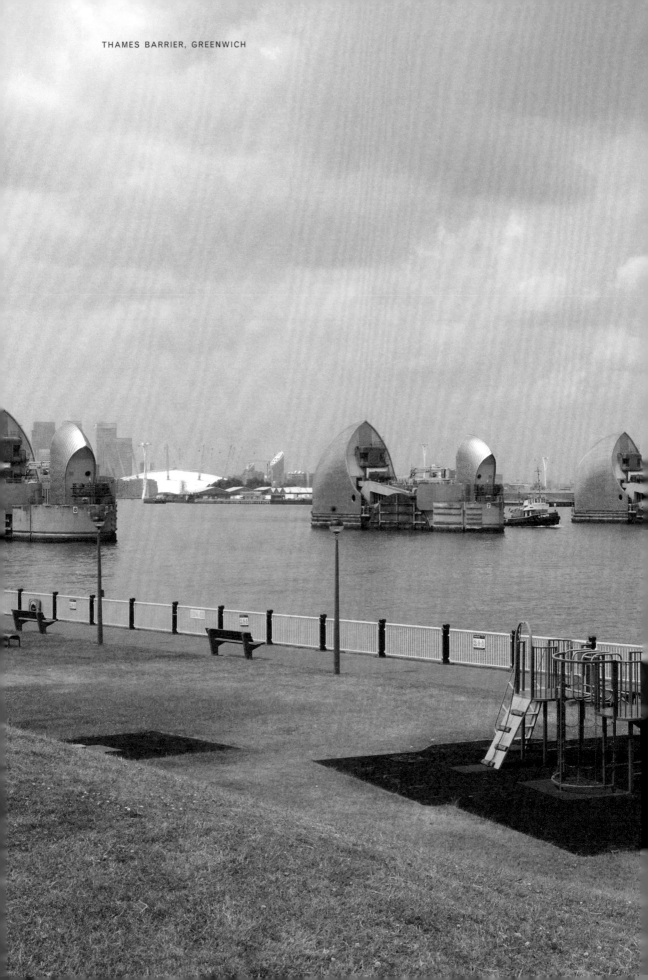

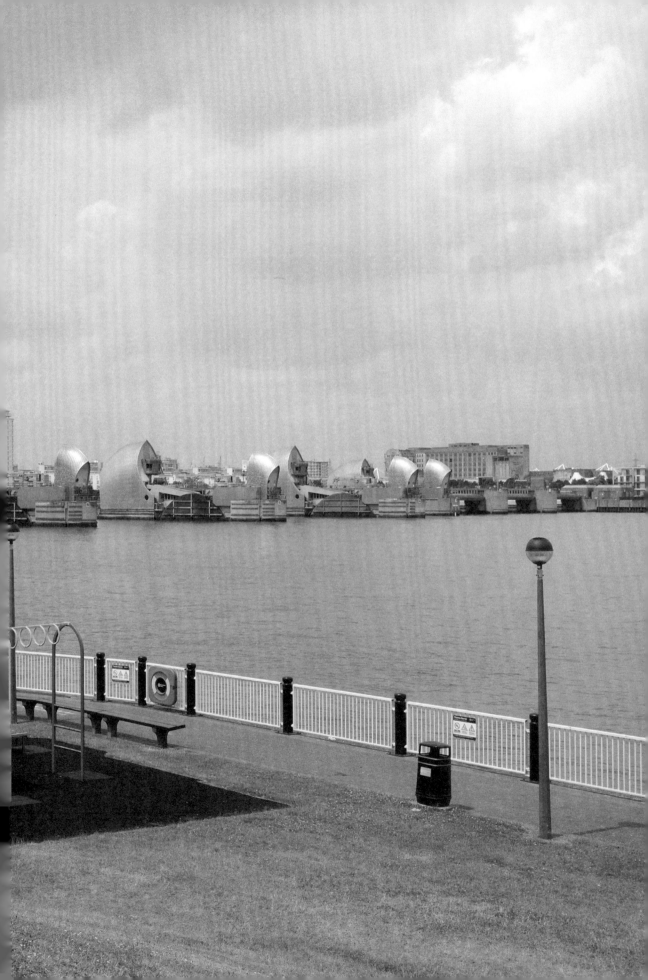

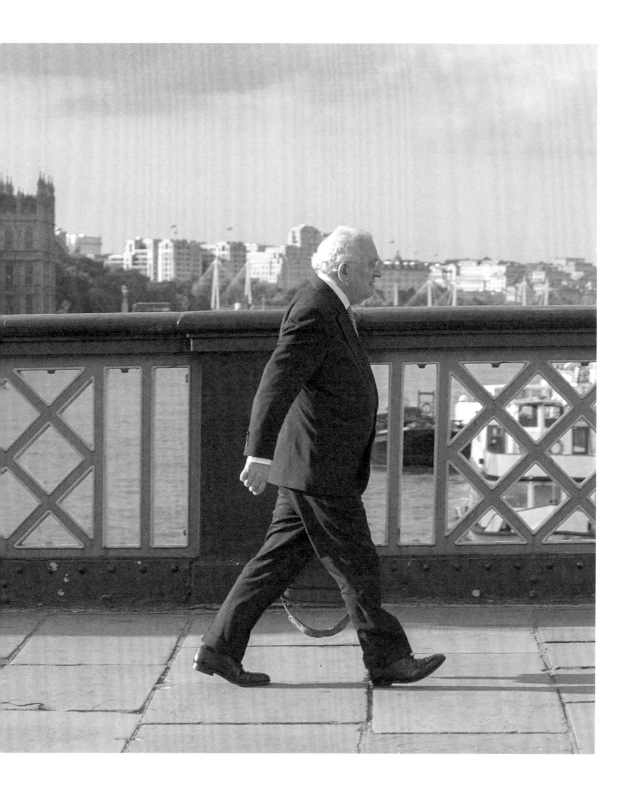

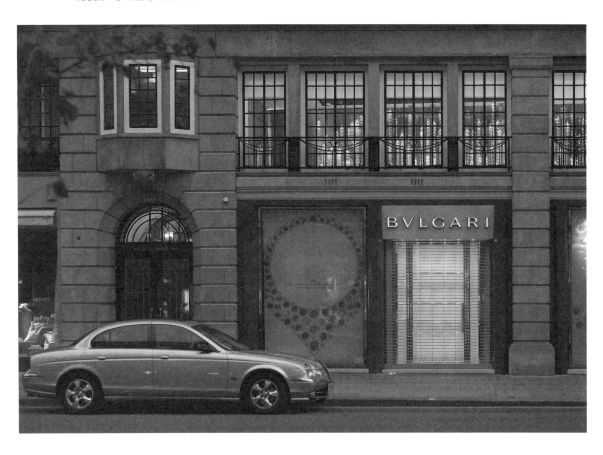

SUMMER JAN FEB MAR APR MAY JUN

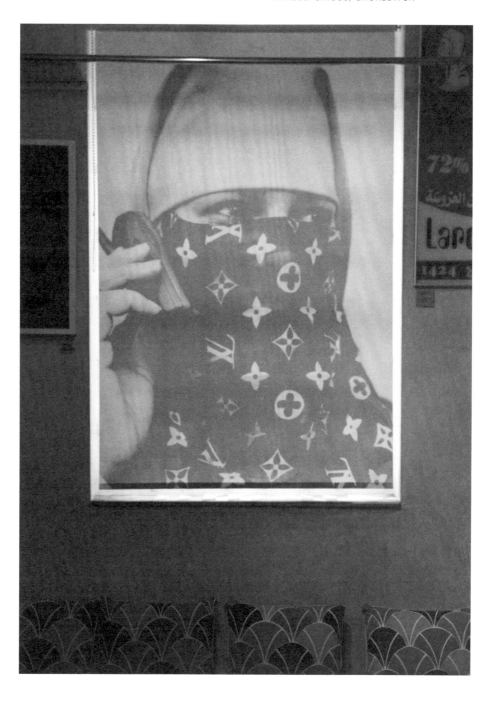

London's East End is full of quirks and eccentricities, it has
a charm that we must seek to preserve.

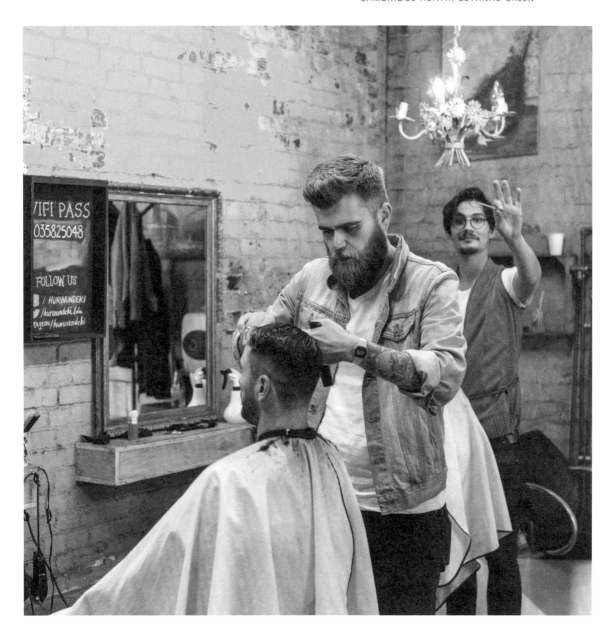

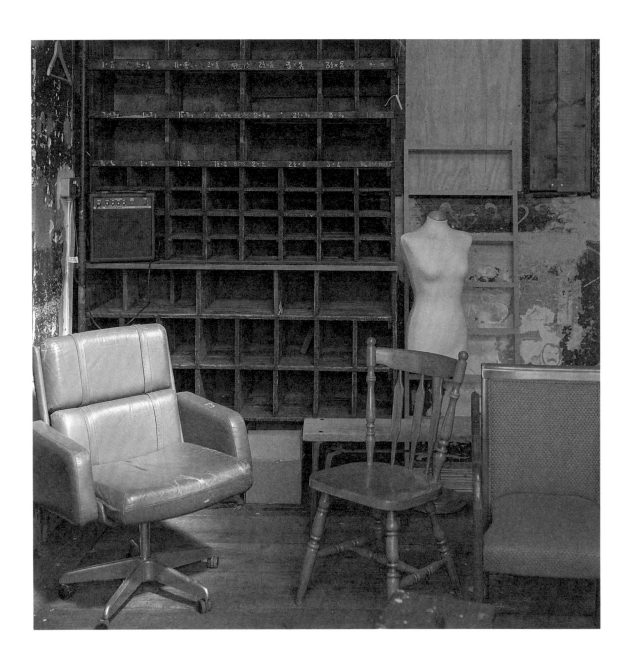

SUMMER JAN FEB MAR APR MAY JUN

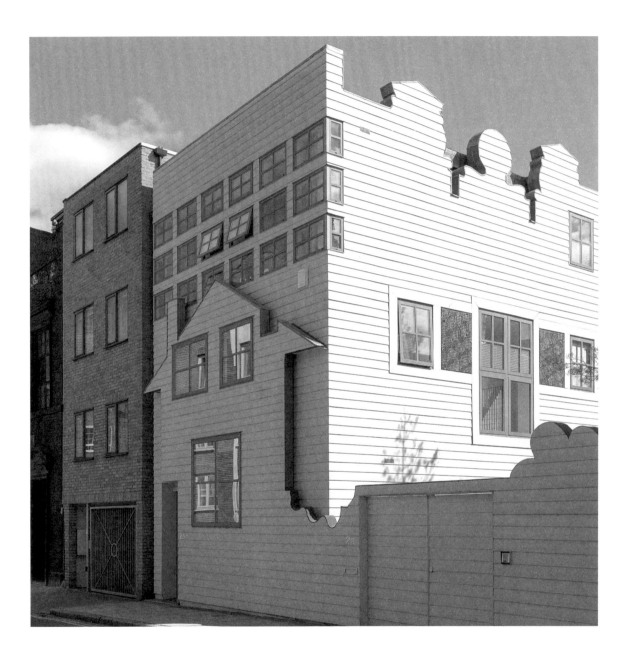

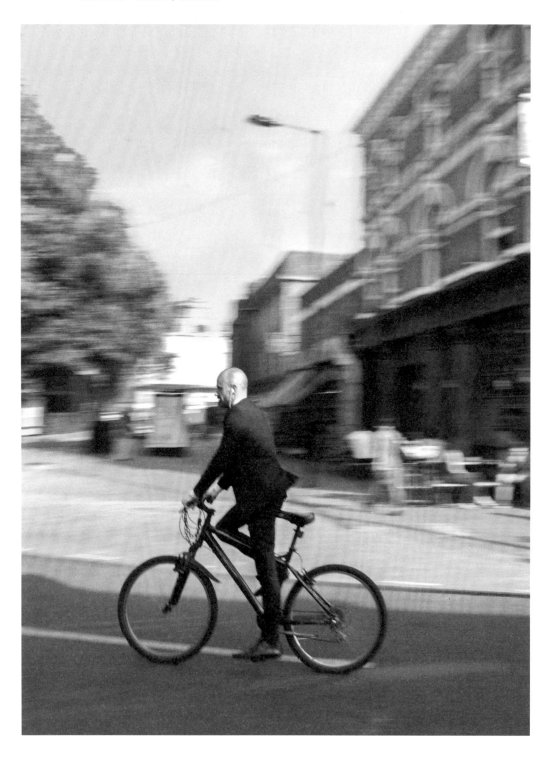

For poets who cannot write or singers without a voice, photography
is a tool that has been embraced the world over for decades, since
the invention of the first portable camera in the 1890s. Photography
offers the possibility to see and describe, to detain something
that is moving while maintaining its essence, its imprint. As Garry
Winogrand said: "When things move, I get interested."

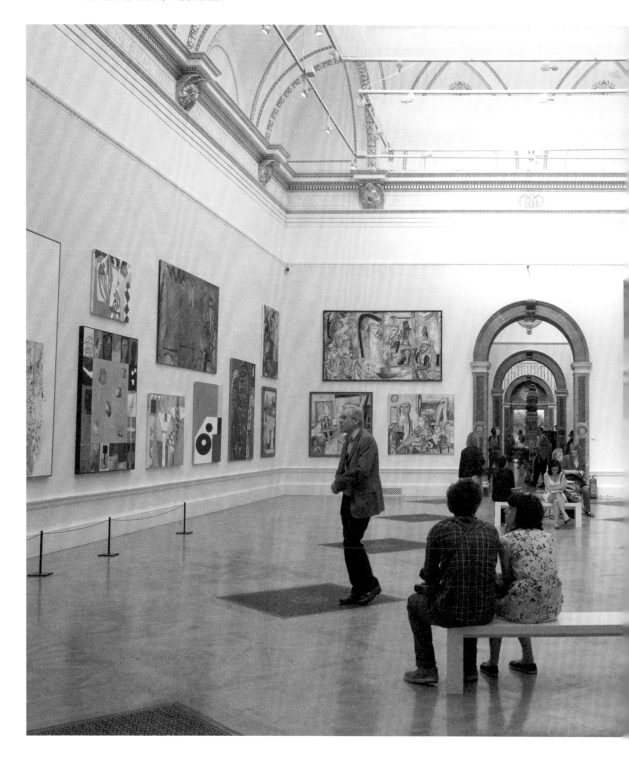

SUMMER JAN FEB MAR APR MAY JUN

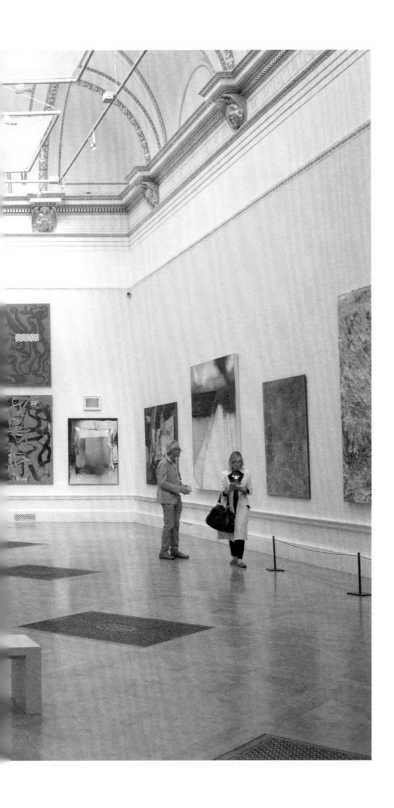

AUTUMN

Autumn in London can be mild and dry, or wet and windy. It's the season when the leaves fall from the trees, the temperature dips and melancholy London begins to set in. From a bird's-eye view, London is a random mishmash of streets with a windy river snaking its way across. It can be chaotic, noisy, peculiar, crowded and unpredictable.

London Every Day aims to provide an understanding of this puzzle-piece metropolis as a complex, long-standing multicultural community. Created in constant dialogue with the city, these images are a response to its own internal rhythms, the style modified depending on the occasion. I plunge into London's streets in order to find the diverse relationships and intersections that create the urban net – an invisible thread linking one to the other. "I can clearly only comment on something that exists, or that I encounter by direct experience," said Thomas Struth. In one sense, it is that direct and personal experience which builds the book, providing the common link. In addition, that encounter, between artist and city, becomes a conductor-wire for sparks of imagination in the audience.

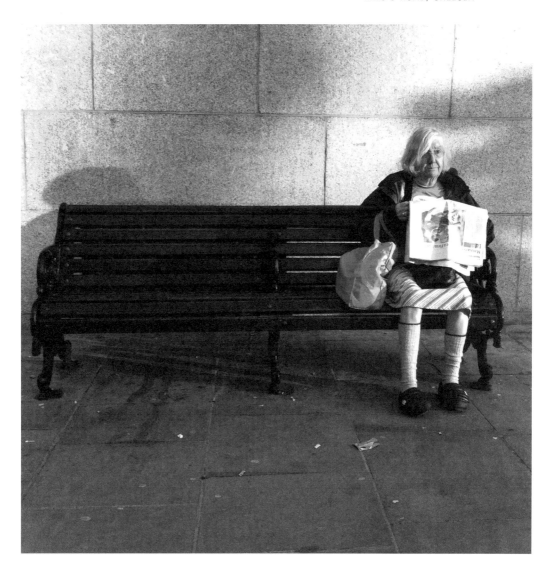

Photographs are an important tool in our ability to better
comprehend our cities. They capture single instances that embody
the dynamics of a larger interaction with the built environment and
allow us to contemplate their lessons. This photograph in particular
shows a moment of lightness in Paddington, a change of pace and
a retreat from the area's usual role as a frenetic commuter hub.
We – especially Londoners – tend to forget that the city exists for
us beyond its role as a monument to civilization and a repository
for our economic output. Part of city life is finding time to let go
of the parochial and simply to enjoy the space and the people we
share it with. Framed by this mindset, the diversity, the creativity
expressed in the surrounding urban architecture becomes playful
in its interaction with us, and we internalize the artistic nature
of materiality and form.

 I find that architecture has a unique role to play in rescripting
the everyday. I try to look for moments like this that bring to the
surface and hybridize the many meanings and narratives that
a space offers. When we institutionalize the notion of using public
spaces for leisure and pleasure, we democratize them to a more
human level and this is when we truly bring them to life. This is
a fundamental aspect of my work.

DAVID ADJAYE, OBE
Architect

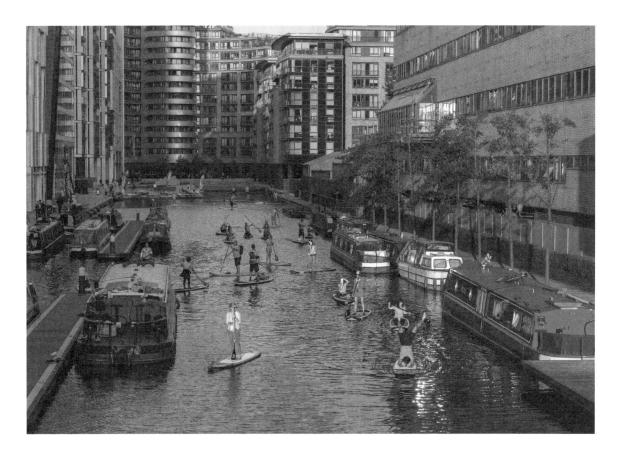

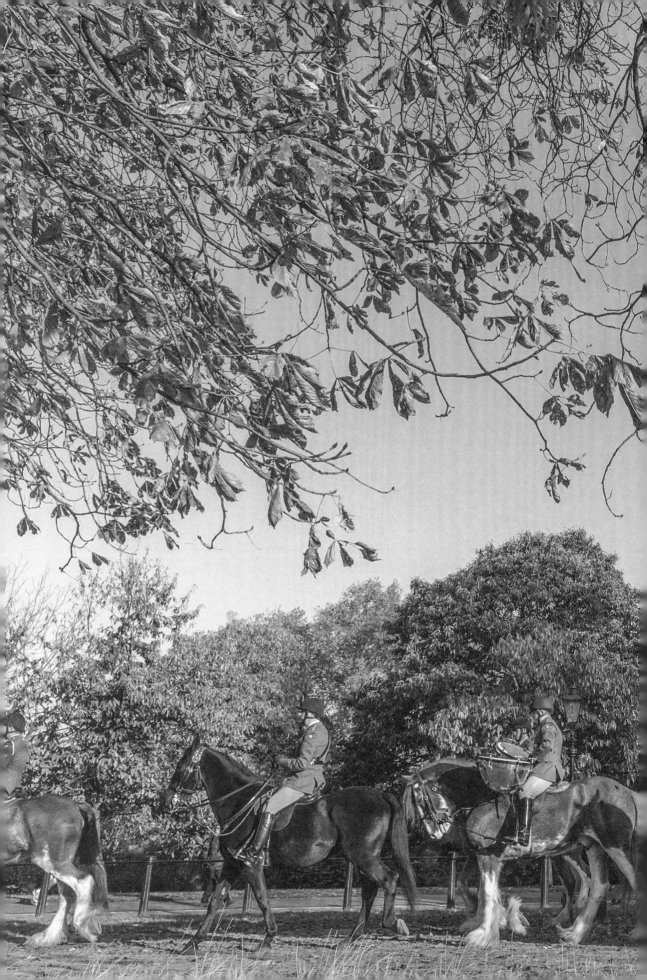

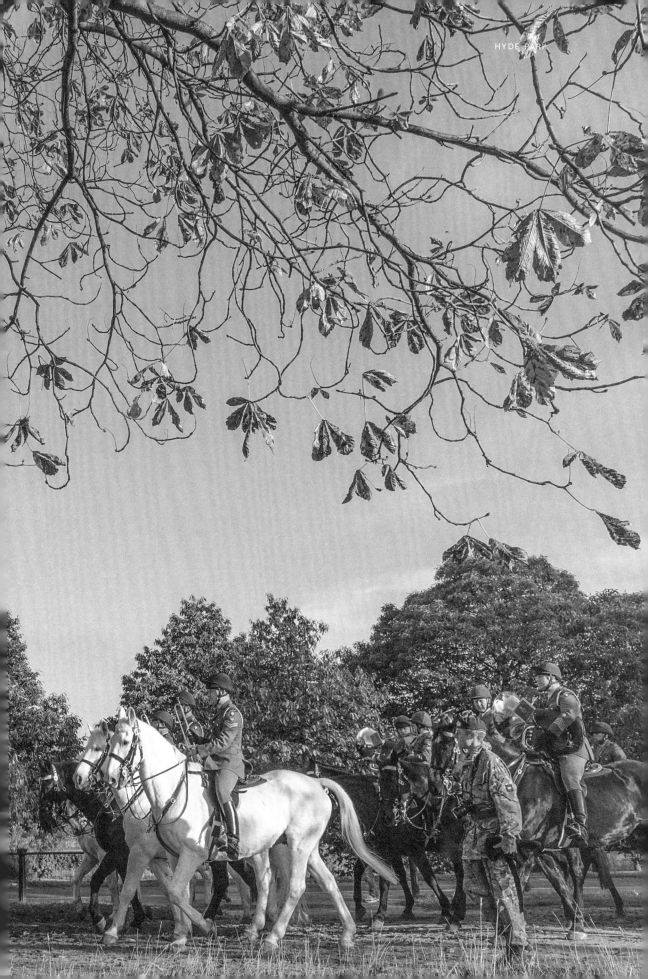

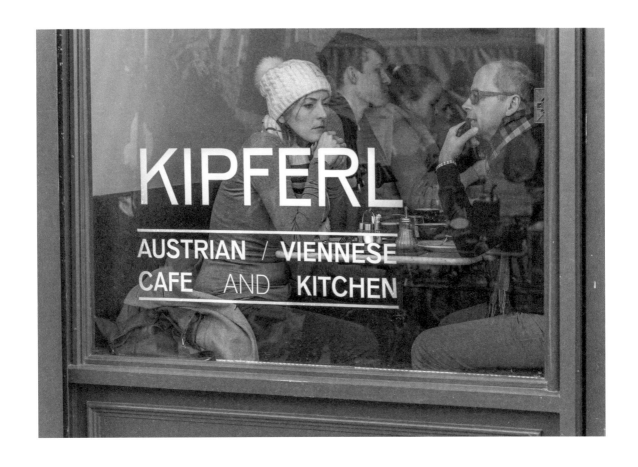

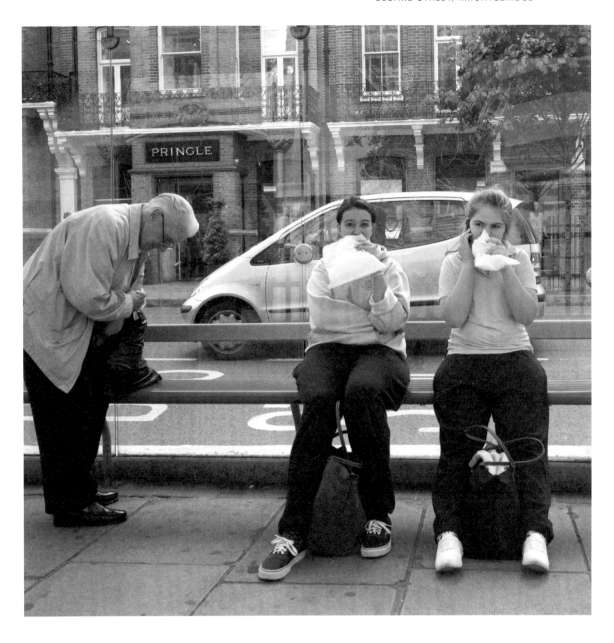

Seeing Norman Foster's Gherkin popping up between the old brick walls is a surreal experience, especially when you are familiar with the history of the Tower and all who have been banished, sought refuge or died there. Mies van der Rohe believed architecture is "the will of an epoch translated into space".

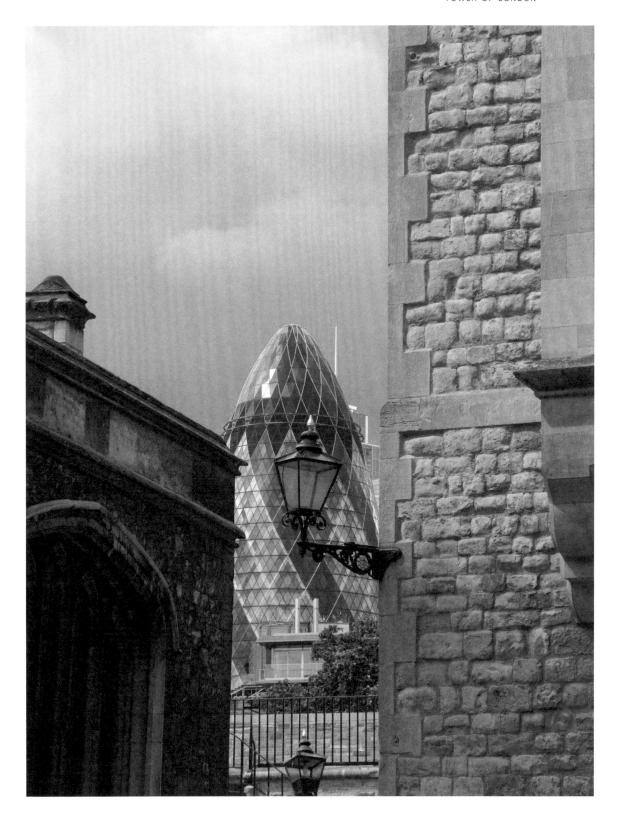

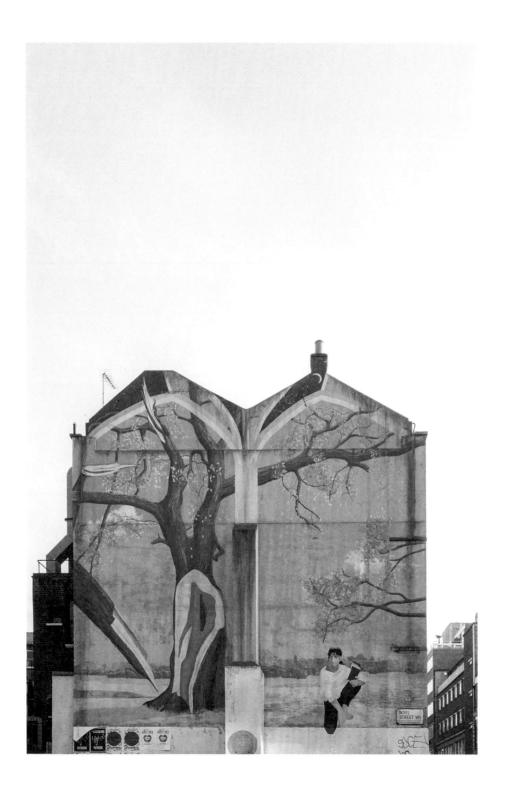

JAN FEB MAR APR MAY JUN

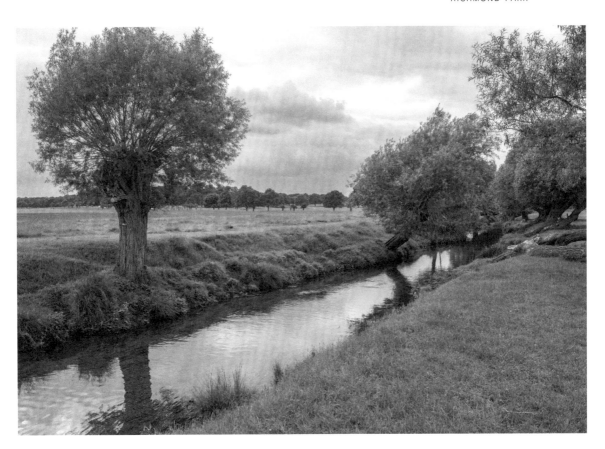

In the many travels I've taken throughout my career, London is the city I've been to (and through) the most, but I'm always excited to come back to it. It is a city that elegantly balances the old and the new. With its undeniably beautiful landscape steeped in historical significance and cultural abundance, London manages to be hip, chic and timeless all at the same instant. Frankly, the only downside seems to be the fact that London's skies are more often streaked grey then blue (a reality that I actually quite enjoy). All of these defining characteristics contribute to my love of the city yet my favorite aspect is not aesthetic or abstract; it is rooted in the very makings of London – the Londoner.

I have always found the people of London to be (much like the city itself) a beautiful dichotomy of the past and present. To me, this photograph captures the ever-present disposition of the Londoners that I have encountered throughout the years. From the recognizable Swan Pub in the background, to the children playing in the foreground, to the groups scattered throughout the frame enjoying their surroundings and one another. The people of London maintain a strong sense of tradition yet they are relaxed and spirited. They are proud of their long-running institutions and heritage yet open and embracing of the new and different. They are anchored by historic structure while at the same time they are not boxed in or restrained by it – they are roaming free on the streets, enjoying each other, having a laugh, of course with a beer close by.

CHARLIZE THERON
Actress

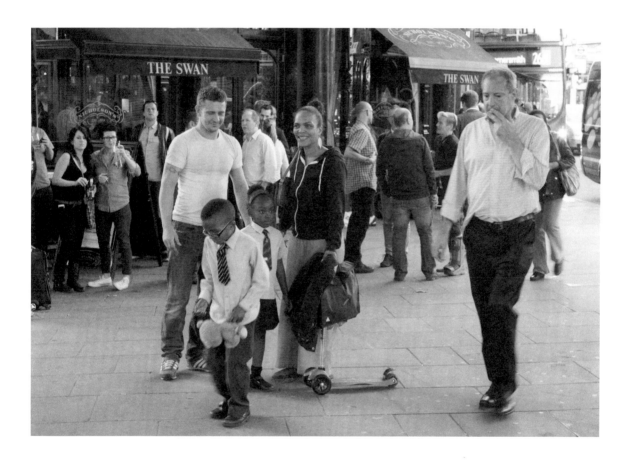

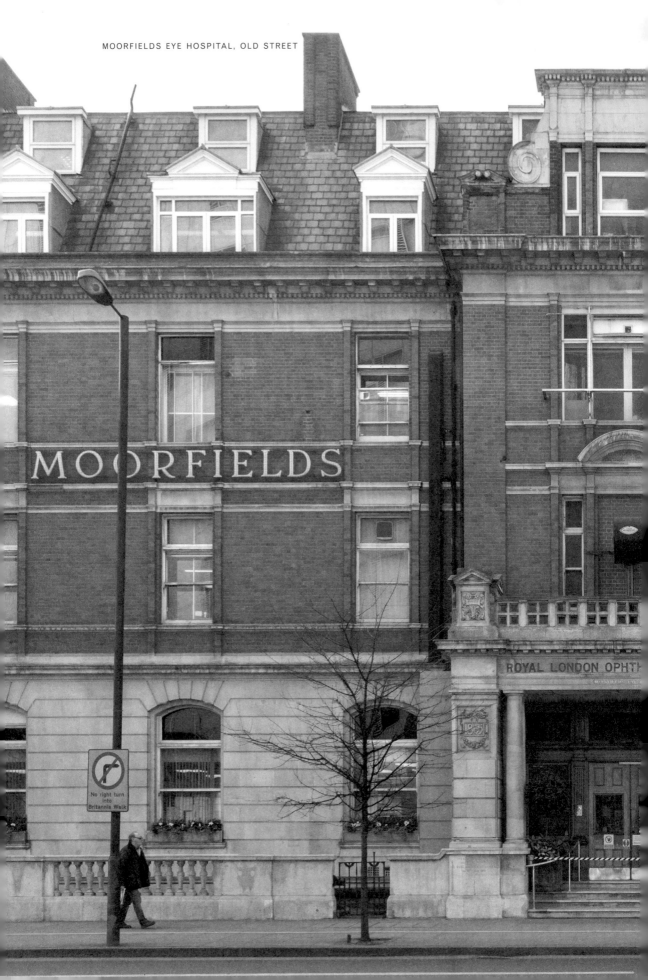

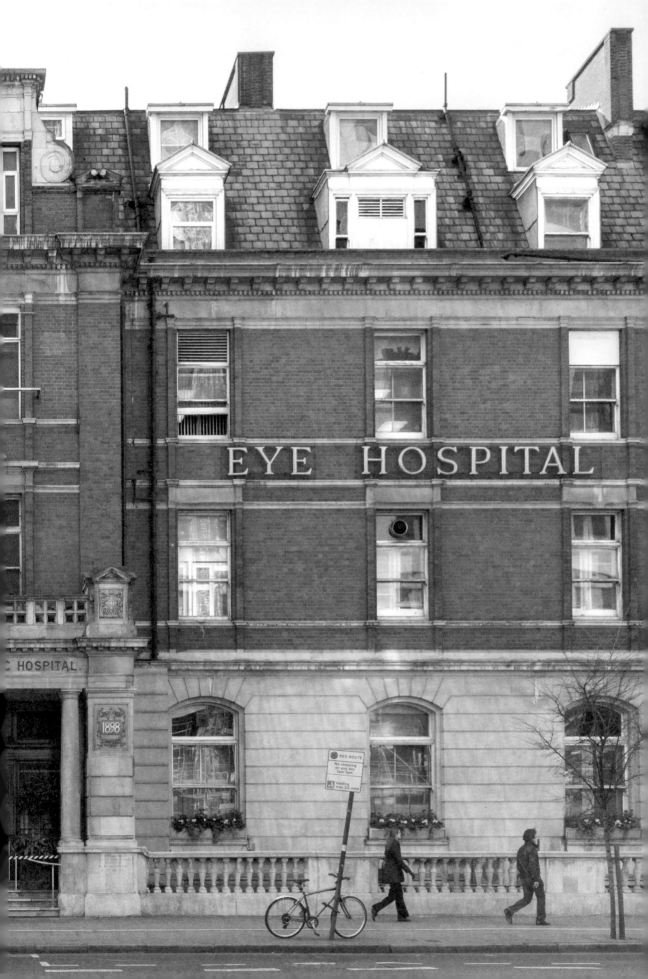

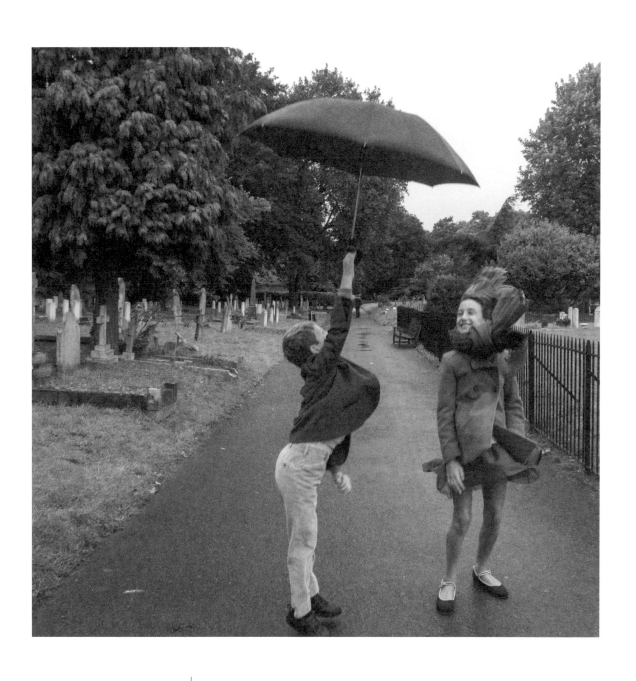

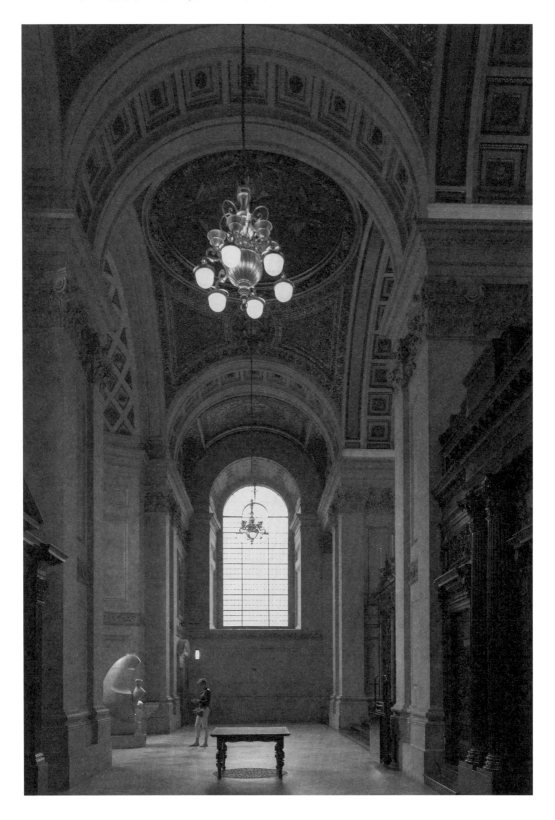

AUTUMN JAN FEB MAR APR MAY JUN

When it comes to architecture, most religious buildings have an incredible impact. They are so powerful that it makes you feel tiny, but also safe. St Paul's Cathedral is a magnificent baroque church designed by Sir Christopher Wren in 1673. I pay homage here to the Düsseldorf School of photography and all its wonderful disciples, especially Thomas Struth and Candida Höfer, for the way they have captured classical buildings.

CROMWELL ROAD, SOUTH KENSINGTON

AUTUMN JAN FEB MAR APR MAY JUN

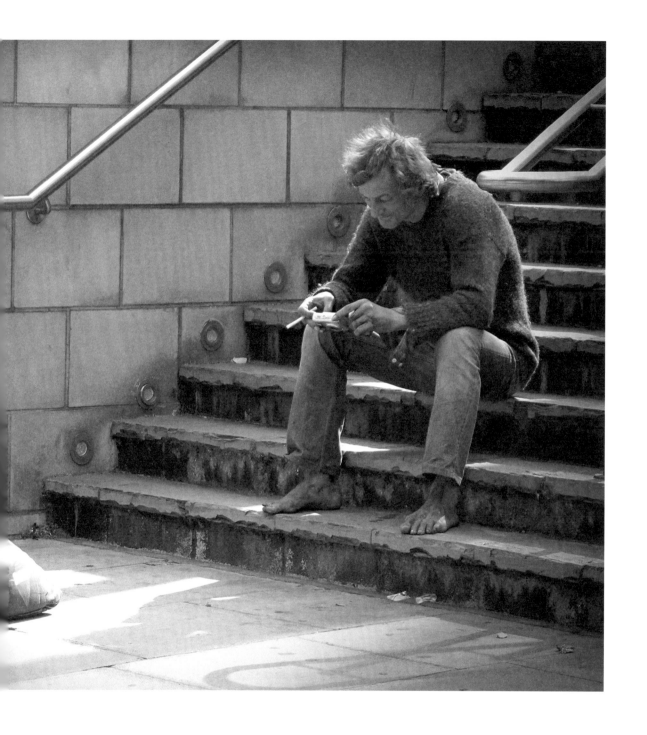

What a city! In this one picture: a river whose history goes back over 30 million years; one of the world's most beautiful cathedrals with an elegant youngster of a footbridge leading to it; the Barbican, risen again, like so much else, from the devastation of the Blitz; the City of London School; at least two cranes, because London, as ever, continues to be work in progress; and a city in 24-hour use by everyday people – for working, walking, living and loving. (I would have included The Shard and Buckingham Palace but unfortunately they built them in the wrong place.) What a city!

SIR MARTIN SORRELL
CEO of WPP

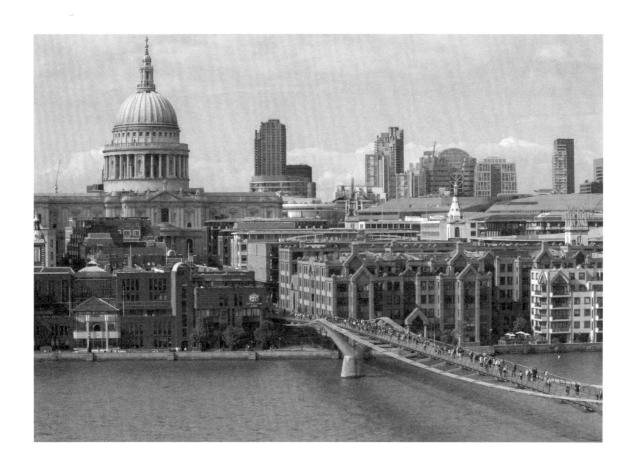

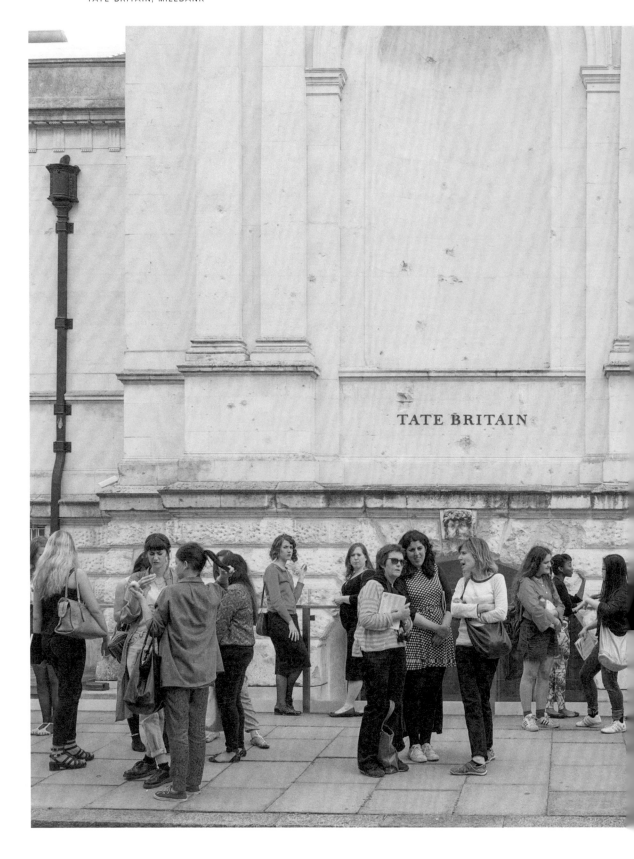

AUTUMN JAN FEB MAR APR MAY JUN

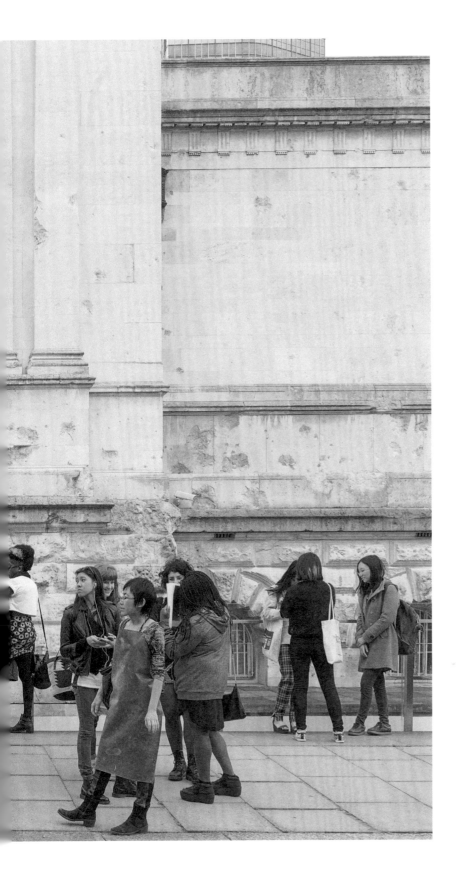

London has beautiful hidden spaces; great escapes from the frenetic moments in the city, from the busy lives that we all seem to live nowadays. Its parks, squares and little gardens, but also wild forests, rivers and canals, are restful spots for those who are looking for some peace and quiet. "London is on the whole the most possible form of life," said Henry James.

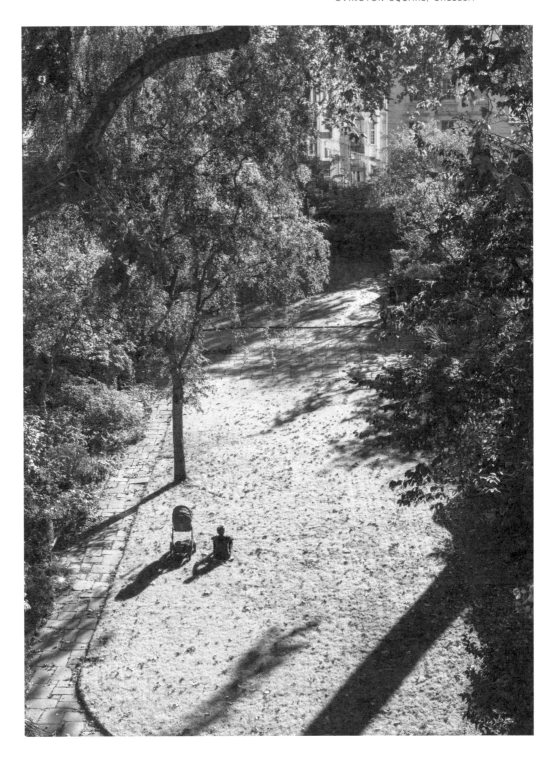

AUTUMN JAN FEB MAR APR MAY JUN

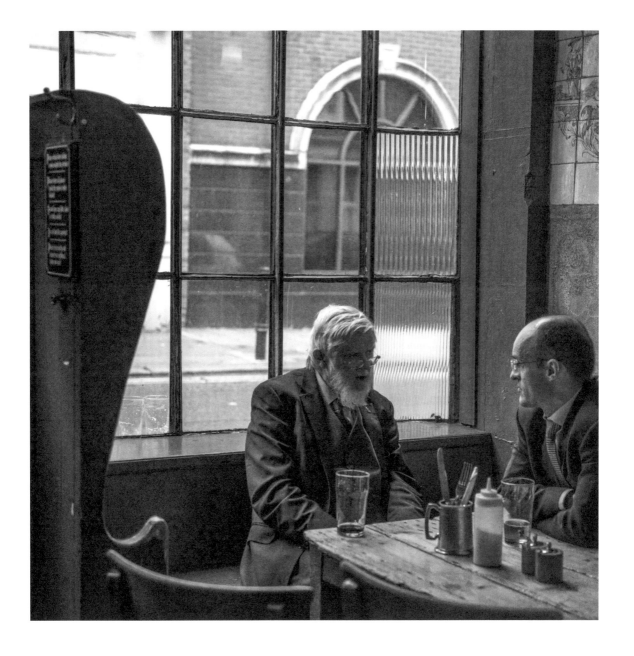

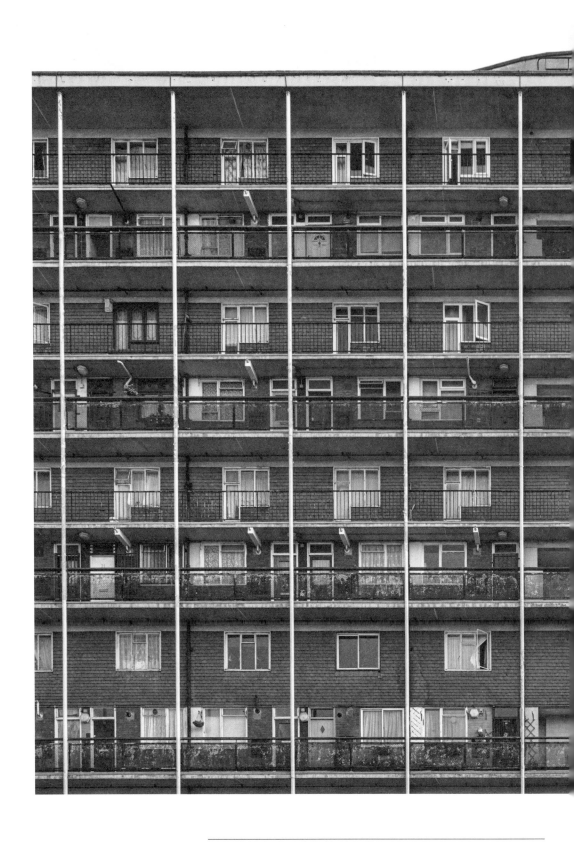

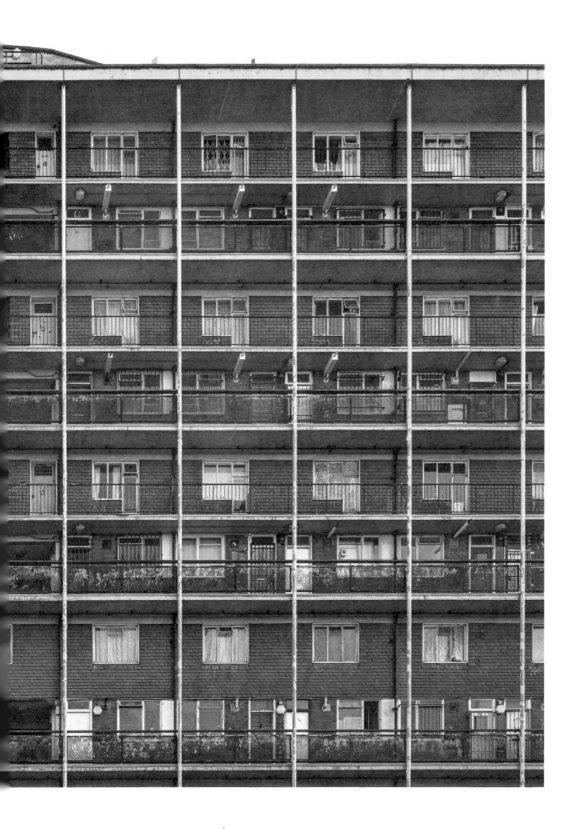

REGENT'S CANAL, HACKNEY

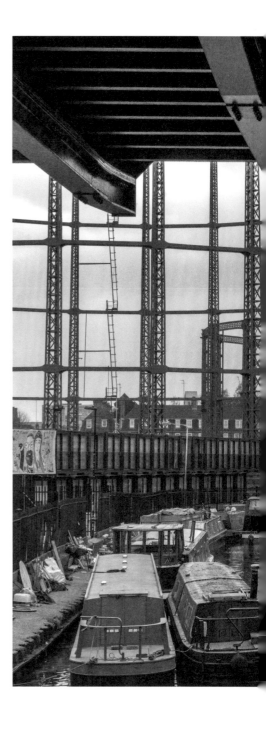

AUTUMN

JAN FEB MAR APR MAY JUN

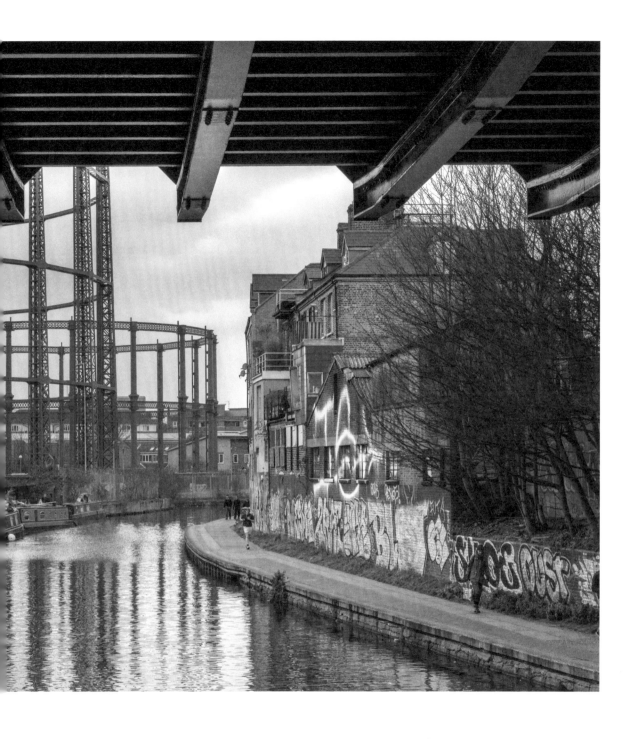

As an artist, I intend to grasp a sort of truth that I happen to find in front of me. This idea of authenticity takes me back to the emotional level that art seems to offer outside of rationality, imagination and creation. In this image I see, among other things, the idea of diversity, of multiculturalism.

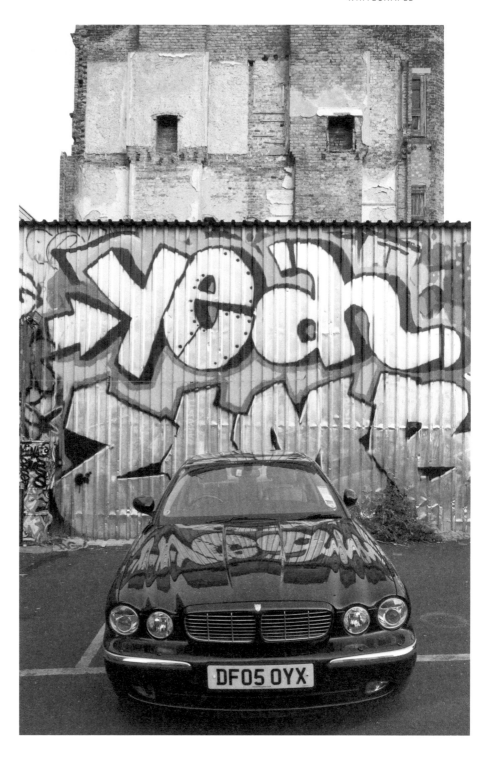

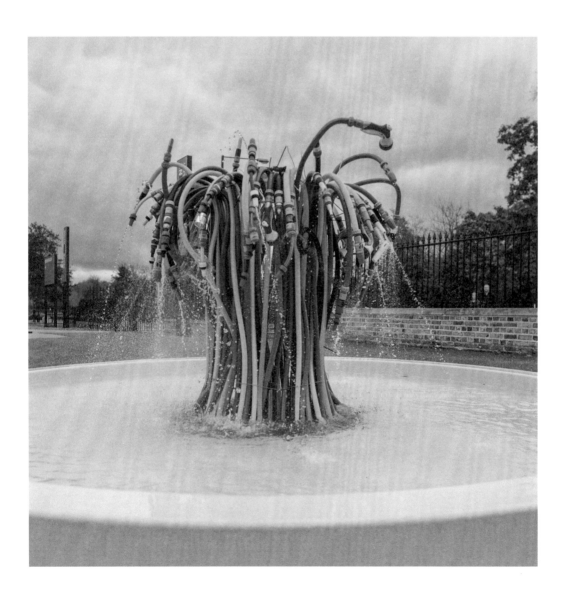

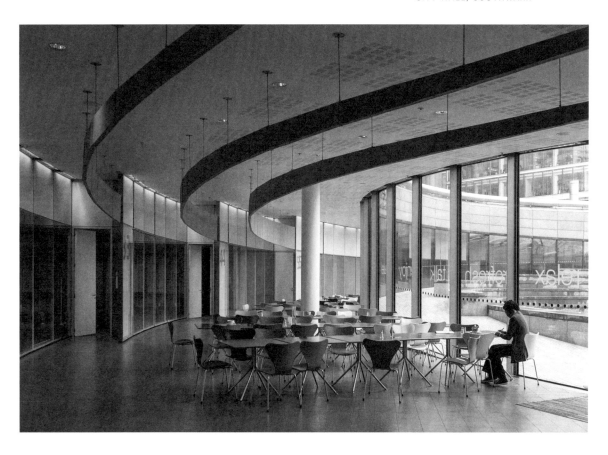

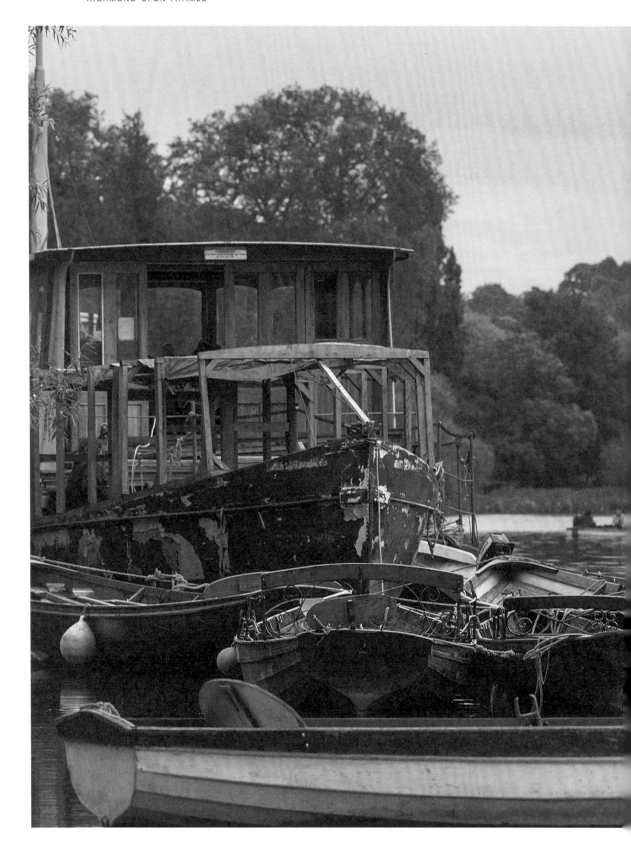

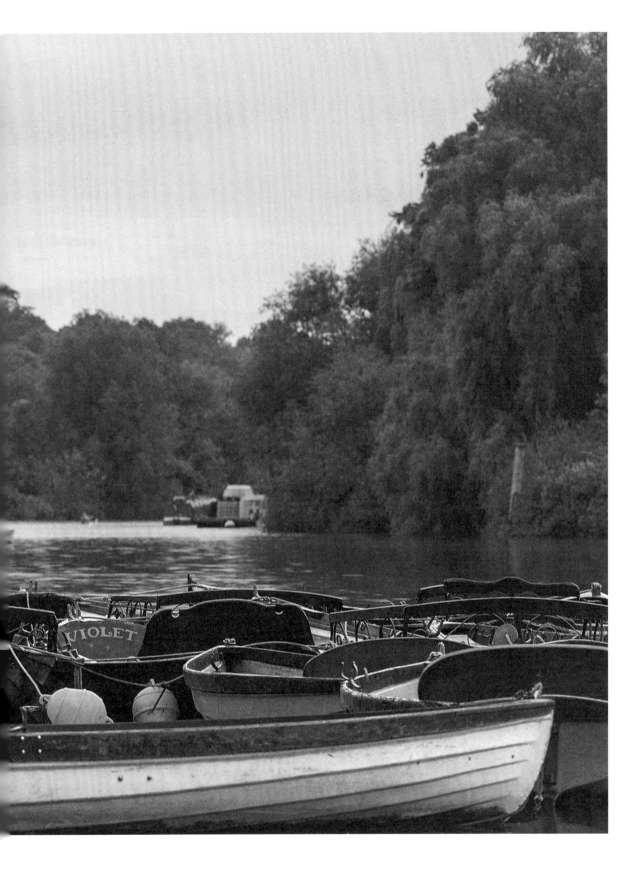

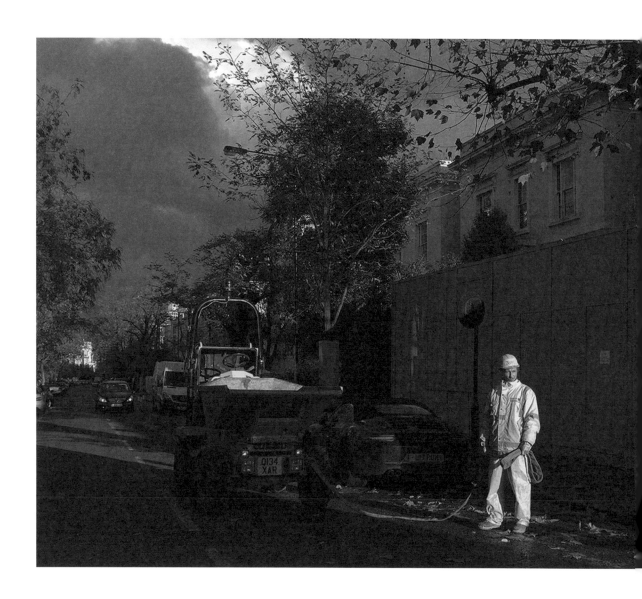

AUTUMN JAN FEB MAR APR MAY JUN

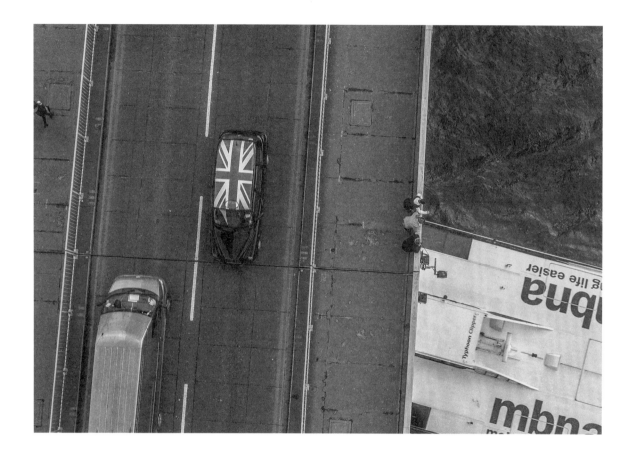

One of the most interesting aspects of photography is composition, the making of something, a rhythm of surfaces, lines, textures and colours. "Whether a photo or music, or a drawing or anything else I might do – it's ultimately all an abstraction of my peculiar experience," William Eggleston astutely observed.

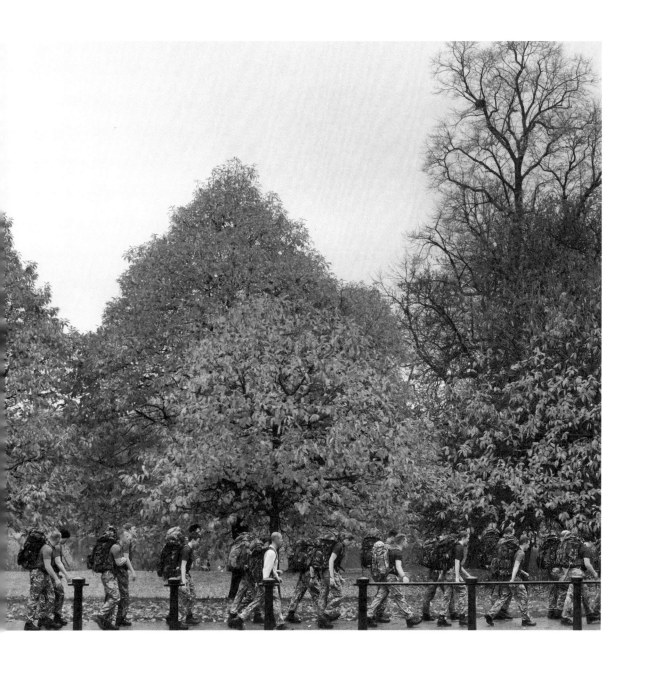

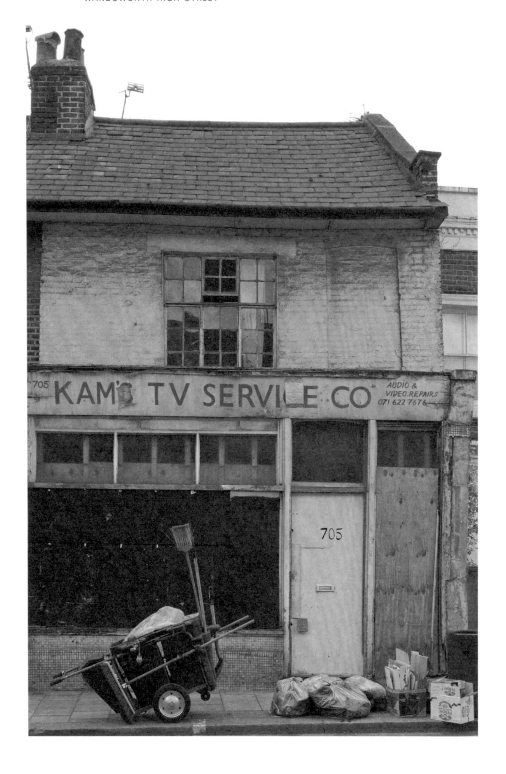

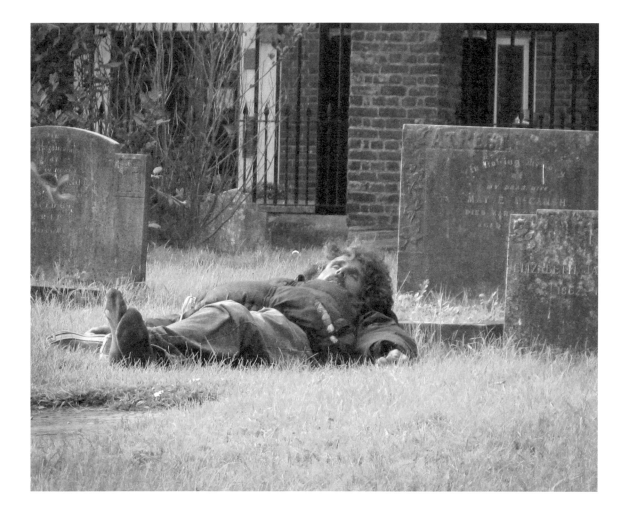

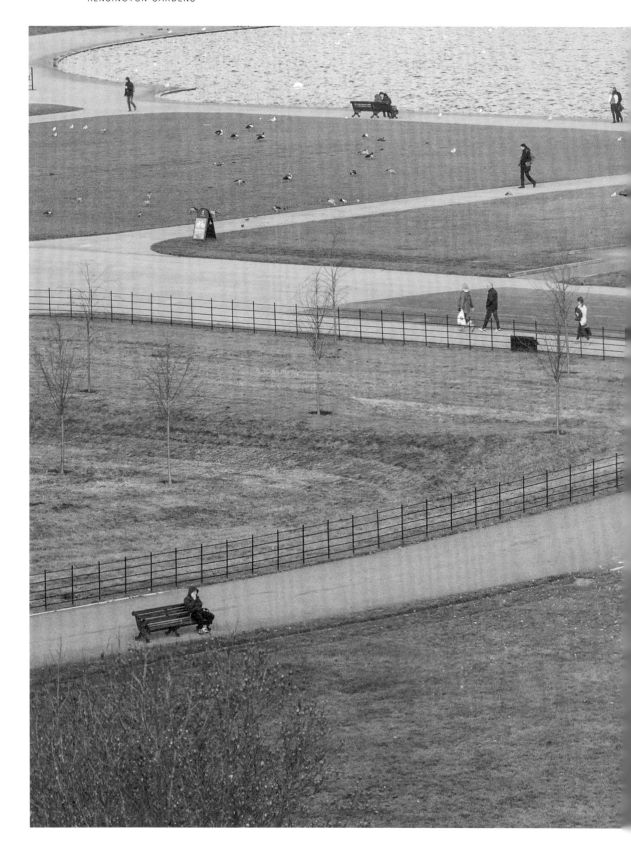

AUTUMN JAN FEB MAR APR MAY JUN

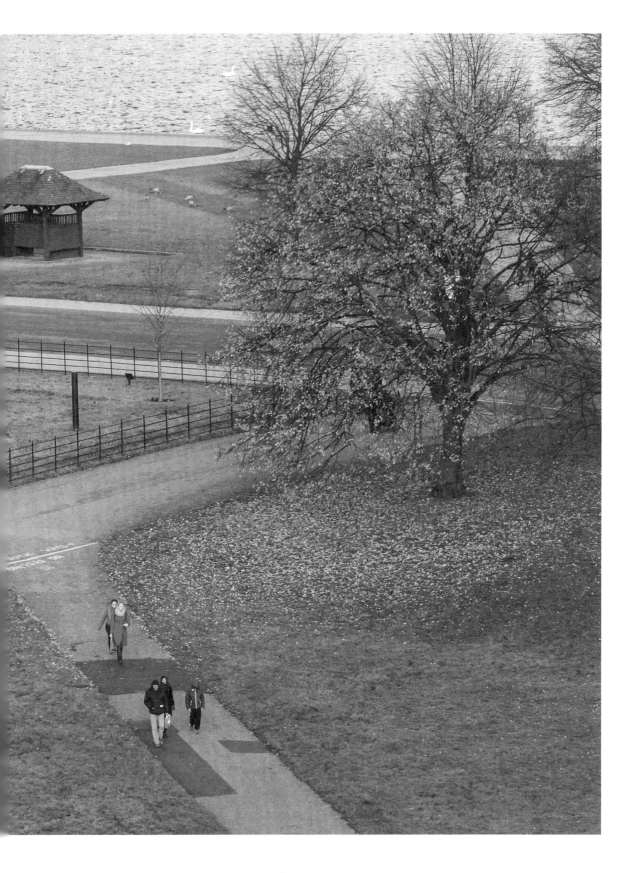

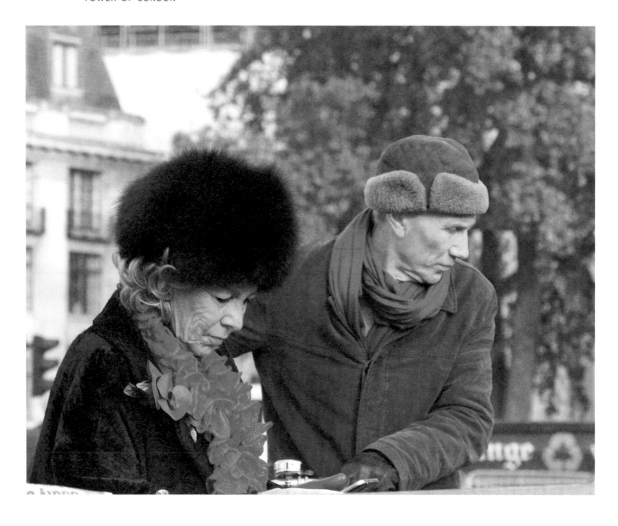

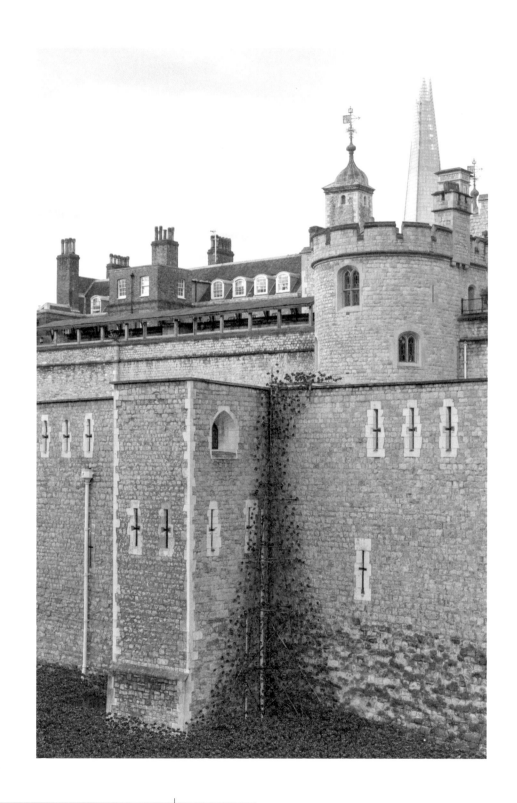

I appreciate the image of the Tower of London, because it is very symbolic of London and of its rich history. This photograph is representative of the wonderful transition from the past to the future, with the colour contrast of the red poppies (a feat in itself) against the grey of the tower. In my view, we see the changing of the time and the zeitgeist. It is a symbol of a post-war generation showing their appreciation and gratitude, remembering the lives lost during World War I against the pain, torture and oppression symbolic of the Tower of London. The juxtaposition of past, present, colour, black and white, sadness and joy is so vast and makes this an incredibly powerful photograph to me.

NADJA SWAROVSKI
Swarovski

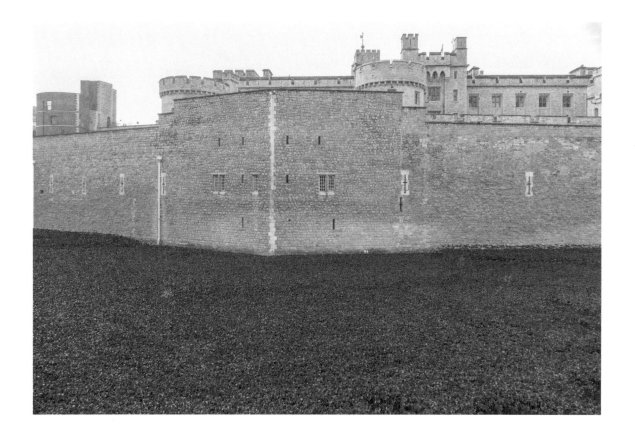

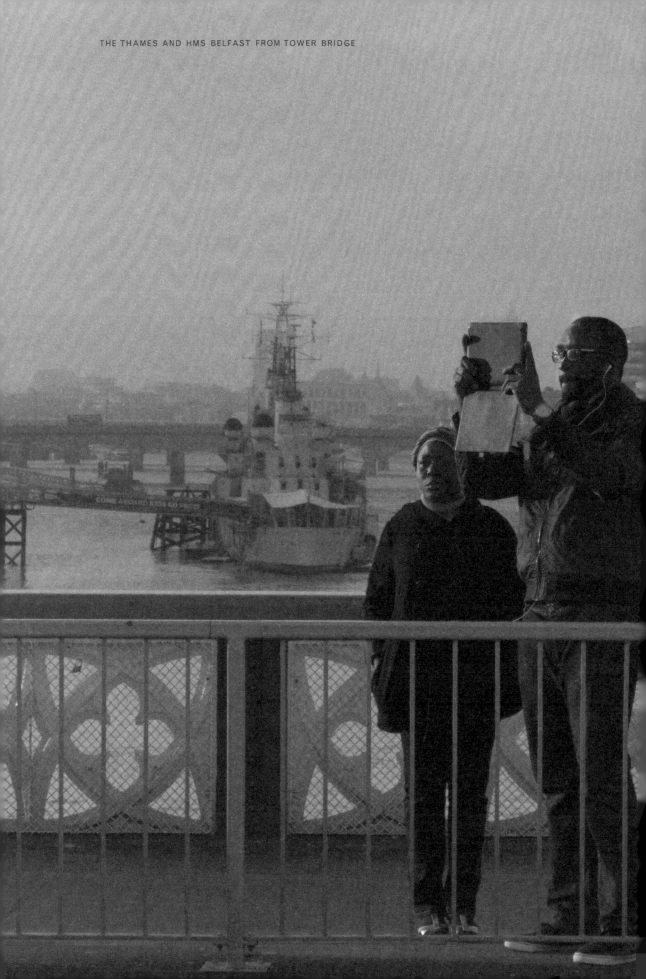

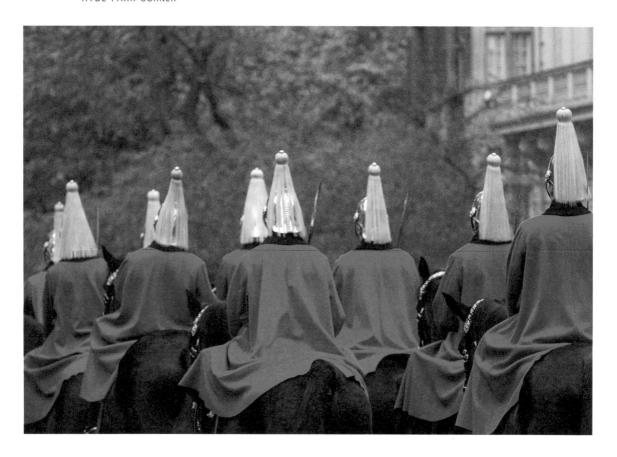

AUTUMN

JAN FEB MAR APR MAY JUN

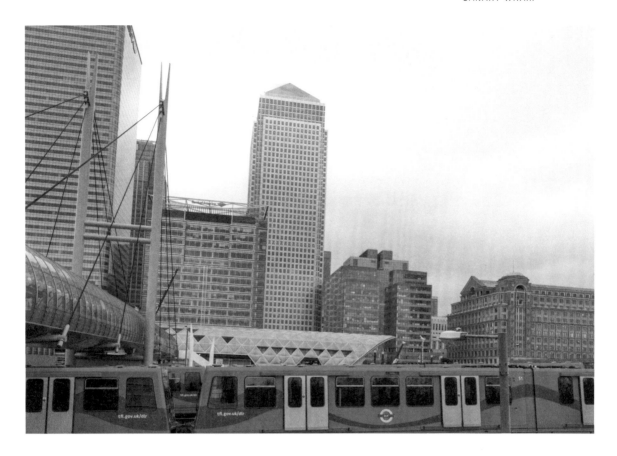

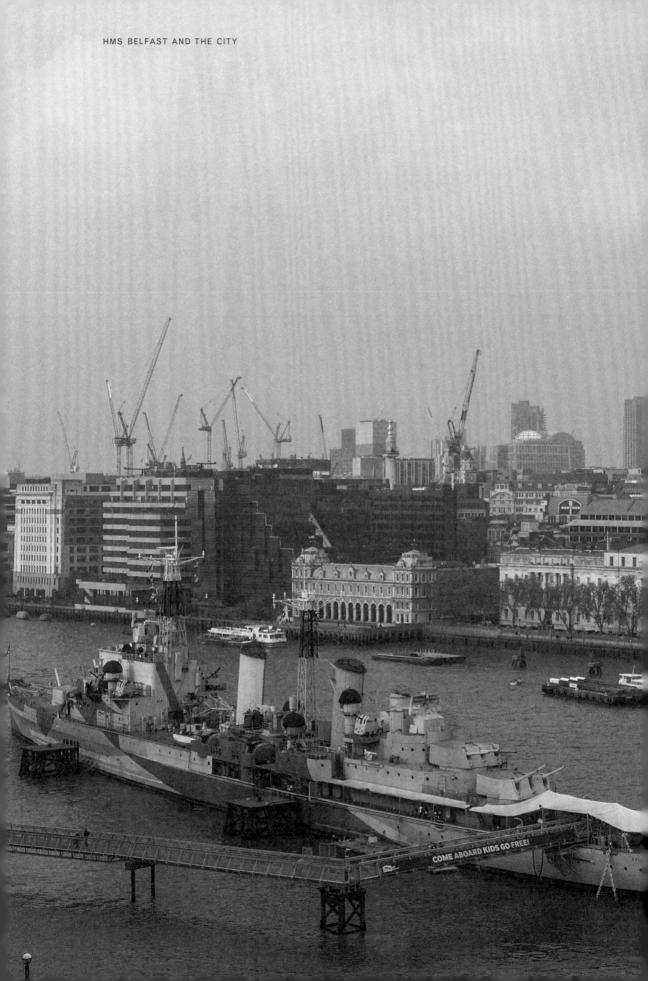

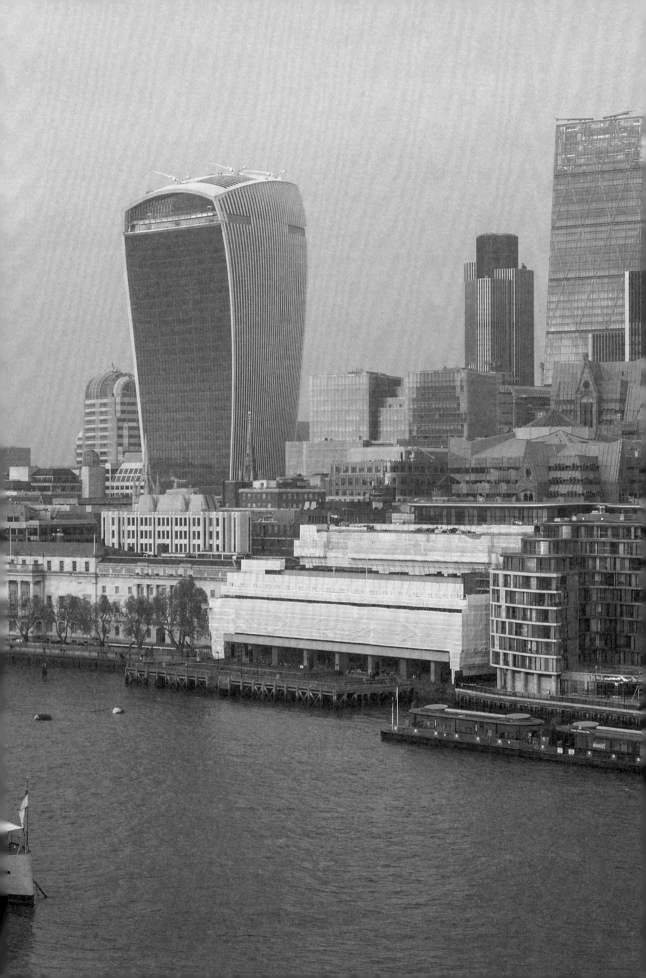

I believe the expressive element is one of the most important ingredients within a photograph. Sometimes it is more significant to click with people than to click the shutter-release button. I connected with this man. Both of us felt as comfortable as if we had known each other from before. Once the connection is made, this becomes defined as a portrait. Here, this gentleman had just crawled out of an oil pipe to get a quick lunch on the Brompton Road.

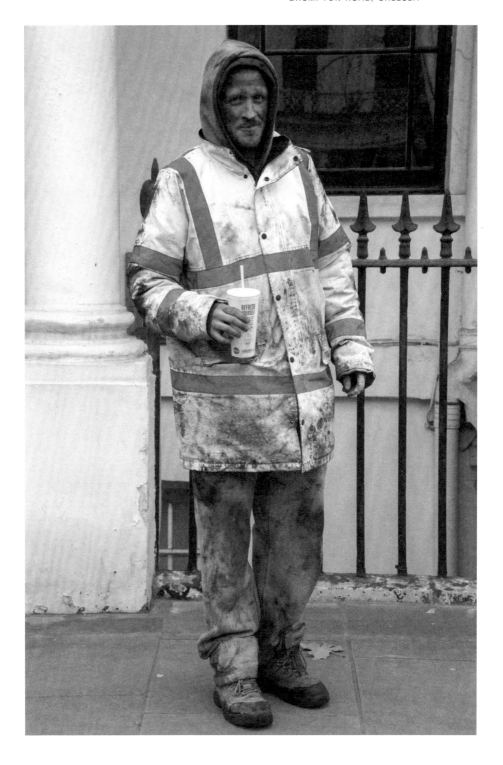

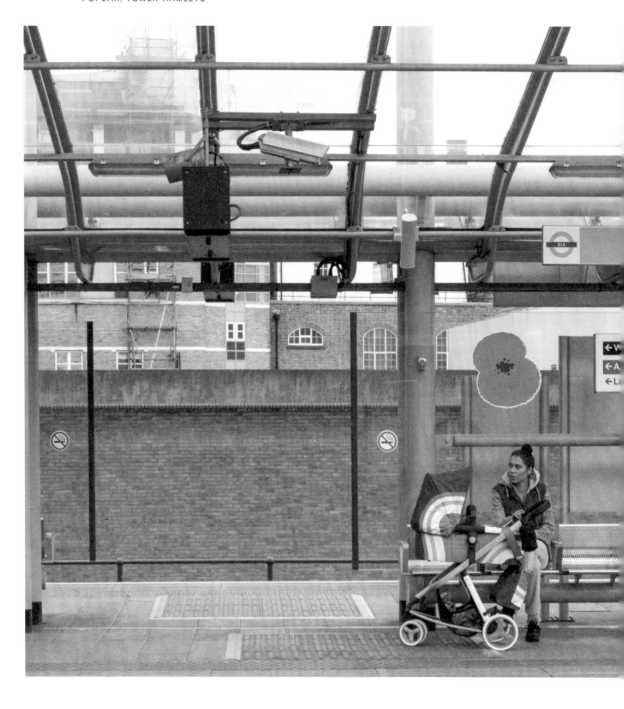

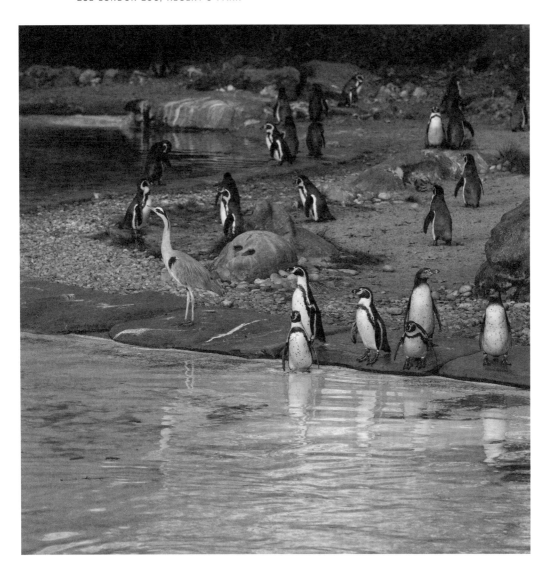

AUTUMN JAN FEB MAR APR MAY JUN

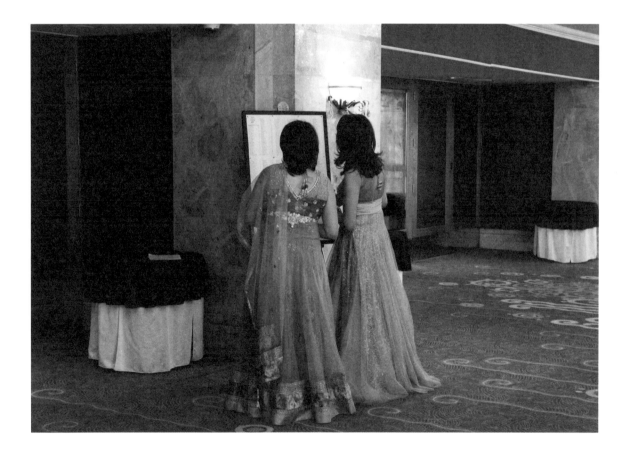

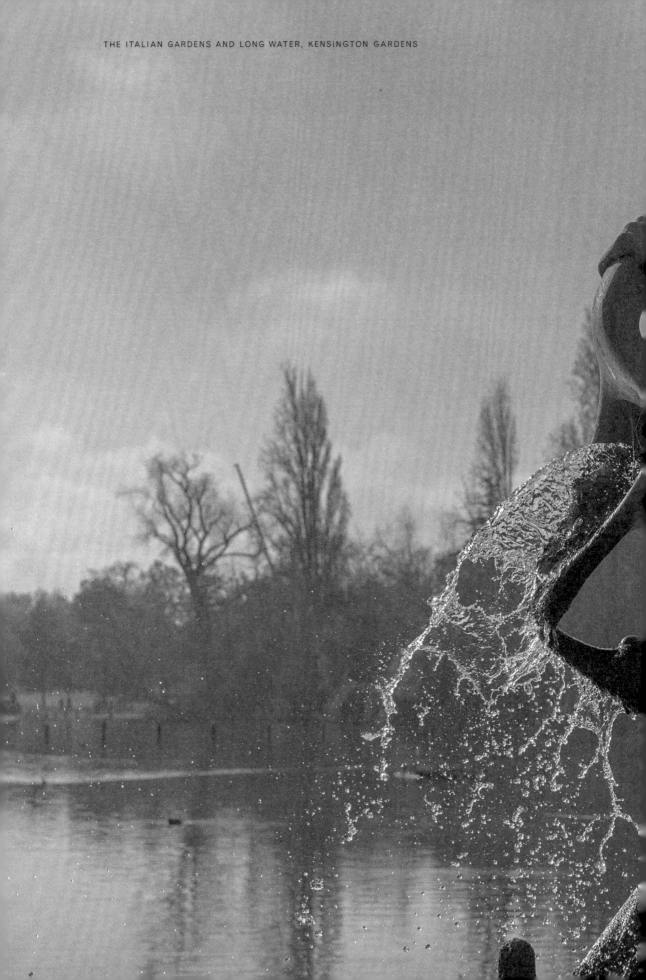

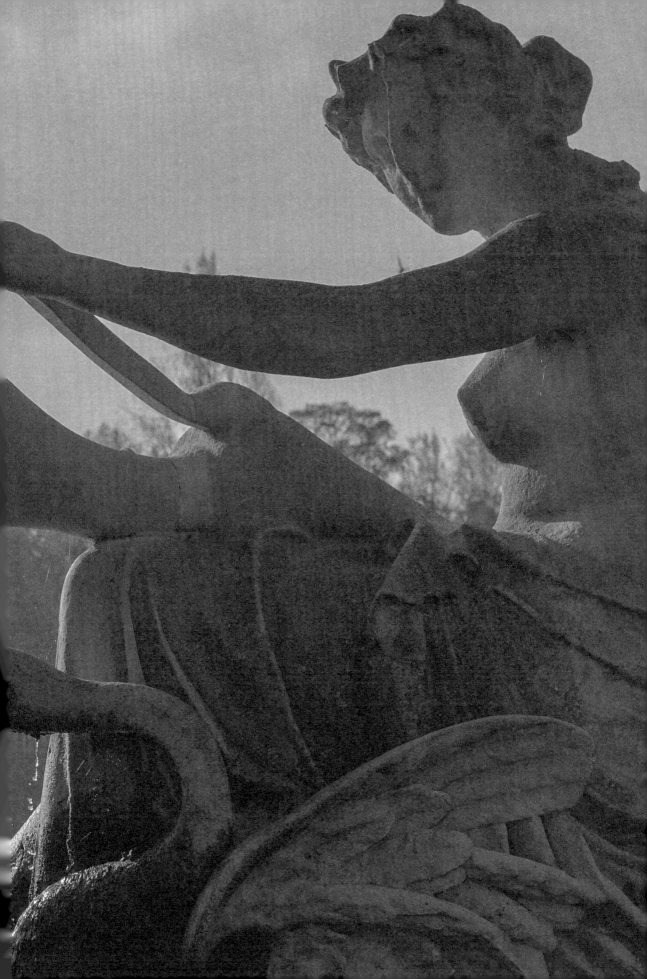

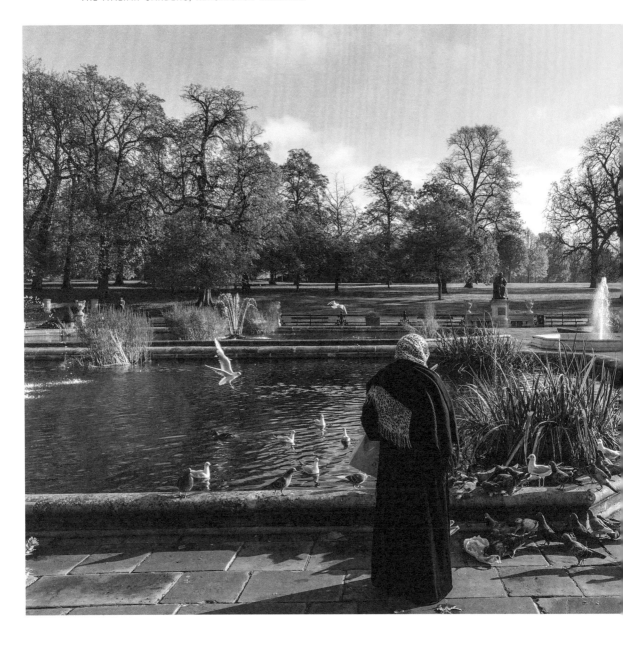

AUTUMN JAN FEB MAR APR MAY JUN

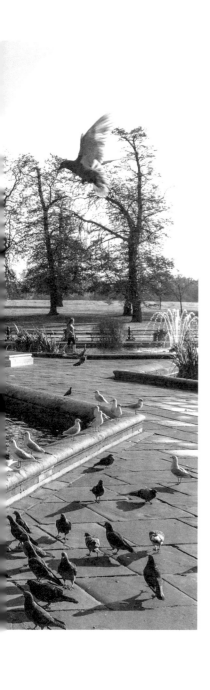

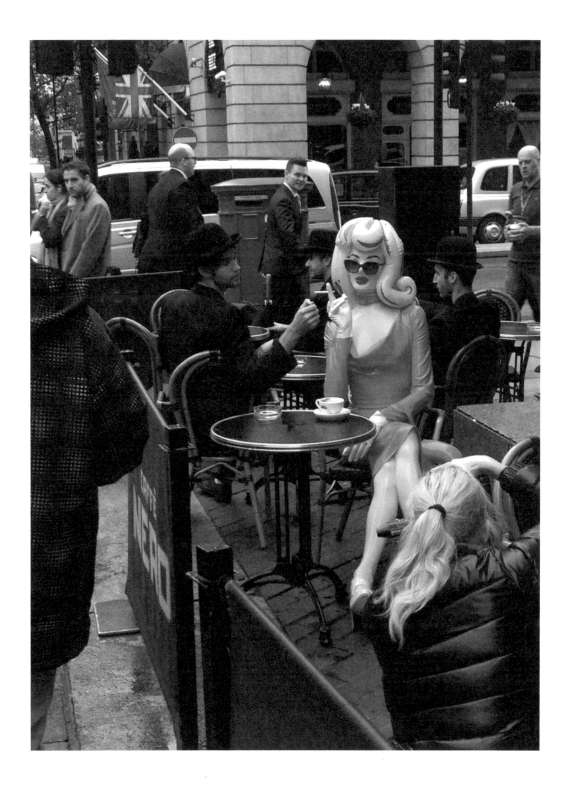

WINTER

Winter is London's coldest season, with freezing temperatures, icy conditions and sometimes snow. Rare moments of visual surrealism make my day. The best that London offers to the imagination is the vast range of people and variety of places.

In the end, I can tell one or a thousand stories but it is the story the viewer sees in each image that excels. *London Every Day* invites you to navigate the city with me, to recognize and rediscover London's magical corners and landmarks, creating a narrative within a frame, where the drama emerges, and the passing resemblance to emotional places we all know becomes visible.

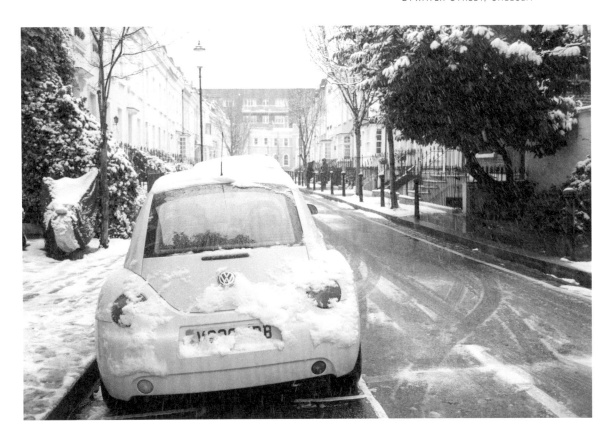

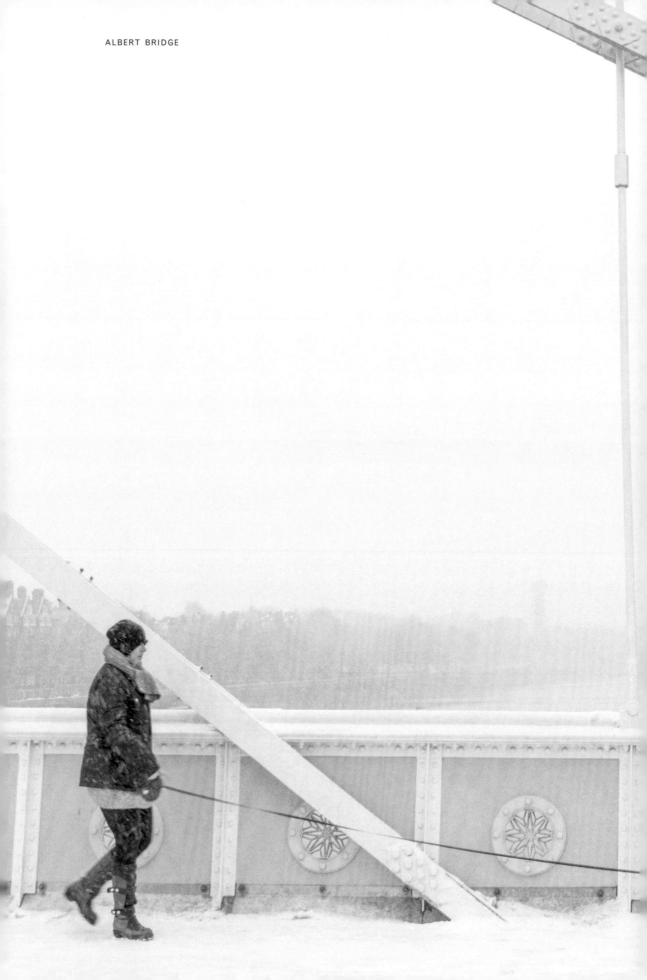

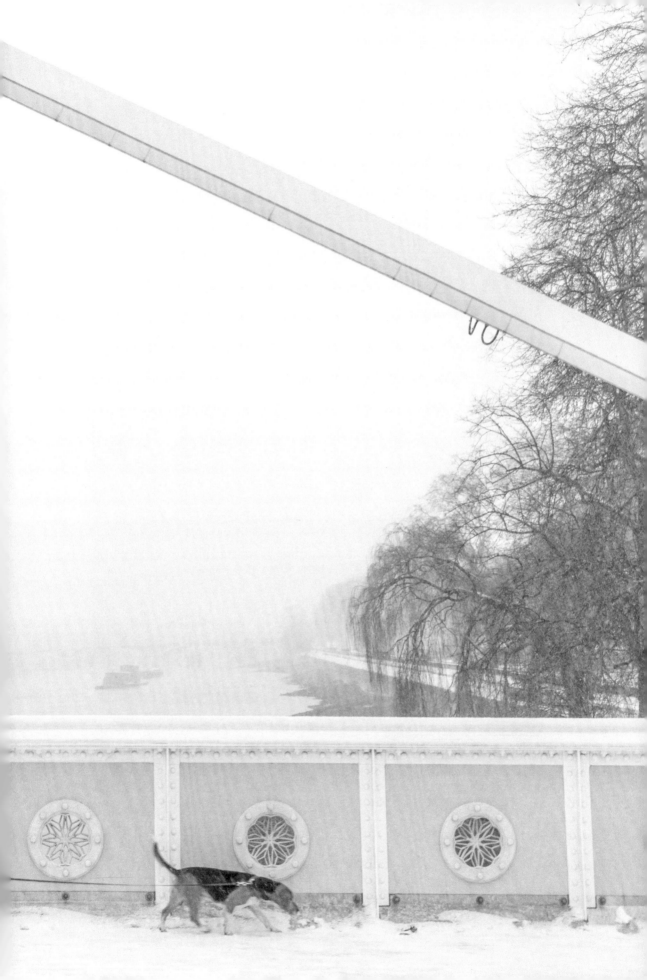

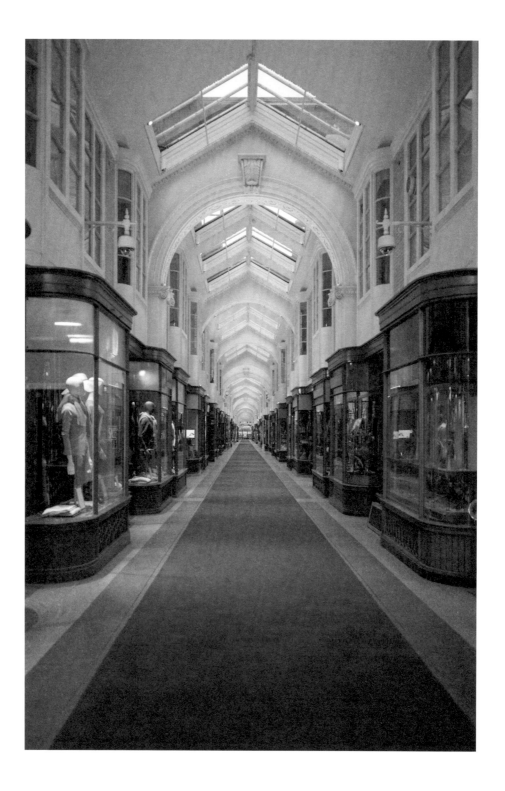

I like to think about life as a long corridor lined with closed doors that we need to open in order to discover what this world has to offer. London is packed with endless galleries that present a great variety of goods while, at the same time, preserve the architecture of past ages. The Burlington Arcade, built in 1818–19, is an iconic covered street that combines these two ideas very well.

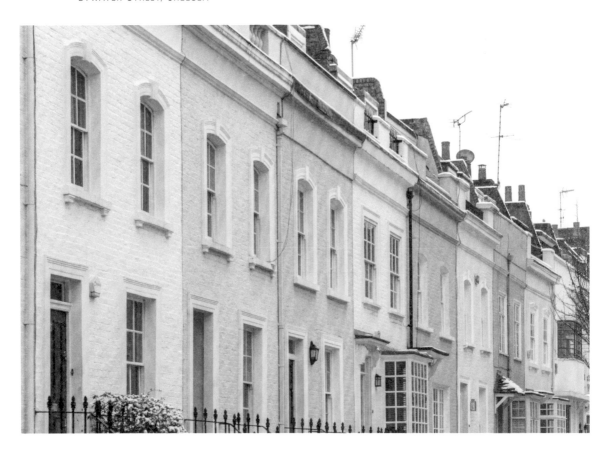

WINTER JAN FEB MAR APR MAY JUN

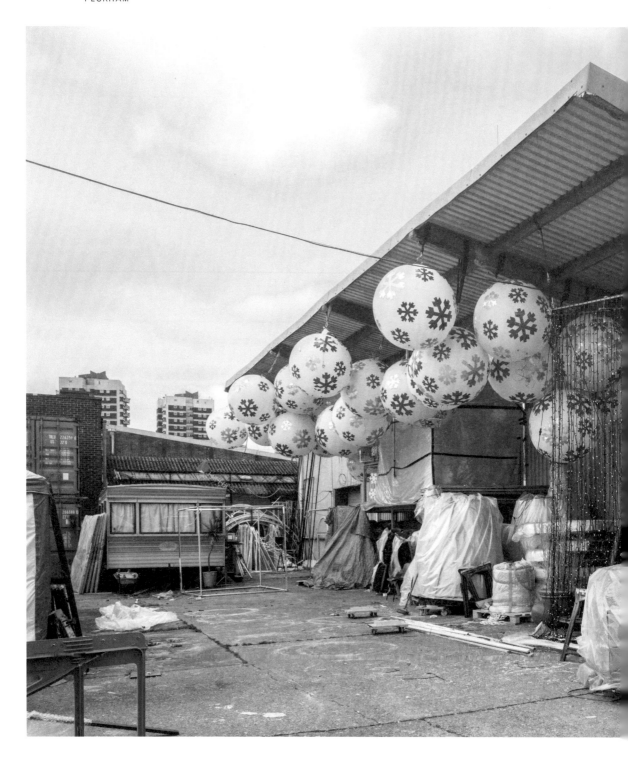

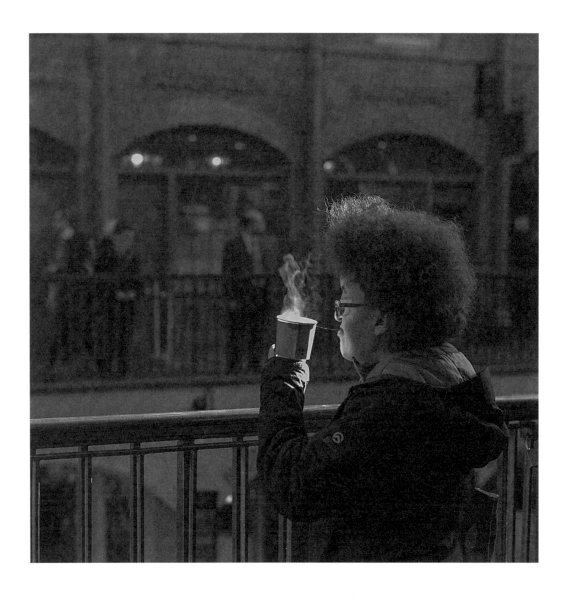

WINTER JAN FEB MAR APR MAY JUN

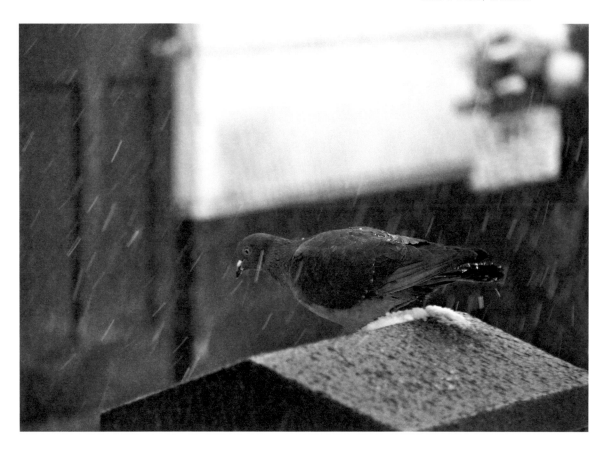

After consideration, I opted for this photograph of the rider on horseback in the park with the London buildings in the background behind the winter trees. I liked a number of the images, but connected with this one especially because this photograph made my mind wander and prompted lots of different thoughts – the view from horseback, the historic role horses have played throughout history in London, a crisp winter's day; how did the photographer come up with this scene, was it set up or a captured moment?
I could go on and on....

MARY MCCARTNEY
Photographer and Author

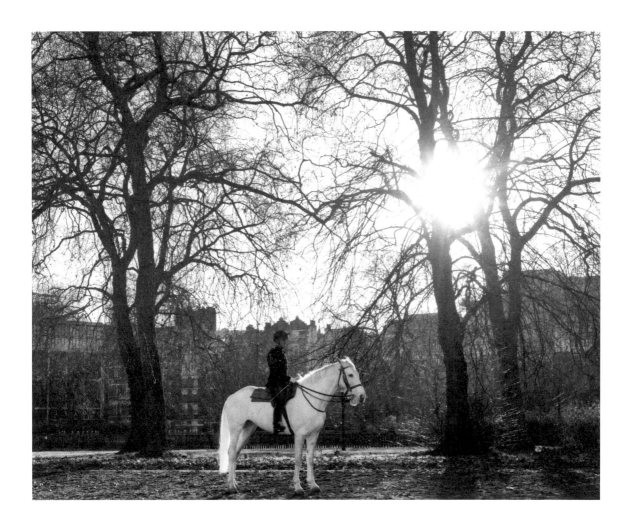

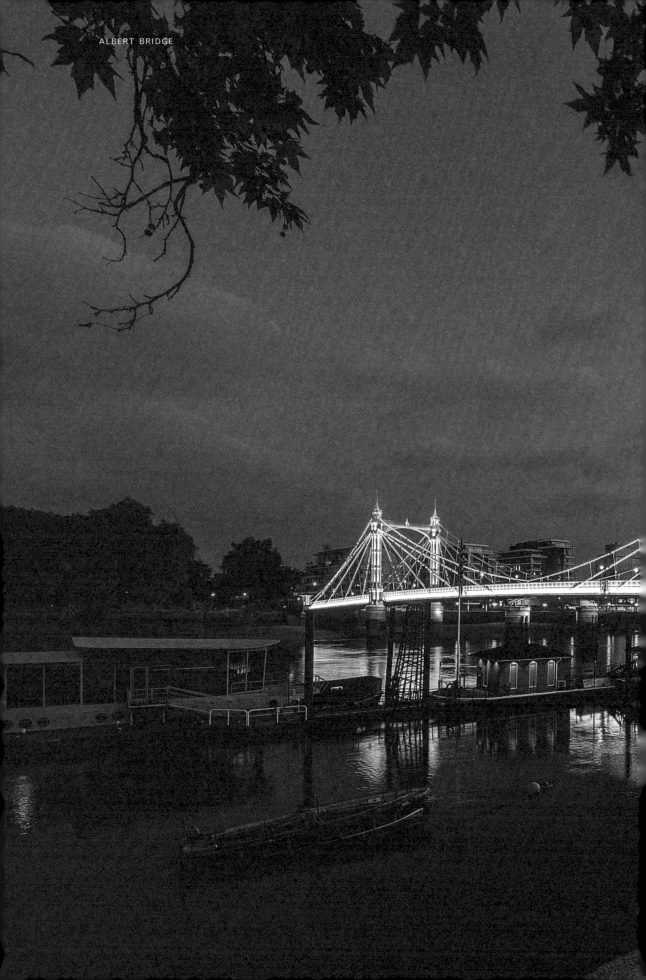

ALBERT BRIDGE

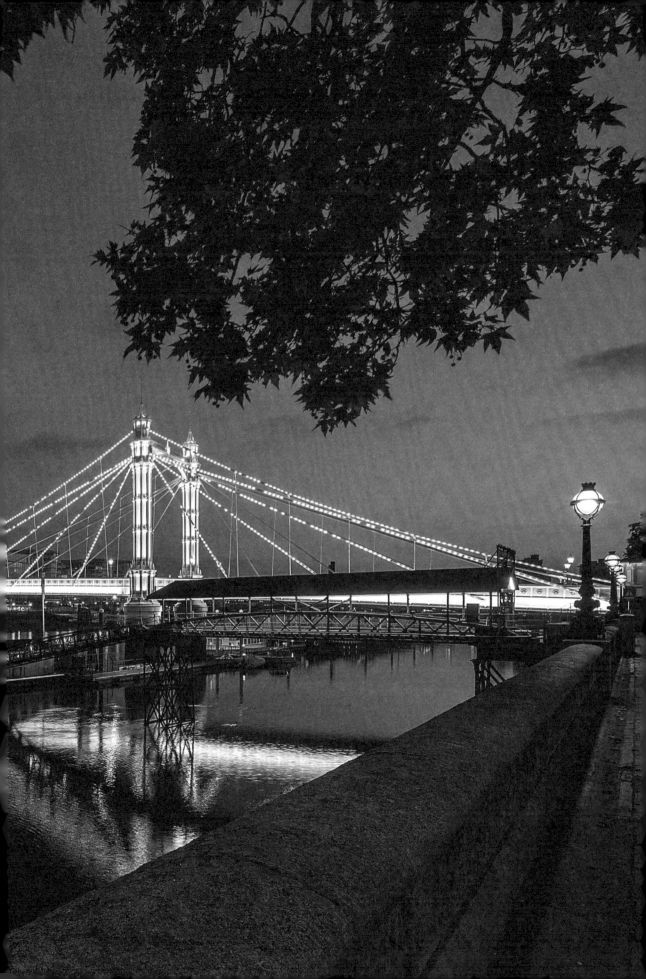

I can only reflect on what I've seen – that is, about my own experience; that's my artistic practice, exploring everyday life and what it brings. "Happiness is being on the beam with life, to feel the pull of life," according to Agnes Martin.

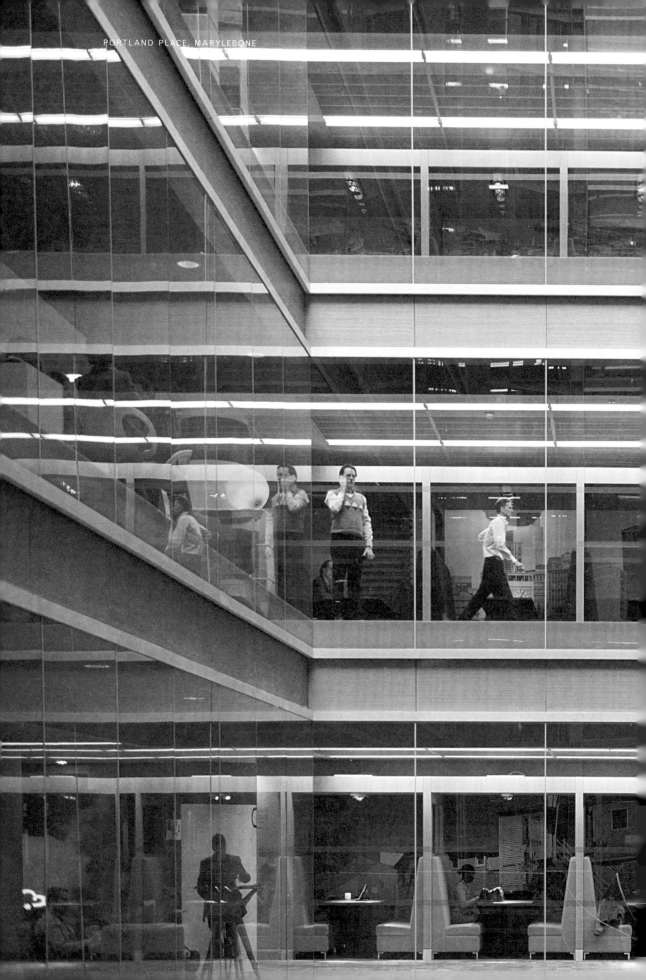

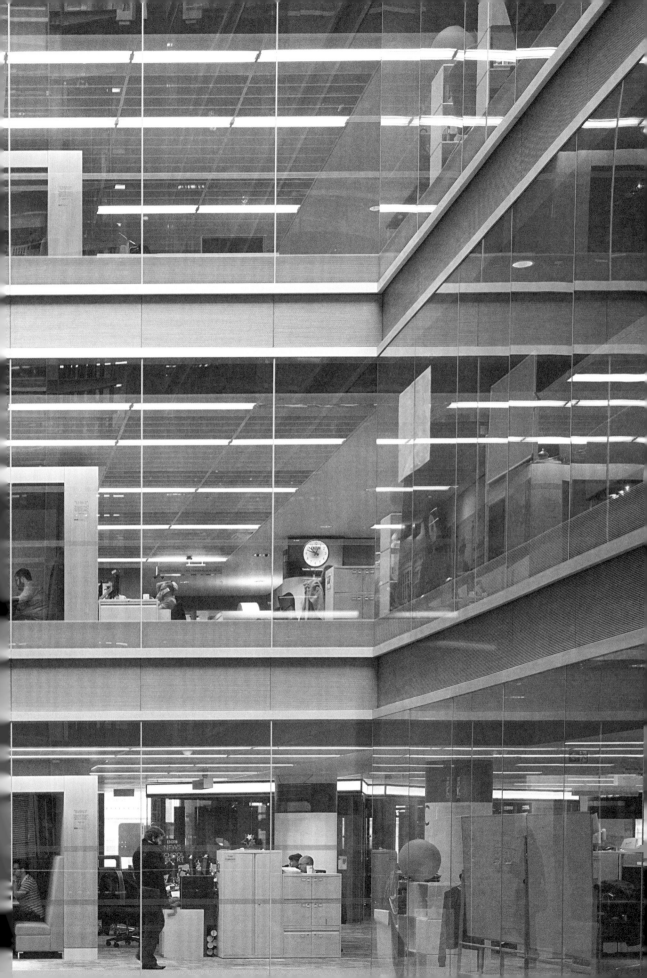

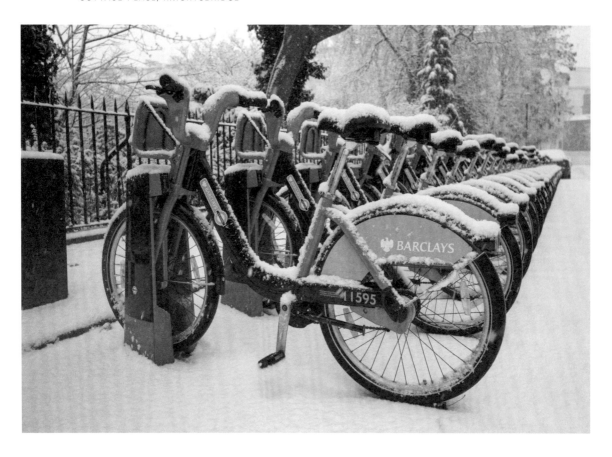

WINTER JAN FEB MAR APR MAY JUN

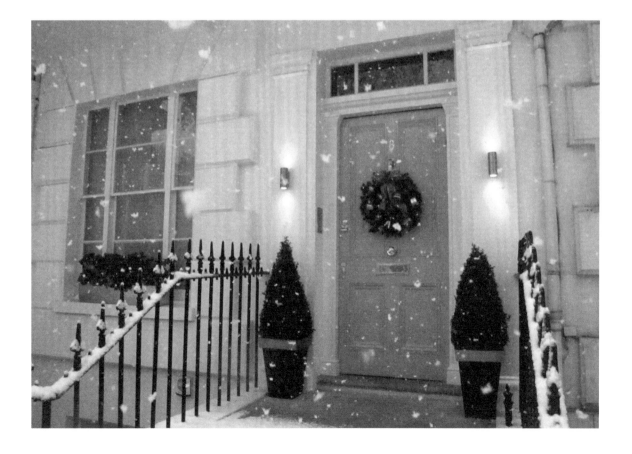

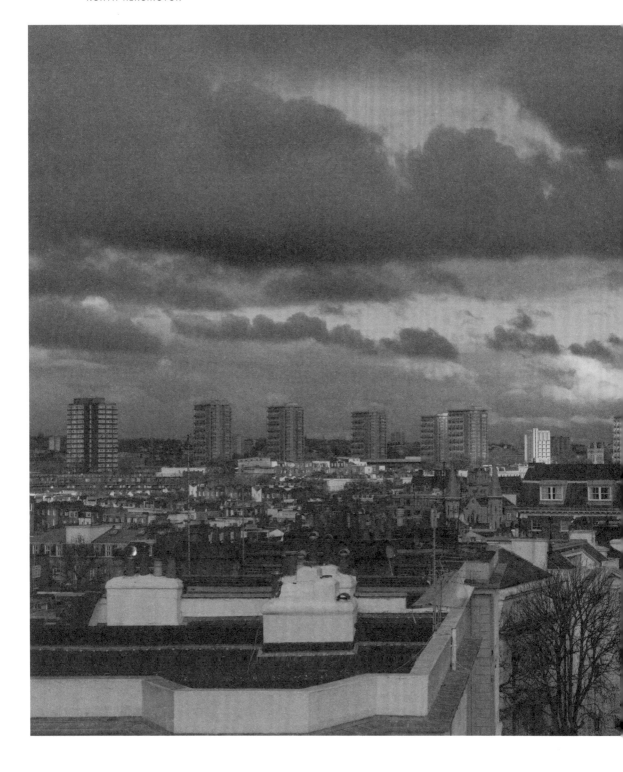

WINTER JAN FEB MAR APR MAY JUN

Some experiences seem to reveal to me a picture I could not have
imagined. As a photographer, you need to be receptive, to stay
in a corner and observe the flow past you.

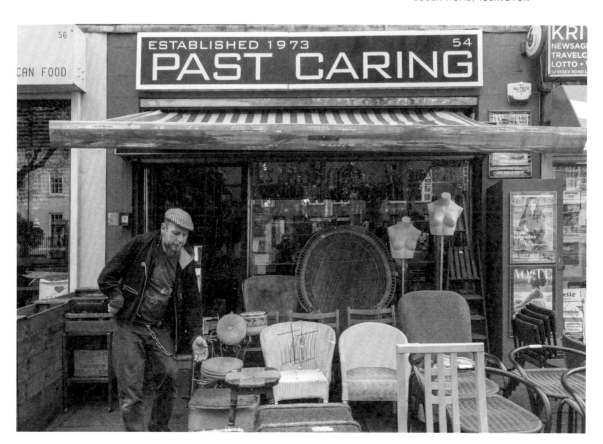

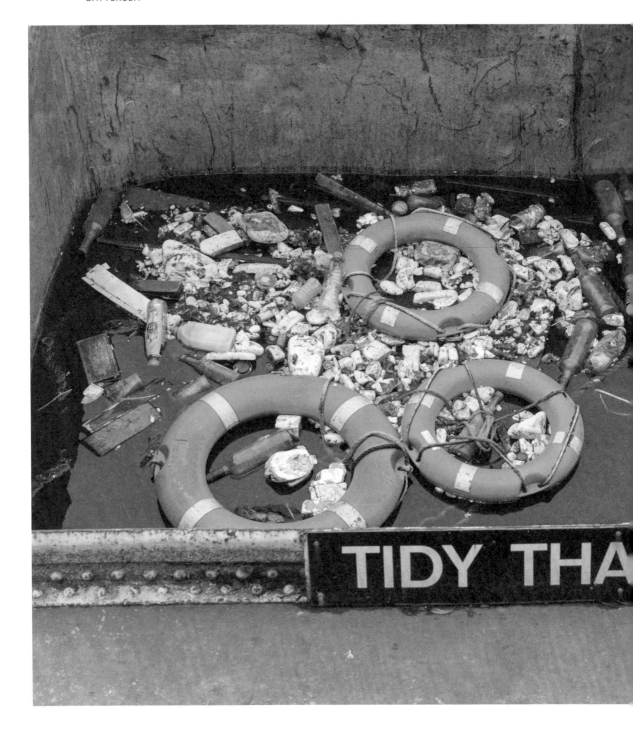

TIDY THA

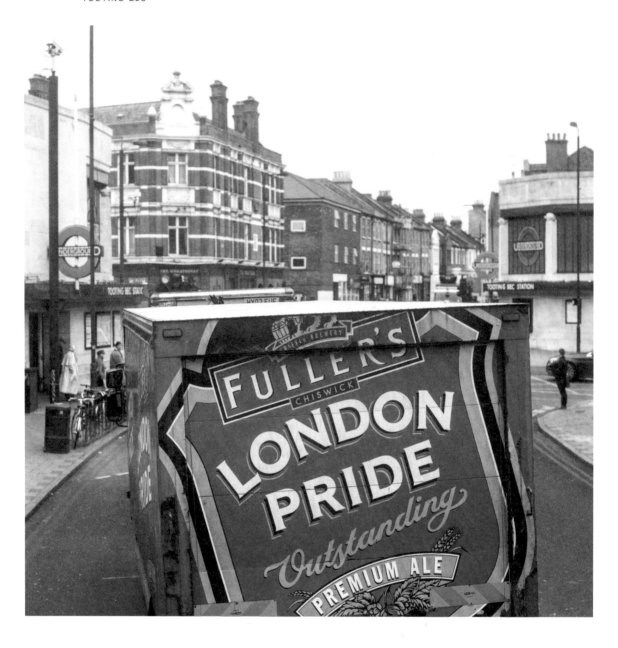

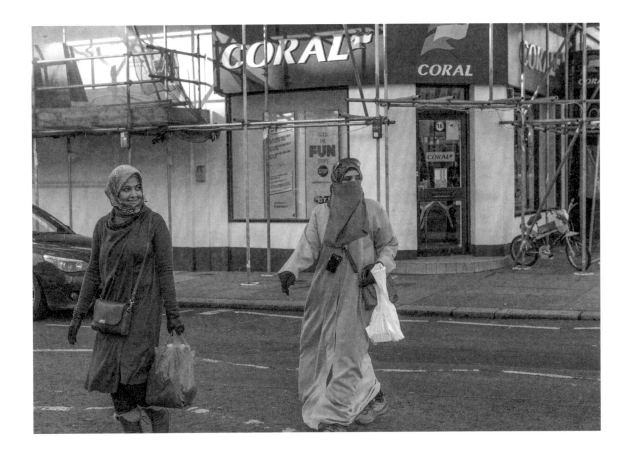

Lee Friedlander said once what I always have believed: "It fascinates me that there is a variety of feeling about what I do. I'm not a premeditative photographer. I see a picture and I make it. If I had a chance, I'd be out shooting all the time. You don't have to go looking for pictures. The material is generous. You go out and the pictures are staring at you."

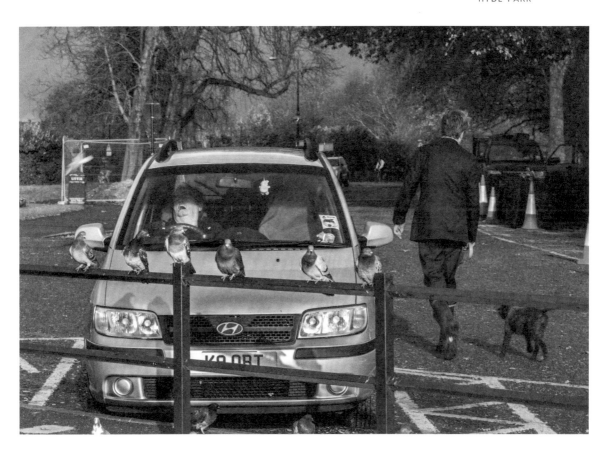

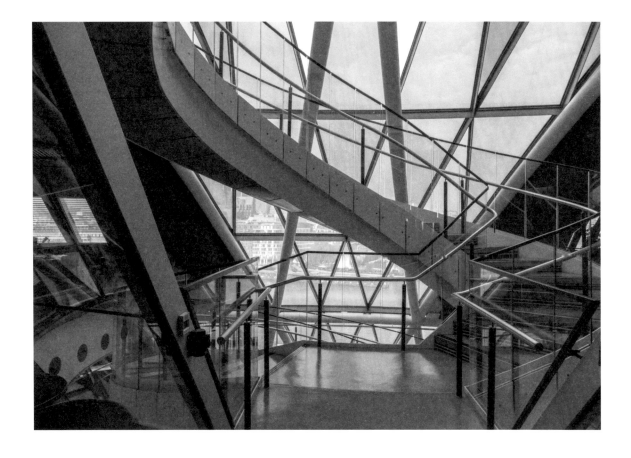

WINTER JAN FEB MAR APR MAY JUN

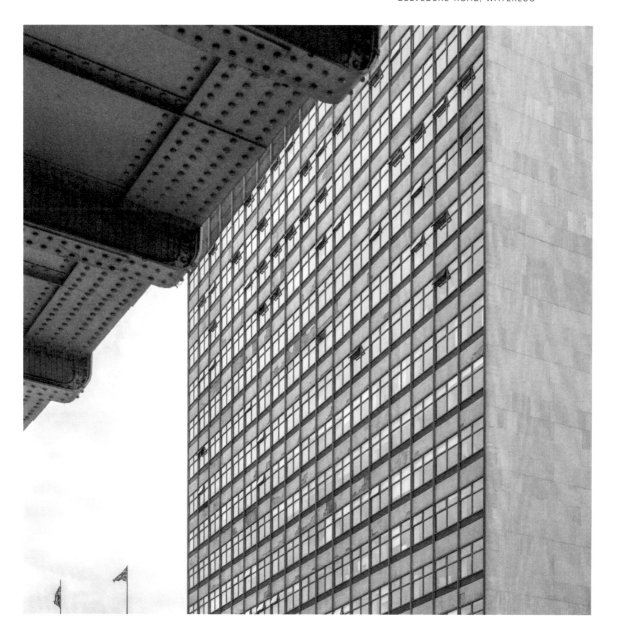

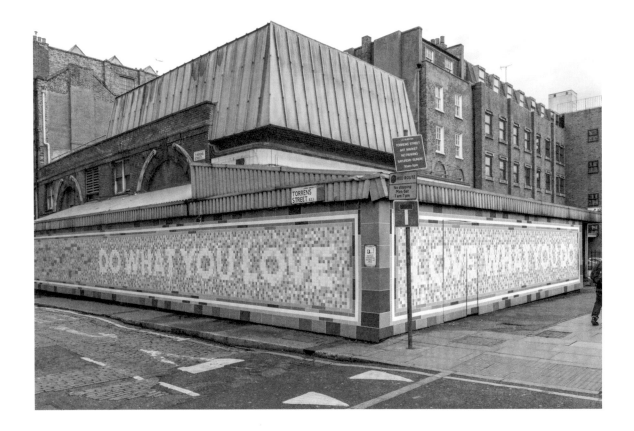

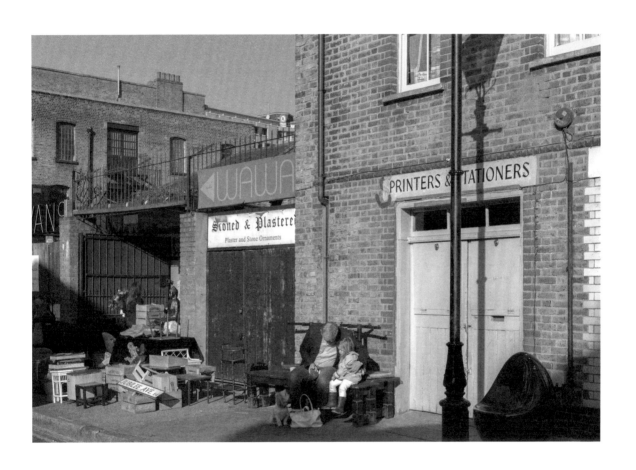

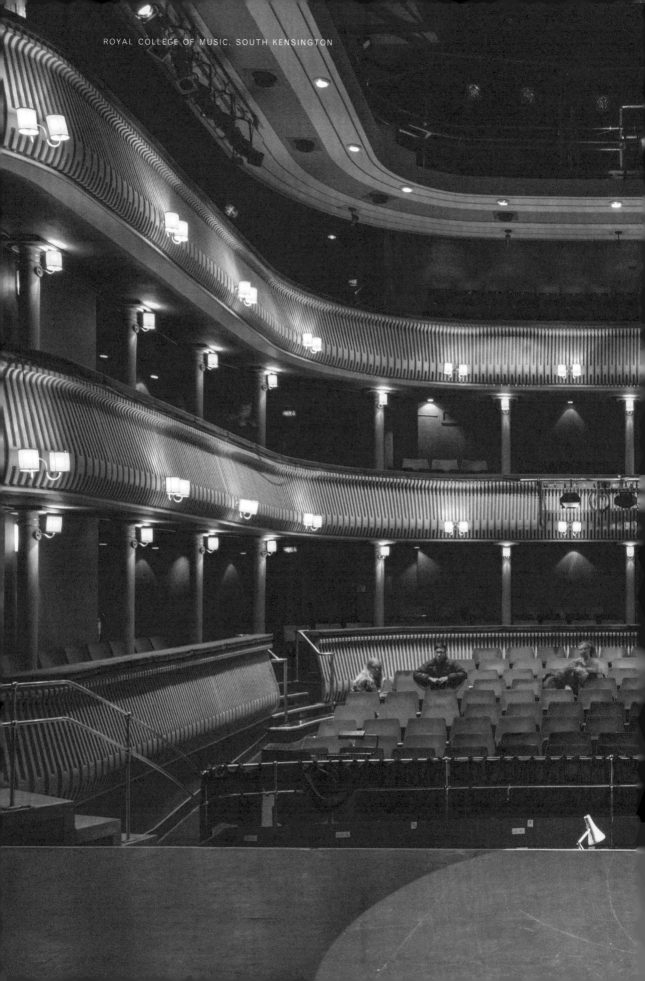

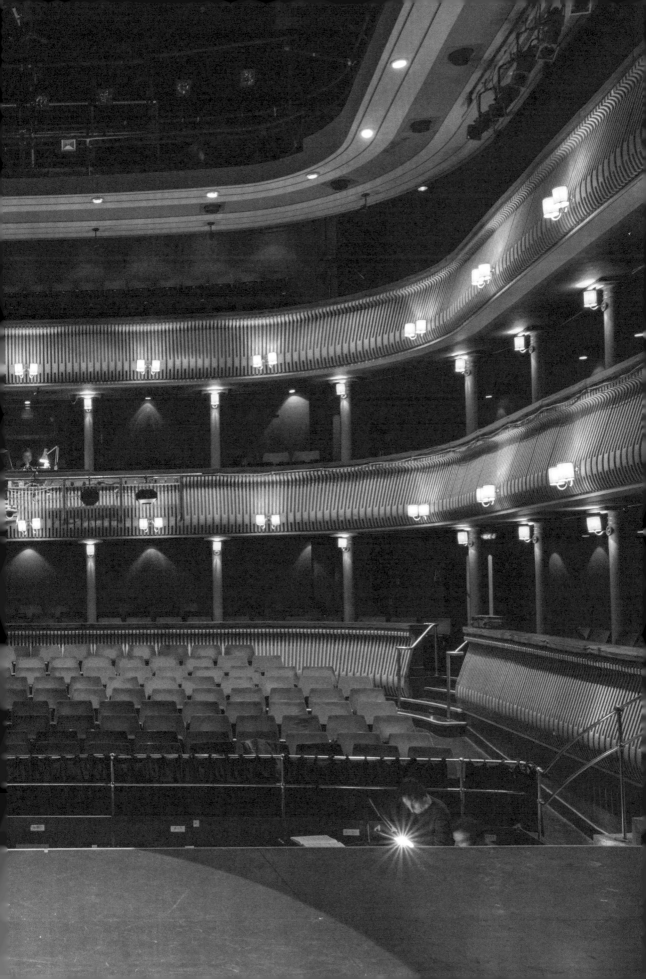

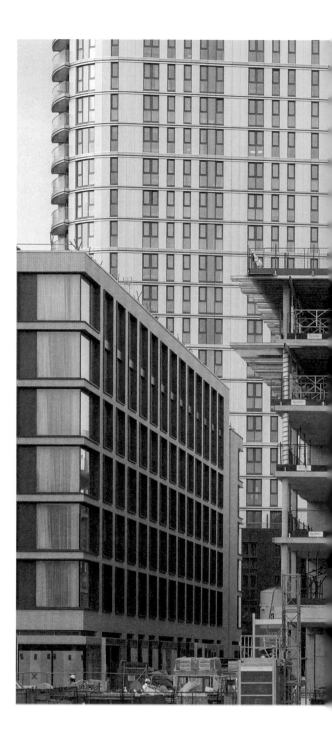

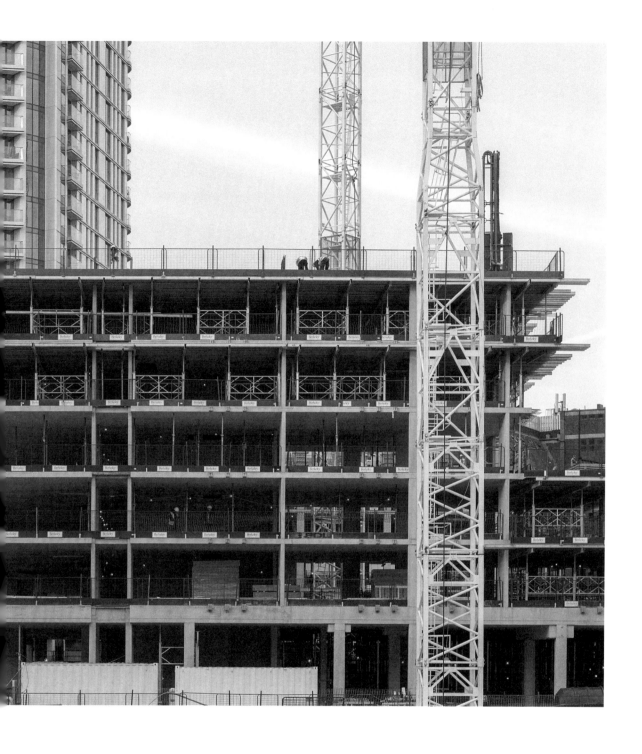

I was born in London, and have lived here for most of my life, and one of the many things that I love about this city is the river that runs through it, and the bridges that connect the north and south banks. You can't see the Thames in this image, but we know that it flows there beneath Westminster Bridge, and that the view from the Houses of Parliament is of water, as well as the great edifices built over centuries of human endeavour. That's what I think of when I look at Big Ben here; and also that our linear notion of time, marked by London's landmark clock, runs alongside something more timeless – the ceaseless flow of the river, a silent witness to the generations of Londoners who have crossed the bridges, to and fro, for time immemorial...

JUSTINE PICARDIE

Editor in Chief, Harper's Bazaar and
Town & Country UK

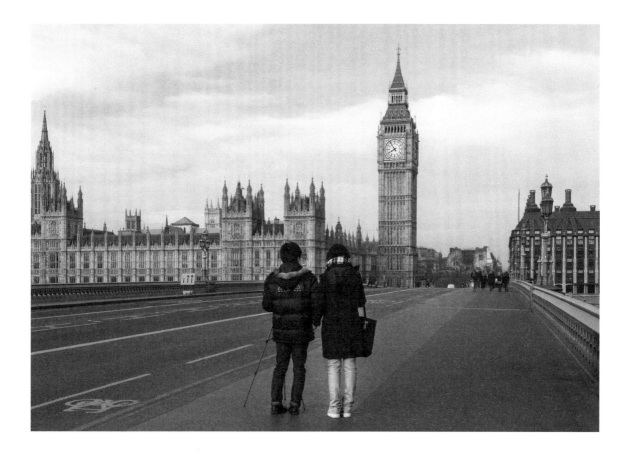

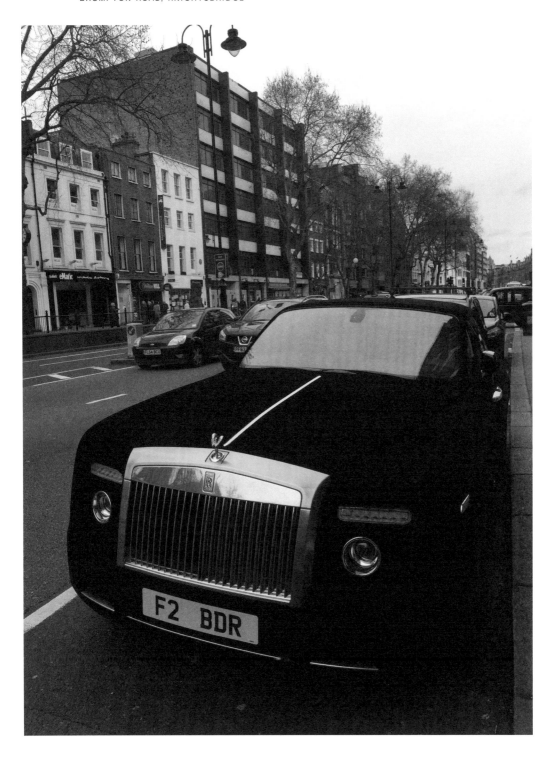

WINTER JAN FEB MAR APR MAY JUN

Supercars are a big theme in London. I have seen them gold-plated, silver-plated, adorned with Swarovski crystals, camouflage, just about everything a small child could wish for in a toy shop. David Bailey rightly noted, "London changes because of money. It's real estate. If they can build some offices or expensive apartments they will, it's money that changes everything in a city. You can't carry on being the same anyway...it makes it more exciting." In my view, the transformation of London means new skyscrapers, and new developments in every single corner.

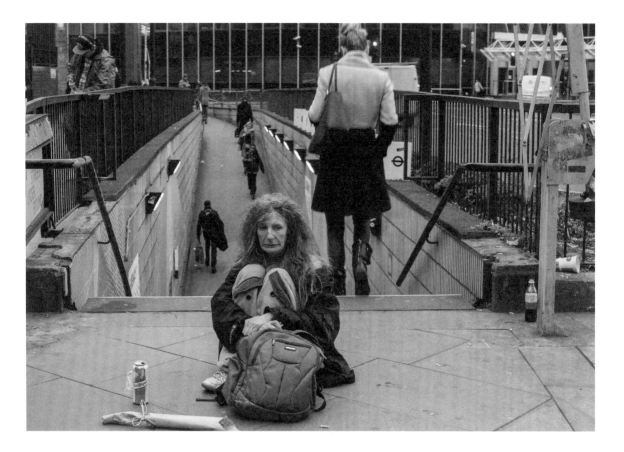

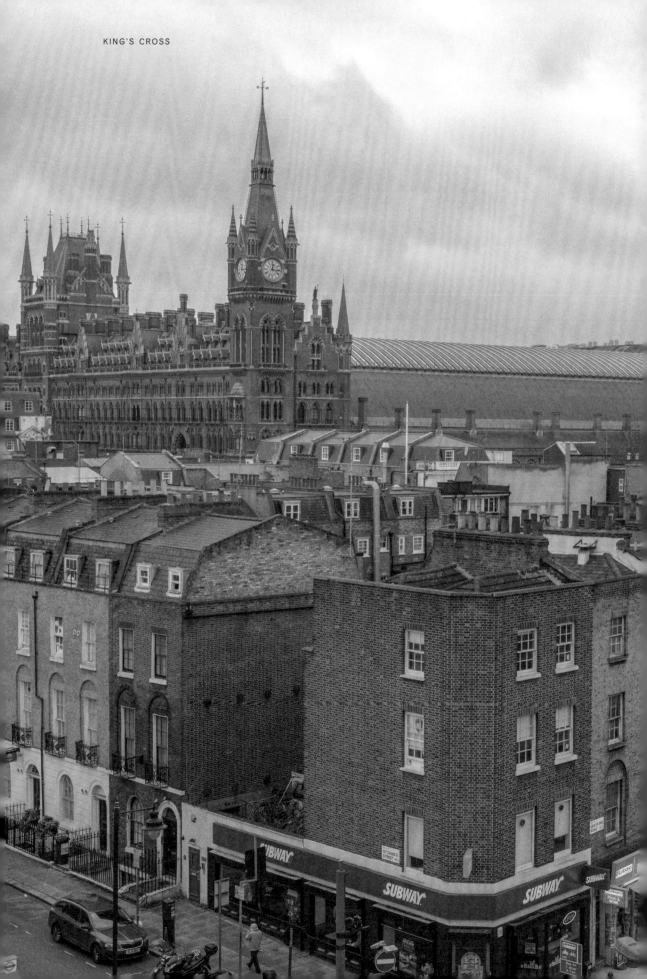

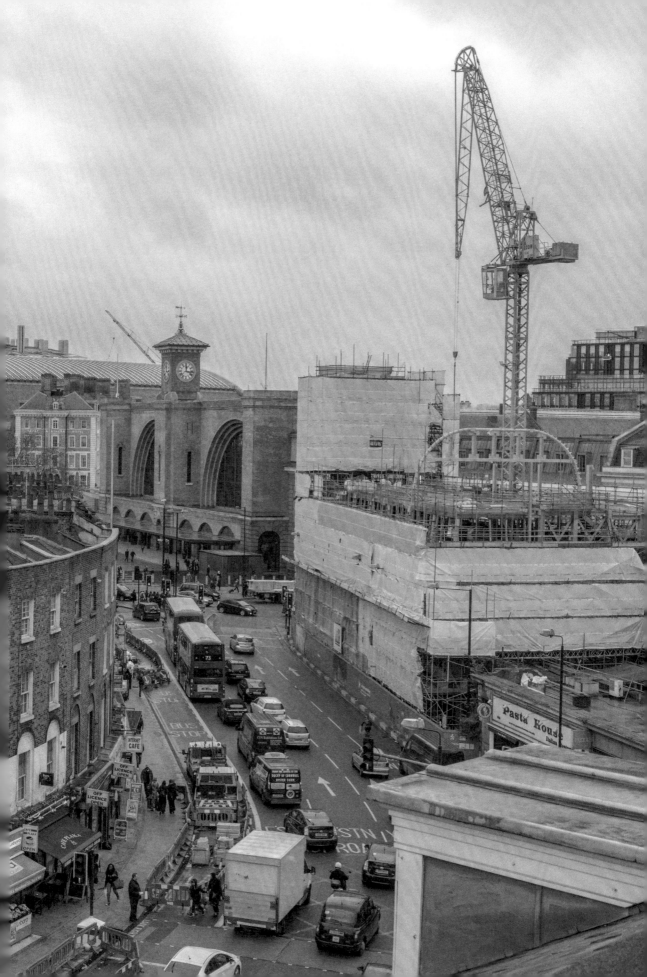

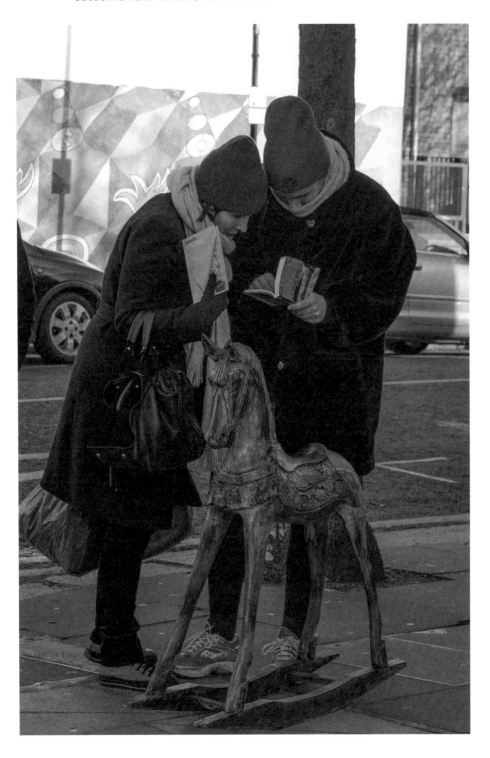

The best way to discover and experience the city of London
is by getting lost and simply wandering around. So many individual
stories are contained within a larger history.

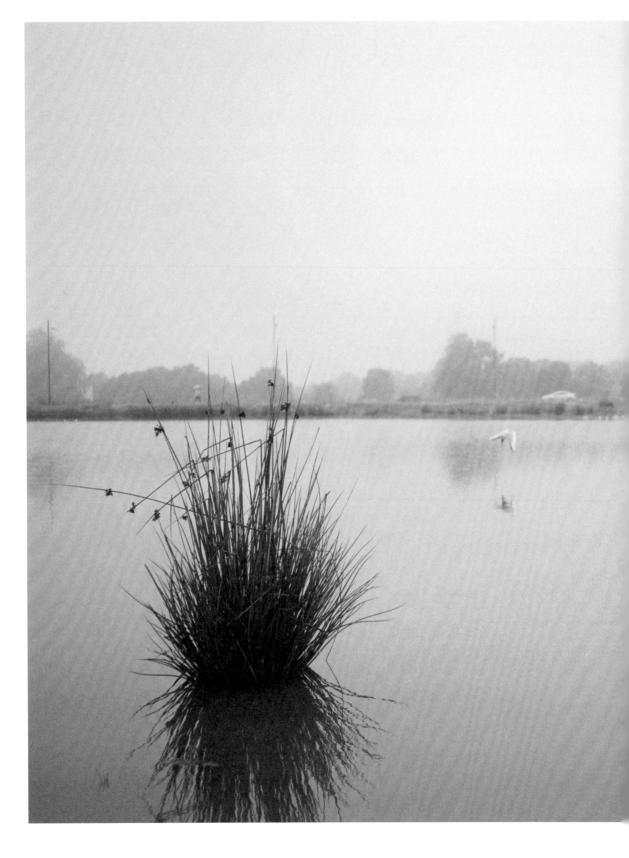

WIMBLEDON COMMON

WINTER JAN FEB MAR APR MAY JUN

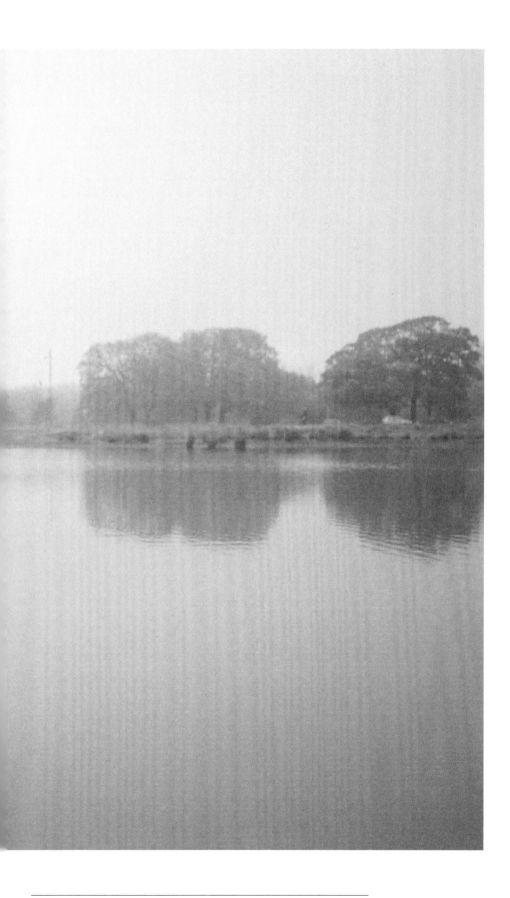

HACKNEY

WINTER JAN FEB MAR APR MAY JUN

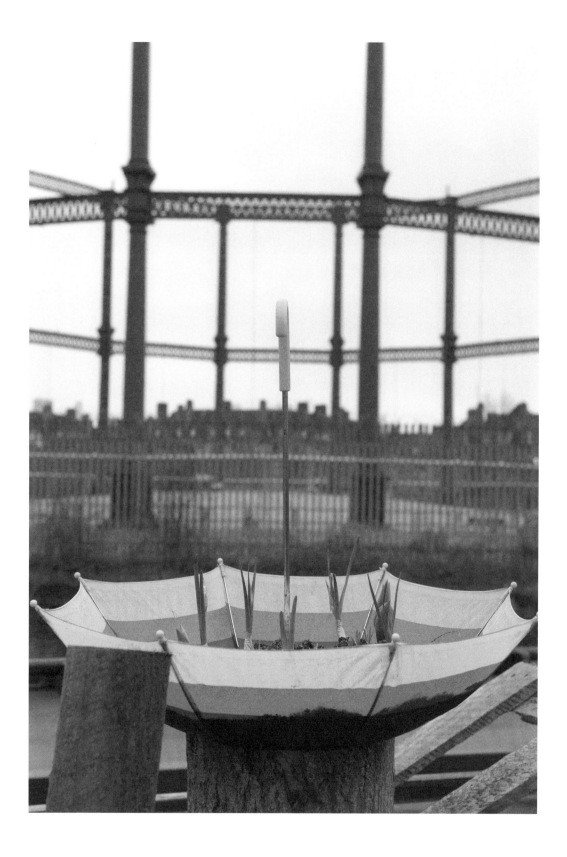

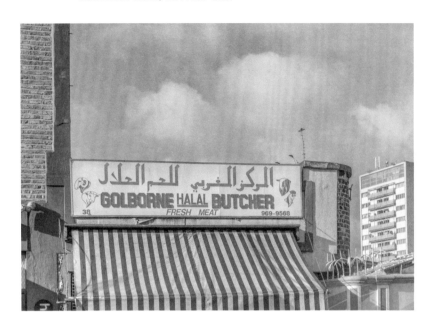

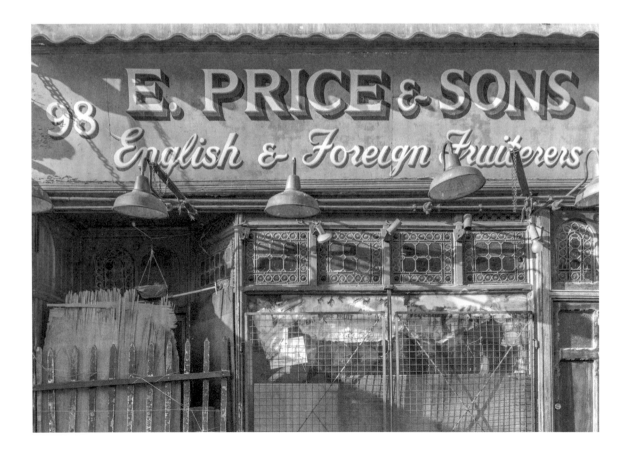

This photograph appeals to me for three reasons. Firstly, it shows a view of London that is timeless. It evokes memories of my childhood – from growing up in London as a small boy I have vivid memories of winters when the snow seemed to fall endlessly, causing great excitement for myself and my three siblings. We would be happily building snowmen and waging snowball fights while wading knee-deep in the snow. These were very happy times for me and my family. It is also a photograph of my favourite time of day – dusk – when we are on the cusp of lightness transforming into darkness. It's the "in-between time", a moment of transformation.

It is to me the most beautiful time of the day when everything you see becomes magical – particularly when all before you is covered in a white coat of snow. I love the soft, warm, glow of the light on the side of the house, turning the wall into a soft shade of pink. In this twilight you notice the coming together of the urban sprawl of houses set against the veil of snow-covered branches of the leafless trees in the foreground. And finally, it also is a reflection of an inner state that is important to me in my life – a state of silence and stillness, of peacefulness and purity from deep within.

JOHN FRIEDA
Entrepreneur

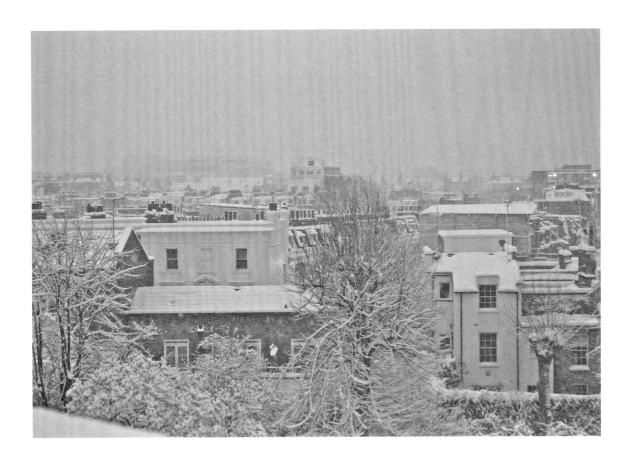

JUL AUG SEP OCT NOV DEC

SOUTH CARRIAGE DRIVE, HYDE PARK

WINTER JAN FEB MAR APR MAY JUN

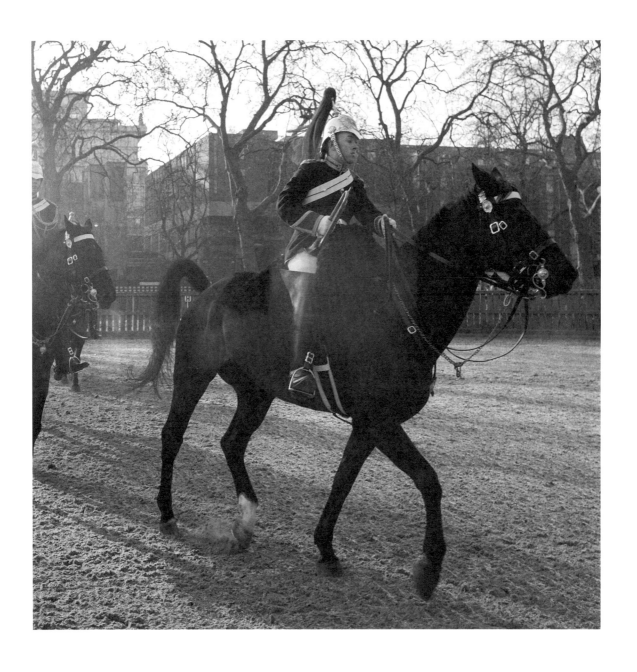

WINTER JAN FEB MAR APR MAY JUN

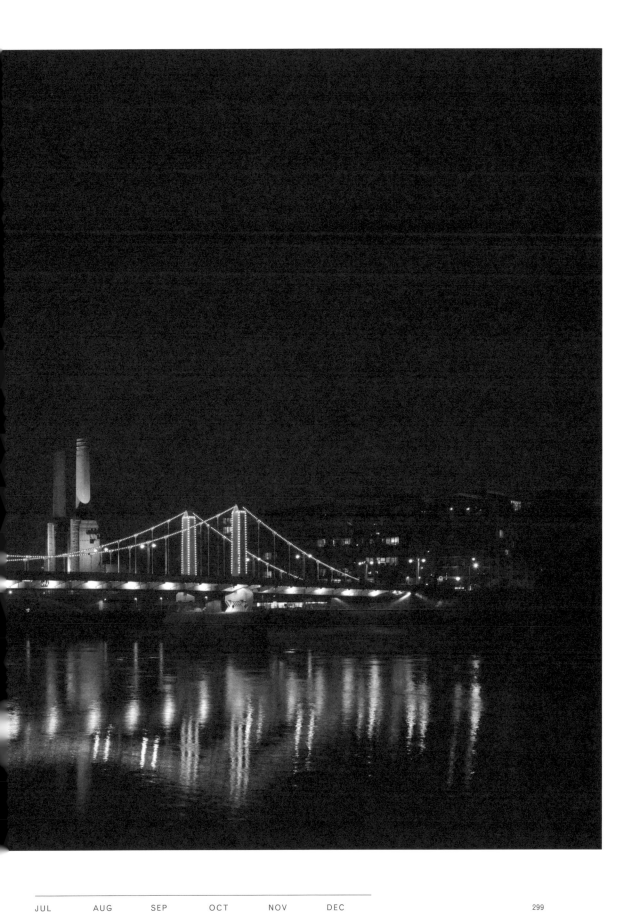

I like pictures to have a musical quality to them, as if the music has just stopped. They should have this kind of gentleness. At university, I studied Literature, and this picture reminds me of Baudelaire: "Even when she walks one would believe she dances."

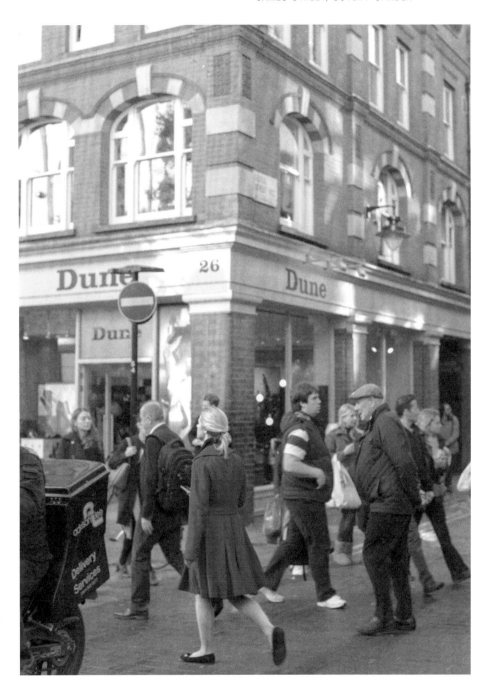

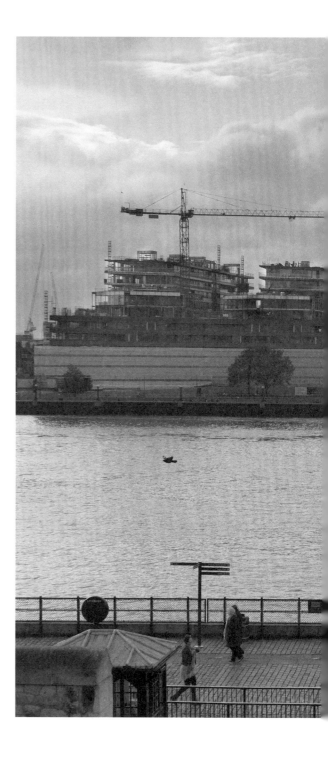

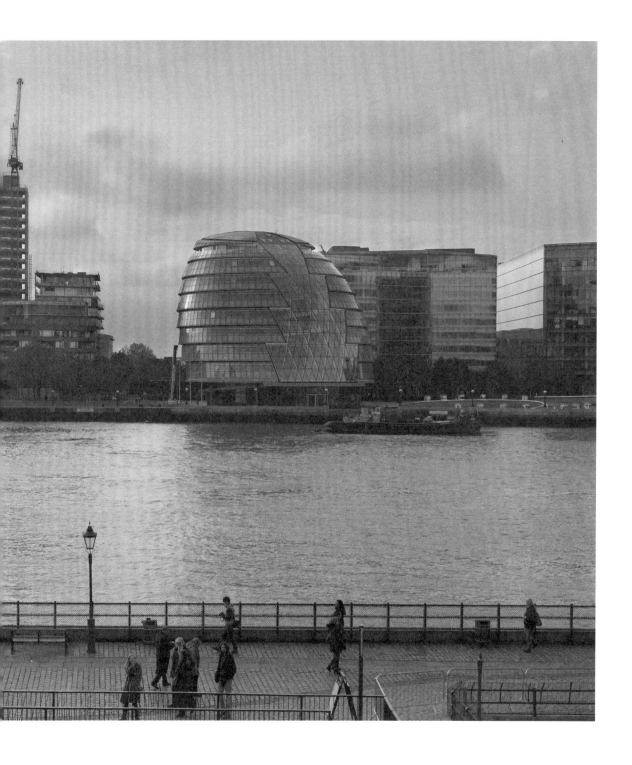

MAYOR'S FUND FOR LONDON

Matthew Patten, CEO

The original title for this project, discussed with Alisa Swidler and Andrea Hamilton, was "Everyday London". But the more we looked at Andrea's photographs, reflected on our own personal experiences of the capital and considered the extraordinary young Londoners the Mayor's Fund supports, the more we realized that there is nothing "everyday" about this brilliant, inspiring and often challenging city.

Aristotle proposed that "a city comes into being for the sake of life, but exists for the sake of living well." And no city has ever been more bountiful than London in offering the finest things in life. But living well is also about how one lives and for whom. Cities are for people and what makes London the world's greatest city is that it belongs to us all. Andrea Hamilton's very personal images collected in this book remind us that we each carry our own unique kaleidoscope of landmarks, faces and moments, our own vision of London.

Our job at the Mayor's Fund is to work with those young Londoners yet to understand this inclusiveness and help them seize the endless possibilities the city has to offer – through focusing on literacy and numeracy skills, health and well being – ultimately, to find decent jobs and lead fulfilled lives. In turn, we depend on a myriad of generous supporters and benefactors whose appreciation of the art of living well is enhanced by helping so many young people escape the threat of poverty.

We are very grateful to our contributors, who have each selected an image that resonates with them and shared an insight about their relationship with London; to our sponsors for their generosity; and to Alisa Swidler and Andrea Hamilton for their vision and boundless enthusiasm. All of the photographs for this project are available to order in limited editions and all proceeds go directly to helping disadvantaged Londoners live well. Aristotle would approve.

MAYOR'S FUND FOR LONDON

HELPING YOUNG LONDONERS GROW

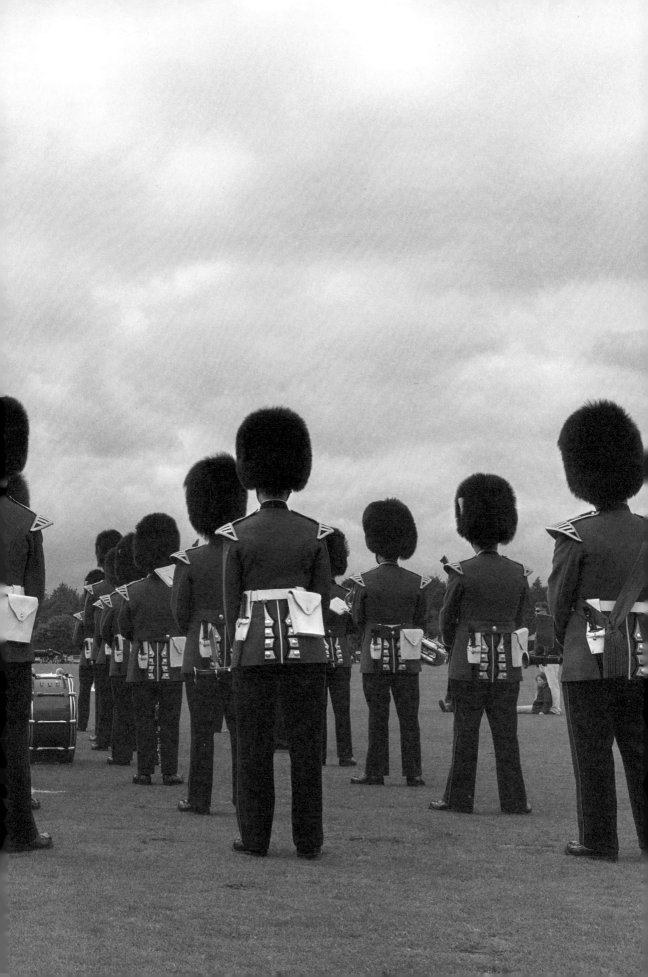

ACKNOWLEDGEMENTS

First of all, I would like to thank my distinguished panel of contributors – Mayor Boris Johnson, Sir Elton John, Geoffrey Kent, David Furnish, Tony Pidgley, CBE, Anish Kapoor, Jessica McCormack, David Adjaye, OBE, Charlize Theron, Sir Martin Sorrell, Nadja Swarovski, Mary McCartney, Justine Picardie and John Frieda – for their intuitive and personal perspectives on my images. I would also like to extend my gratitude to uber-philanthropist Alisa Swidler and Mayor's Fund for London CEO Matthew Patten, for their incredible enthusiasm and innovative ideas from the outset, in building the seed of an idea into an exciting project. Paul Green, Director of the Halcyon Gallery and Niki Gifford, Marketing Director, for hosting the exhibition. Fiona Kearney for coordinating the project and exhibition at City Hall and Tom Pountney, public relations for the charity. Curator Charlotte Cotton wrote an exceptional introduction to my work by which I feel honoured. Furthermore, I would like to express gratitude to the outstanding team behind the publication and their support of the charity including dynamic Romilly Winter and David Tanguy, designers from Praline Studio, publishers Edward and Julia Booth-Clibborn for their critical eye and my editor Tamsin Perrett for her flawless attention to detail; Eric Bailey Ladd at XY Digital for assembling the team; Laura Vallés for her outstanding coordination of the book; Nico Kos Earle for her invaluable input on the content; Rosie Duca for her perfectionism with the printing process; Andrea Algueró for her constant smile and for delivering all graphic content to the charity, panellists and publishers; and Emelie Martin for her assistance with all the phases of my assignments. In addition, novelist Stephanie Keating Berke gave it an expert check with fresh eyes and creativity.

This book would not have been possible without our team of sponsors, who have underwritten the cost of producing this book so that funds raised by sales can go directly to the charity. These are: Devika Waney, together with Aurore Ogden and Susanna Warren of the Dover Street Arts Club; Charles McDowell, one of our initial

backers; Dan Bricken from Wells Fargo who also brought in his friend David Currie from Codex Capital. A huge thanks to Kasim Kutay and Lauren Hurwitz from Moelis who have given us wonderful ideas as well as support. Steven and Kumari Blakey from CFAB, Maritzina and Mark Slater from Slater Investments. My thanks extend also to Paddy Byng, CEO of Linley together with Linley's Carmel Allen, Creative Director and Annie Davidson, PR for arranging the book launch as well as Andrew Nicholls from Hudson Sandler.

Also, I would like to acknowledge Paolo Moschino and Philip Vergeylen from Nicholas Haslam: Emma Farah from Rob van Helden; Laure Ghouila-Houri from Arkitexture; Christiane Monarchi from Photomonitor; and especially Catharine Snow from Clearview Books, for their help and guidance.

For support in the process that led to this publication I am additionally grateful to: Gry Garness, who I have in my heart; Maryam Eisler and Hossein Amirsadeghi (my editors on *London Burning*) for their never-ending friendship and generosity; Hannah Barry for her freshness and creativity; Anthony Downey for his contribution to our lecture series; Kathryn Bricken, Alison Corbett, Leslie McGuirk, Catherine Heeschen and Anne Prevost for their friendship and support throughout. This book is dedicated to my parents David and Ina Jarvis, my supportive husband Greger Hamilton and my three amazing children Felix, Hugo and Allegra.

LOCATION INDEX

CREDITS

Andrea A. L. Scala, *About Photography*, Lulu Press Inc (eBook), 2014.

Elizabeth M. Knowles, ed., *Oxford Dictionary of Quotations*, Oxford University Press, Oxford, 2009, 166.

Alec Soth, "Dismantling My Career: Alec Soth in Conversation with Bartholomew Ryan," *From Here to There: Alec Soth's America*, Walker Art Center, Minneapolis, MN, 2010, 138.

Winston Churchill, speech to the House of Commons (meeting in the House of Lords), 28 October 1943. See online at: http://www.parliament.uk/about/living-heritage/building/palace/architecture/palacestructure/churchill/

Henri Cartier-Bresson, *Famous Photographers Tell How*, 1958. See online at: http://petapixel.com/2015/05/03/an-interview-with-henri-cartier-bresson-from-1958/

Deconstructing Harry, dir. Woody Allen, 1997.

Hisoshi Sugimoto, "Hiroshi Sugimoto: Tradition," *Art 21*, 2005. See online at: http://www.art21.org/texts/hiroshi-sugimoto/interview-hiroshi-sugimoto-tradition

Jeff Wall, "The Hole Truth. Jan Tumlir talks with Jeff Wall about *The Flooded Grave*," *Artforum* no. 39, 7 (March 2001), 114.

Sean O'Hagan, "Garry Winogrand, edited by Leo Rubinfien et al – review," *The Guardian*, 19 May 2013. See online at: http://www.theguardian.com/books/2013/may/19/garry-winogrand-photography-review-sfmoma

Gil Blank and Thomas Struth, "The Tower and The View: Gill Blank and Thomas Struth in Conversation," *Whitewall* (New York, 2007) no.6: 104–119. See online at: http://www.gilblank.com/images/pdfs/blankstruthintvw.pdf

Simon Unwin, *Twenty-Five Buildings Every Architect Should Understand*, Routledge, London, 2014, 37.

F.O. Matthiessen and Kenneth B. Murdock, eds, The Notebooks of Henry James, University Chicago Press, Chicago, 1981, 28.

"William Eggleston, The Father of Color Photography," *Dodho Magazine*, 10 December 2012. See online at: http://www.dodho.com/william-eggleston-the-father-of-color-photography/

Holland Cotter, "Agnes Martin, Abstract Painter, Dies at 92," *The New York Times*, 17 December 2004. See online at: http://www.nytimes.com/2004/12/17/arts/design/17martin.html?pagewanted=all&_r=0

Arthur Rothstein, *Documentary Photography*, Focal Press, Boston, MA, 1986, 109.

"Q&A: David Bailey Interview," CNN.com, 3 November 2006. See online at: http://edition.cnn.com/2006/TRAVEL/11/02/london.qa/

Charles Baudelaire, trans. Richard Howard, *Les Fleurs du mal* [1867], David R. Godine, Boston, MA, 1983, 33.

Eugene Garver, *Aristotle's Politics: Living Well and Living Together*, University of Chicago Press, Chicago, 2012.

Published on the occasion of an exhibition at City
Hall and an auction held at the Halcyon Gallery in aid
of the Mayor's Fund for London, November 2015.

The Mayor's Fund for London reaches every London
borough. Hungry children in 65 London schools start
the day fit and ready to learn thanks to its breakfast
clubs. Its literacy and numeracy projects are helping
5,000 young Londoners improve their reading and maths.
In the next three years, the Mayor's Fund will find over
1,500 decent jobs and opportunities for unemployed young
Londoners. The charity's programmes are on track to
reach 50,000 more young people in the capital's most
disadvantaged communities.

Design: Praline: Romilly Winter and David Tanguy
Editorial: Tamsin Perrett, Laura Vallés
First published in 2015 by Booth-Clibborn Editions

Printed in Italy
ISBN 978-1-86154-379-0

Booth-Clibborn Editions
Studio 83
235 Earl's Court Road
London SW5 9FE
Email: info@booth-clibborn.com
www.booth-clibborn.com